THROUGH THE VIEWFINDER

Jeremy Hoare

ENTERTAINMENT TECHNOLOGY PRESS

Television Techniques Series

To my parents: June Hoare for giving me the gift of creativity and George Hoare for giving me the practicality to use it.

THROUGH THE VIEWFINDER

Jeremy Hoare
Interviews edited by John Ruler

Best wishes,

Jeremy Hoare

etpress

Entertainment Technology Press

Through the Viewfinder

© Jeremy Hoare
Interviews edited by John Ruler

First edition published December 2008
by Entertainment Technology Press Ltd
The Studio, High Green, Great Shelford, Cambridge CB22 5EG
Internet: www.etnow.com

ISBN 978 1 904031 57 4

A title within the
Entertainment Technology Press Television Techniques Series
Series editor: John Offord
Photographs by the author unless otherwise stated

CODE /TTV01-12/08

CONTENTS

ACKNOWLEDGEMENTS

I would like to thank sincerely all the contributors who have given their time for the interviews, Jennifer Hoare who faithfully transcribed the recordings, and John Ruler who edited them so superbly.

8 Through the Viewfinder

PREFACE

Julie Andrews in 1963 at the closing party of 'My Fair Lady' at Theatre Royal Drury Lane. Photo: Jeremy Hoare.

As much as I would love to forward some constructive comments on cameramen for you, alas the technical aspect of their craft mostly remains an awesome mystery to me. All I truly recall is how talented, conscientious and knowledgeable they all seemed to be.

Dame Julie Andrews

FOREWORD

The qualities common to all who belong to that special band of film and television makers labelled "cameramen", are anonymity and mystique – in equal measure. Jeremy Hoare's admirable book, which I am privileged to introduce, begins to redress these two failings of public understanding.

Jeremy is well placed indeed to remove some of the mystique from the art of the cameraman having enjoyed a life time in the television production industry during what some have dubbed a golden age.

In passing on his knowledge and the collected wisdom of many of his distinguished contemporaries, he has not only addressed the anonymity question, but also provided a great service to Britain's crucial creative industries. Here, at last, is a first hand, hands on account of experience, craft, skill, art and passion that will be a must read for present and future generations of young, aspiring moving image creators.

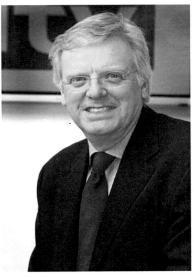

Michael Grade, Executive Chairman of ITV, London. Photo: Rex Features

No theory here, just the recounting of a lifetime spent helping directors, actors, writers and sound men to realise their creative ambition and entertain, educate and inform the wider public. He tells it like it was and like it should be. There can be no excuses in future for not appreciating the crucial role of the camera and its operators.

This book, I hope, will inspire many to follow in his distinguished footsteps.

Michael Grade CBE
ITV Executive Chairman

1 WHAT IS A CAMERAMAN?

Egotistical, opinionated, arrogant, conceited …, that'll do, enough words to describe my own television camera career. I think I may have upset more programme directors than anyone else, but I sincerely hope not. I take no pride or pleasure in writing this, but will be severely rebuked if I do not by those who will remember – and they will. I have got to that point in life where I can accept the past, albeit with a Dunkirk grin.

Cartoon of the author operating a TV camera.

Being a cameraman is many things but there is a key to unlocking the greatest mysteries of why one is better than another. The good ones know how to tell a story with a boxful of metal filled with plastic and glass called a camera. Why? Because they put their heart, passion and emotion in it. In some ways cameramen are dreamers, always looking over the horizon to better things, but they are also very pragmatic, and as such have their feet firmly on the ground.

I went through an entire camera career never really knowing how the things worked, but they did and I was grateful as they enabled me to tell stories with them. But that was in yesterday's world of union protected jobs (no card, no job) when you could say and do whatever you wanted to; being fired was only possible if you actually broke the law. Otherwise the unions would uphold the right of anyone to maintain their employment, and that's what killed them off.

How times change! Today that attitude is out of the question – a freelance world where you are only as good as your last job. And there's the inevitable gossip that goes with it in what is still a virtual cottage industry worldwide. The gossip bit at least has not changed though!

So, act as I did in the past and you will not exactly find the phone ringing itself off the hook. It will be time to investigate supermarket shelf stacking work instead of having a career in one of the best jobs in the world's best businesses – being a cameraman in television production.

There in a nutshell is a paradox; unless you stand your ground sometimes and do what you know to be right (and which gets noticed), nobody will ever get to know what magic employing you brings to a production. In short, you have the greatest of dilemmas: how to be just enough of an opinionated cameraman without overstepping the mark so that that is all you are. Back your character traits with good camerawork and be part of the production team, then through your strength of personality deliver far in excess of what is expected and you should never be out of work.

For someone like myself with minimal education (no 'diplomas', not a single qualification) to do what I have done as a television cameraman has been a fluke of luck and ambition combined. Luck is being in the right place at the right time and having the ability to seize the moment; ambition is what has driven me forward together with the vital passion and emotion. Though failure is ever present, and it is tempting to stay in your comfort zone, never let that demon win the day; you will be doomed to creative oblivion if you do.

These are my own personal opinions but here in this book are those from many colleagues I have been privileged to have worked with throughout my career. Read and learn, then put your ideas into practice and always remember, in the end there are only three words that describe the secret of good camerawork and television production: tell the story.

2 SHOWBIZ FAMILY INFLUENCES

I have always counted myself lucky in being the third generation of a showbiz family going back nearly a century, and believe this continuity gave me a 'feel' for working at the forefront of television production. My career has certainly not been typical and countless other cameramen have achieved a lot more than me without any showbiz background whatsoever. Where you come from is not necessarily where you are going to go, it is entirely up to you.

Grandfather – William A Hoare
My grandfather William Hoare was a music hall comedy actor and became Charlie Chaplin's understudy in *Mumming Birds* with *Fred Karno's Army* which toured America before the First World War. Chaplin stayed to win fame and fortune but William came back broke and somehow evaded WW1 although he didn't avoid a spell in the 'glasshouse' after going AWOL.

After the war he formed a trick cycling act with a partner, *The Willenors*, which took him all over Europe with circuses as well as to most music halls in the UK, even performing in a *Royal Variety Performance* at the London Palladium in 1936.

Not a healthy or successful man, he frittered away much of his hard earned income on petty gambling and towards the end of World War Two a German V1 Flying Bomb dropped onto a house two doors away. In the blast he was pinned down by a wardrobe and although uninjured never really recovered and died not long after.

Father – George WA Hoare
My father started work age 15 in 1926 as a film rewind boy during the screening of the first *Ben Hur* film at the Stoll Theatre Kingsway. He was much more ambitious than his father and studied hard so by the time World War Two began he was made manager of the Leicester Palace. This was closed for much of the time and as he was unfit for military service his wartime duty was making shells on a lathe at a factory north of the city. When I drove him past the same building one day on my way to light the Central TV Studio for local news in Nottingham, he excitedly recalled

George Hoare
Photo: Jeremy Hoare

sitting on the squat roof at night with a machine gun on lookout duty and was thankful he didn't have to fire the thing. After the war he was transferred to the Frank Matcham designed Wood Green Empire in north London and remained there until 1955 when it became ATV's first principal studio in which I first worked.

His first West End theatre took him back to his beginnings when he managed the Stoll Theatre during the musical *Kismet*. Sadly he was to close this theatre as well, the final production being Shakespeare's *Titus Andronicus* with Laurence Olivier and Vivien Leigh. The Olivier's hosted a lovely day-long Sunday party as a farewell at their home near Thame in Oxfordshire and to this day I remember how soft and gentle Vivien Leigh's handshake was.

Then in 1958, Stoll Theatre's managing director, Prince Littler, appointed George to the post that every manager wanted, general manager of the Theatre Royal Drury Lane – and this theatre wasn't going to close! His first musical was an end-of-an-era classic, *My Fair Lady*, and he revelled in friendships he made with its stars: Julie Andrews, Rex Harrison and Stanley Holloway.

Years later I worked with Julie Andrews and was too reticent to mention the connection and that I had also gate-crashed her first wedding to which my parents had been invited. When I wrote to her about this book she not only kindly provided the introductory quote, but added: "How well I remember your father. He was a fine gentleman, kind, courteous and we had many lovely chats together". Julie's response was typical of what I heard often from many who knew him; he was a very hard act to follow.

Myself – ATV Kingsway

I was 15 when after a gap weekend I started work at ATV in Kingsway and the day was not only a Tuesday after an Easter Monday, it was also the day Grace Kelly married Prince Rainier in Monaco. As I did my rounds

I could watch the progress on TVs in various offices. Lew Grade's office was in the middle of the sixth floor near the lifts – he and Val Parnell shared the same office.

I walked by these old offices some time ago to find the site being redeveloped and all that was there was the façade covered with sheeting, a big hole was where the building's interior had been. It was a pity as I'd had an idea to revisit.

Associated Television (ATV)

Being employed by ATV was not working for a company but for a man, Lew Grade. Subsequent managements tried hard to convince me otherwise but always failed miserably, I was a lost cause to them in an industry that runs on its creative talent.

Lew, always known as such, was the last of the true showmen; someone who started at the very bottom, worked his way up to become a champion Charleston dancer and never took his success for granted. Television was impoverished by his passing, but his nephew, Michael Grade who kindly wrote the foreword to this book, has followed in those formidable footsteps and is a much needed creative force in television today.

Lew's great strength was to correctly gauge public taste, although he made occasional blunders, most notably with the feature film *Raise the Titanic*. Ironically the film has subsequently recouped its cost many times over with television repeats worldwide. Numerous amazingly successful programmes were instigated by Lew which propelled many to international stardom and to name just a few: Roger Moore, Eric Morecombe & Ernie Wise, Tom Jones, Englebert Humperdinck and Jim Henson's Muppets.

Jim Henson had done the children's show *Sesame Street* for many years in New York and was guesting with Kermit on a *Julie Andrews Show* at Elstree. He was a quietly determined man and got a meeting with Lew who gave Jim Studio D for two days to make a one-hour special – the rest is history. It was only because of Lew having the foresight to see the potential of puppets working with stars, with which its variety of spin-offs have given pleasure to umpteen millions worldwide, that Jim succeeded.

This is my story; we all make our own destiny – so go ahead and make yours!

3 CAMERAWORK THROUGH THE YEARS

I blame it all on Queen Elizabeth II. If I hadn't gone to her Coronation in 1953 I might never have thought of becoming a television cameraman.

I was taken with a whole busload of other excited schoolchildren to witness the Coronation spectacle in the rain; we were allotted a special area on the Embankment, one of the prime viewpoints. After clambering off the bus, I saw the newspaper placards, 'Everest Conquered!' Edmund Hilary and Sherpa Tensing had made the most of their remarkable achievement as it was announced to the world on this special day. But the thing that really stuck in my 12-year-old mind was seeing television cameras for the very first time. They looked wonderful and powerful; I envied the men operating them and I knew from that moment what I wanted to do in life, to be a television cameraman.

We had been watching television at home for several years by 1953; it was no novelty as my father had made a television set as soon broadcasting started again after World War Two. It had a nine-inch green ex-radar cathode ray tube and the first production I saw on it was Shakespeare's *Macbeth*, quite scary for a seven-year-old. But we were the only household around to have a television and the envy of the street. Everyone suddenly became our friends, they wanted to see what the 'telly' was they'd heard so much about. What with that and the first jet fighters passing overhead, RAF Meteors, the late 1940s and early 1950s were an age of discovery for me.

Early Days at ATV

Leaving school at 15 with no academic qualifications, my first job was as a post boy for ATV, and I'd got my feet in the door of television in the very early days of commercial enterprise during the spring of 1956. Part of the job was working unpaid at

Jeremy Hoare age 15 posing on a Pye Mk3 camera at ATV Wood Green Studio.

weekends as a callboy on live shows, mainly the big *Saturday Spectacular* LE show which ATV transmitted from what had been the theatre my father had managed, renamed as the ATV Wood Green Studio.

Moonlighting for the BBC

But as a complete irony, the first television pictures of mine that were transmitted and my only link with news as a cameraman was when I was 17. Across the road from my parent's home in north London lived BBC TV news cameraman Graham Veale who was using B&W 16mm film. I had bought a 9.5mm Pathe cine camera so pestered relentlessly to go out with him on a story until he finally gave way.

So one afternoon we went in his dull green BBC Humber Super Snipe to what was then the Saville Theatre in Shaftesbury Avenue, now an Odeon cinema. The story was for a magazine programme the next day about the new musical show and he gave me a silent Bell & Howell Filmo with a 100 foot roll of film to shoot whatever I chose on the stage. This got me nicely out of the way so he could concentrate on shooting the dressing room interviews with his Auricon sound camera. When we wrapped, I handed the camera back to him with trepidation before we went to the Marquis of Granby pub over the road and had a few beers. I was amazed the next day to watch some of my footage go out, my first ever pictures on television, a huge thrill at 17 years old - and it was for the BBC!

Getting into the Camera Department

Back in the 1960s, it was a case of dead-mans-shoes before anyone moved up in television, and I was too young and immature anyway to get into the Camera Department when first at ATV. So I stayed in the Post Room until I finally made it into the Camera Department at 19. I was the youngest at the time, and they really wanted older, wiser, saner people, but I was just dammed persistent; not a bad quality in a cameraman as it happens.

As a camera assistant, I tracked the Vinten Pathfinder dolly as well as driving the Mole-Richardson Crane, which I really enjoyed. It was still mostly live television then so I quickly learnt to be confident and decisive when tracking these dollies and the original Vinten pedestals; to hesitate was to be lost which is just as true today as it was then.

Tracking the Mole and Pathfinder dollies meant having control of the width of the frame, usually with the cameraman using a 2" prime lens, so

if the two people in front of camera suddenly moved apart I had to react rapidly and without waiting for instruction from the cameraman, otherwise one of the people would go out of frame. Inevitably, it did happen, and the cameraman's only option then was to go with the money or whoever was talking or singing at the time. If this seems a bit hit-and-miss today, you're right – it was.

The cameras at Wood Green, Hackney Empire and Foley Street Studios, and on Outside Broadcasts, were Pye Mk 3 image orthicons with four-position turret lenses, typically 2", 3" 5" and 8". In the studio, it was only the brave and foolhardy who used the 1½" and 12" lenses, but everyone tried at least once, it was part of the learning curve.

These cameras were ahead of their time with electric lens change and focus, the latter switchable to either side. When the control packed up on a live show, which was frequent, the right side of the camera was opened up and the focus adjusted by sliding the tube carriage forwards and backwards manually. This was vital as it kept a camera going when the normal complement on any show was usually only three and sometimes, but rarely, four.

Wood Green Empire Studio

The Pye Mk 3s were used at Wood Green up until Lew Grade did a deal with an American network to produce some *Dick Cavett* shows, live from north London to the USA coast-to-coast with a five-hour time difference to New York. So the Pyes were replaced by Marconi Mk4s as they were switchable from 405 to 525 lines. These were good cameras that delivered excellent pictures, and from my use of them as a cameraman, I found the viewfinder sharp enough to give me confidence to try shots that I wouldn't have dared with the Pyes.

Hackney Empire Studio

My best days as a callboy were spent working on every one of the greatest rock 'n' roll shows of British television in the late 1950s: O*h Boy!* produced by the dynamic Jack Good. Going out live from the Hackney Studio filled with a screaming teenage audience it was 30 minutes of non-stop energy every Saturday evening and made Cliff Richard a star.

It was also where I spent my memorable first day in the Camera Department, doing Tilt & Bend on the Vinten Pathfinder with John

Glenister operating and the Everly Brothers performing *Cathy's Clown* just a few feet in front of me. With such amazing stars, my mind was on them rather than the camera and I was rightly reprimanded. But I wasn't alone and saw many go through this rite of passage.

I did the theatre lighting for Japanese cabaret act *Frank Chickens* there years later and could find no trace of its studio days – even less chance now, but at least it is one Frank Matcham theatre that has survived.

Highbury Studio

ATV had another converted studio at Highbury, the old Gainsborough Film Studio, and on one live transmission of *Emergency Ward 10*, the first 30-minute medical soap, one camera then another died completely quite early on. So the director was forced to fade to black, the remaining camera moved to the next set rapidly, then faded up again. This was for more than half the programme, but the show did go on although viewers must have thought it either rather odd or daringly avant-garde.

Foley Street Studio

ATV's smallest studio was in Foley Street, London and my main association was being sent on either a Saturday or Sunday to cover Presentation – basically short live links between programmes. This was seen by some directors as a way to exploit a 30-second slot with a camera to make a masterpiece, but it was doing the Epilogue with a clergyman around midnight that the solitary cameraman was really on his own. It was a great way of giving very young and inexperienced cameramen a chance of the responsibility that goes with operating a camera live.

While working on Presentation one Sunday I got a call from the senior cameraman at the Palladium to get down there as fast as I could, someone had gone sick. I ended up in the wings on the stage of ATV's flagship programme, *Sunday Night at the London Palladium,* operating a camera on a Vinten OB dolly. On one shot of a pianist I had to track across the stage, go past the piano then zoom in to the keyboard. The director could then cut to another camera before coming back to me when I reversed the move back into the wings.

Was I nervous? Most definitely, but anyone would be as this was a huge responsibility for a 22-year-old cameraman as usually half the UK population would be watching. That shot is as vivid to me as if it were

yesterday. Whoever went sick that day I owe a grateful and belated 'thank you'. This happened a couple of times in my camera career and I was always ready to seize the opportunity presented by someone else's misfortune, and so should you.

Move to ATV Elstree

Wood Green and the other studios were successively closed with the move to Elstree in 1960, the old National Film Studios having been equipped for television production. For the first time ATV, apart from the head office in Cumberland Place, was all in one place: studios and OBs, props, scenery, construction and engineering workshops as well as all the production offices. It meant it was easy to wander into another studio during breaks and see another production being made. All this, and the sheer volume of work then, made for a good atmosphere, and to be able to talk to colleagues working on other productions was a real plus.

A huge competitive spirit built up in the camera department amongst the crews; we all wanted to be on the best crew as it got the better and more prestigious programmes. Such rivalry pushed up everyone's standard, as to be seen to fail (we all did sometimes) was to be ridiculed by the rest of the crew and the whole department once word got round, which was very quick! A few couldn't actually cope with the pressure and moved to less stressful studios outside the London area, whilst some got out of television completely.

In Elstree's four studios the cameras were Pye MkVs, still B&W but with a splayed turret that allowed any combination of lenses so the lens hoods did not get into shot. These cameras were in my opinion unwieldy and not conducive to being operated creatively. But we all tried, and the best cameramen succeeded with many fine productions being shot with these cameras.

Location Shooting

Around this time, someone had the idea of taking one of these Pye MkV studio cameras and an Ampex 2" Quadruplex VTR machine out in a very large truck complete with generator to power it all. The first location inserts on videotape for ATV were shot this way, memorably for me a shot supposedly being the subjective viewpoint of a WWI soldier running through a wood. It was madness in reality; the camera was mounted in a

swivelling tilt device upon a Vinten OB dolly. Operating this was a large Welshman, Dai Higgon, and the combined efforts of myself and several riggers tracking it all uphill (yes) could hardly have got what was wanted. This was a case of ambition being thwarted by reality, but amazingly, the shots were used.

In the studios, we had also gone hand-held with a small Pye camera onto which a small monitor was gaffer-taped for a viewfinder. Hardly the combination to produce the best pictures, it was certainly better than when I operated it on one show when all the monitors for the camera had packed up. So I gaffer-taped a Bolex 16mm film camera eyepiece viewfinder on the side for framing and glanced at a nearby studio monitor for focus. I still find it hard to believe this actually happened in a mainstream ITV network studio, but it really did!

Colour Cameras

The Pye MkV cameras lasted at Elstree until colour finally came knocking loudly on the door in the shape of another coup by Lew Grade. He had agreed to produce Anton Chekhov's *Ivanov* for a US network and at the last minute they demanded it in colour. So ATV's first colour production was done using hired in RCA Colour cameras (nicknamed 'coffins' owing to their size and shape) with a 10-1 manual zoom stuck on the front. They were not very sensitive, the light level had to be boosted to an unprecedented 400 Foot Candles to get good pictures which LD John Rook delivered using Brute arcs that inevitably managed to splutter or die in the middle of a take.

I tracked Bill Brown operating Camera 1 on a Vinten Fulmar pedestal for this production and from the side they were very difficult to line up if an actor was off his marks, as they were so heavy to start with. It was the tracker's job to ensure the shot was always there by moving the camera without being told as by then it would be too late. Colour quickly became the 'in thing' and several other plays with stars such as James Mason, Sean Connery and Paul Schofield followed.

England won the football World Cup against Germany in 1966 in a never-to-be-forgotten Wembley Final, broadcast by the BBC in B&W as the debate was still going on about line and colour standards. The very next day the entire England squad attended a live broadcast luncheon which was set up in Studio D at ATV Elstree. I had the job in Studio A of getting

the first Phillips PC60 literally out of its box, mounting it on a tripod set onto a rostrum so the lens height was around eight feet, then operating it so that the players who had been so victorious the day before could see themselves in colour. It was a great moment for me, but the heroes of English soccer didn't seem impressed, and I didn't get lunch either.

A period followed of shooting in both B&W and colour using two sets of cameras, a *Morecombe & Wise* series was done this way, as was a *Tony Bennett Special* on which I was promoted to operating the colour camera. Shooting in tandem like this was because the 525 line colour version was solely for the USA; the 625 line B&W for UK only. On some programmes, notably the *Kraft Music Hall* series, the Phillips PC60s were used in 625 PAL to record the UK version in the afternoon, virtually the dress rehearsal, then cameras were changed over to 525 NTSC, which meant several hours with a soldering iron. Then we shot the USA version in the evening, inevitably better for the afternoon's rehearsal on tape. The stars on this series were many, but for me the most memorable was the sublime Ella Fitzgerald. What a privilege!

Then in 1970 the EMI 2001 cameras were installed and they revolutionised what I could do creatively. They lasted until the USA demanded better technical quality for *The Muppet Show* so Phillips LDK 5s were brought in. I never liked these as the zoom stuck out so far but it was not too much of a disadvantage on LE.

Central TV as a Lighting Director
On the closure of ATV Elstree, I went to Central Television in Nottingham as a lighting director for the years 1983-1991. I lit a large variety of programmes for ITV Network such as *The Price is Right!* as well as *Central News East* for the local region. Having left ATV Elstree where we never had anything to do with news, I was amazed at the inflated egos of news people who got over-excited about what I saw as screen filling stories. Fortunately for me they were padded out with magazine items such as food demonstrations and bad pop groups in the studio who I was asked to make something of as there was no budget for anything but using lights and a bare cyc.

After putting keylights on the lead singer and musicians, I placed some backlights on the floor, used smoke to lose the cyc then overexposed by about half a stop to burn everything out which the engineer's hated doing

as it wasn't in the book. The last thing I did was to letterbox the pictures so it looked like widescreen, long before it became a reality. The news directors thought I was wonderful, simple souls that they were.

Freelance

Then came the point in my career when I had to decide to 'jump before I was pushed'. So I opted to leave Central when they were going to reduce staff by a third and went freelance in 1991. It went well to start with. I returned to light a sitcom which had become ITV's highest rated, *The Upper Hand*, but only lasted one more series as the Central bean counters decided the in-house LD should do it because that was cheaper. The stars, Diana Weston and Honor Blackman, were appalled and Honor even wrote to the MD asking for me to be reinstated but to no avail. The bottom line won.

I did a few other jobs lighting in what people called studios but were actually normal offices with low ceilings. That was enough. I decided the time had come to move on so became a travel and portrait photographer which is what I have done most of the time ever since.

4 JUST LIKE RIDING A BIKE!

I have always been interested to trace back as to how I have arrived at a given point in my career – so know this book came about after being talked into operating a camera on a multi-camera shoot again after a gap of 21 years. Doing it reminded me of so many of the good things about camerawork. A lot had happened in between, although I had been sceptical about whether I could operate to a high professional standard after so long. Thankfully, experience helped – it all came back to me in about 30 seconds – just like riding a bike! And experience was something I wanted to pass on, not just my own, but also that of many other talented people I've been privileged to work with through my career in television production.

Sleeping Beauty
The shoot was in a 600 seat theatre in Kyoto, Japan, and I was to operate the main camera in the second row centre of the stalls on a full-length three-act classical ballet, Tchaikovsky's *Sleeping Beauty*. This was a four-

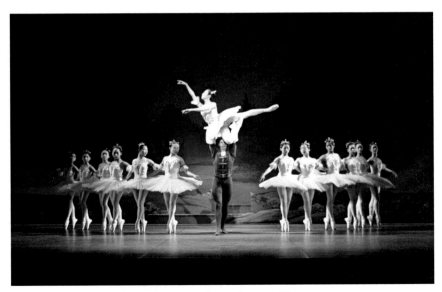

'Sleeping Beauty' in Kyoto Japan. Photo: Jeremy Hoare

camera shoot of a ballet school production which could be considered amateur but was of a such a high standard it was anything but. Nobody in Japan apart from the national broadcaster NHK would dream of covering it this way; except my client. But he was no ordinary one, he was a good friend and another cameraman, Christopher Fryman.

It was April and I was in Japan as my wife is Japanese so we go at least once a year. Christopher suggested that if I happened to be there again in September he would like me to operate a camera on his wife Mitsuko Inao's ballet school annual production. How could I turn down the chance when the only rule of a freelancer is to say 'yes' to any job!

These days Christopher mostly plays jazz trumpet and I have seen him perform with several bands at gigs in clubs and other venues around Kyoto. But on this production he couldn't operate a camera as he was performing in the ballet playing the role of Carobosse the wicked witch, a part he performed with great enthusiasm.

Ballet – Theatre and Studio

Ballet is an incredibly visual art form so any cameraman should jump at the chance to operate a camera on one if given the opportunity; it is a wonderful way to collaborate with performers in a completely sympathetic and almost spiritual way.

It falls into two distinct categories; ballets shot on a theatre stage and those shot in a television studio. Staged ballet is primarily a performance for a paying audience in the theatre and is played for their maximum advantage, not for the cameras; they are there to record it. Ballet in a television studio is broken down into sections to be edited together afterwards for transmission as a complete piece.

Giselle

I have operated a camera on just one ballet shot in a studio, *Giselle*, but it was with Rudolf Nureyev who escaped from Communist Russia in the 1960s and became the greatest male ballet dancer of the 20th century. He was partnered by the ballerinas Lynn Seymour and Monica Mason and it was shot on a conventional linoleum studio floor, not the sprung floor that dancers really need to work on as it easier on their feet.

A five-day studio shoot for a ballet would probably be impossible with today's constrained budgets, but this was Nureyev's project and he

had total control. In fact he was a bit of a tyrant – I think he shouted at everyone in the studio for anything he saw being done the wrong way, but he was equally tough on himself, a paradox of being a perfectionist in an imperfect world.

I was shouted at on the third day when I mis-framed a shot and chopped off a dancer's foot while performing an arabesque. There was no point in arguing, he was one of the few people I have worked with who it seemed was actually right all the time. Through that I learnt that with dance you keep hands and feet in the frame unless directed to do otherwise. I certainly made sure that I framed the shot correctly on 'Take Two'!

Kyoto

Although I've been operating cameras professionally since 1960, on *Sleeping Beauty* in 2005 I still felt a real need to practice on the rehearsals as much as possible. The other three Japanese cameramen were sadly lazy; they didn't take the opportunity to practice much during rehearsals which showed subsequently. Apparently they considered getting it technically correct was their role, which I find hard to understand and the opposite way to my thinking which was to get it right creatively.

A rehearsal is for everyone, the performers and the technical crew, and it is the only opportunity for you as a cameraman to work out the point at which a dancer will make a big move before it happens. Moves are invariably signposted by positioning and body language as well as dance steps so it is vital you understand the story behind the ballet and try to remember it, as well as being aware of what the other cameras are shooting from their positions.

The Rehearsal

Before the Sunday afternoon performance there was one full rehearsal in the morning so I recorded it and in a break, Christopher came over with the other cameramen to have a look at my pictures. He seemed pleased while the three cameramen seemed happy, a little relieved and possibly a touch impressed at what someone who started out operating B&W cameras with prime lenses could do with a Betacam and a zoom. It gave me a good feeling, one of confidence, but not too much as that can be dangerous.

As well as the entire production team, the performers rely on a cameraman to give his best; the cameraman in turn expects the best of the performer,

a balancing act of empathy. A trite summary of acting is confined to two easy rules; 'remember the lines' and 'don't bump into the furniture'. But ballet dancers perform both individually and as a team, each reliant on the others. The ballerina relies on her poise, balance, memory and above all, confidence. When that's missing it shows – something I could see and sense through the camera.

The Performance

During the afternoon's performance of just over three hours intense concentration I had to keep in my head that there is a lot of romance in dance and to echo that with the camerawork. It needs great finesse – which is demanding – as smooth and precise camerawork is needed more than in any other form I can think of. Shooting with concentration at 100% all the time means that any lapses show on the recording, and I didn't get it all right. I doubt that anyone can get such duration of performance spot on and that includes the dancers. But it is very important to try.

I have never really been able to count bars but over time developed a feeling of music rhythm as it dictates cutting points, as well as an understanding of body language, which is completely vital. You really have to go with gut feeling at all times, thinking is too late to act on, so you have to develop the ability to anticipate movement. This is intuitive camerawork at a very high level. From my Nureyev experience I knew only too well to keep the dancers' feet and hands in the frame at all times, but also knew that in a theatre I had to watch outside the viewfinder as well as through it; it helps to anticipate what is about to happen.

My camera position was wide enough to see most of the stage but when two dancers split I had the choice of going with the one who was important at that moment, or making the editor cut by letting both dancers go out of frame. Dancers are extremely athletic and move very quickly and will certainly use all the space available to them; the whole stage is theirs. It is important to lead the frame with air space; classic composition is needed here – not the wacky stuff – and you need to try to maintain a usable frame at all times so you can be cut to at any point; it's hard to do, but that should be the aim.

Like all camerawork, it can only help if you understand the lighting – and the stage lighting was not compromised for the cameras, it was lit for the theatre audience. Dancers cannot see much of the audience or the

cameras beyond the first few rows of the stalls because of the FOH lights and low angle side lighting from the wings, the classic way to light dance. Solo dancers are usually picked out in a followspot, soft edged mostly as it blends better with the other lighting. So because of the variations of lighting level I had to manually rack the iris between f2.4 and f6.8 through the whole performance.

A strong point that came over to me, and a great joy, was feeling like one of the performers; it was almost as if I was on the stage with the dancers. Seeing every detail of their movements as well as their nerves through the viewfinder made me feel for them in turn. This is the true spirit of camerawork, a partnership with the performer, and when it works well each gets a great buzz from it.

The Day After

Throughout my career as a cameraman, I never gave myself 10/10 for performance as it would imply failure, not of the work done but my lack of ability to be self-critical; I think all creative people are very similar. The fear of failure is something to be recognised and dealt with on an everyday basis, and never to be accepted if you are to succeed; it is the spur for all and the downfall of many. Experience does make it easier to dig myself out of a hole, but I'd rather not be there in the first place. Inevitably, nothing in camerawork can ever be perfect, it is not a science, it is a craft form of intuitive skill and creative input. Without creativity camerawork is invariably pedestrian and mundane, which can show even in cameramen who have operated for many years.

The next day came and I sat around after breakfast in a pensive mood; all the euphoria of the performance gone, a fading memory. Then Christopher rang and was full of praise – what a relief! It wasn't actually praise I wanted, acceptance would have been fine, but it is always good to be told that you have contributed and added to a production. But only from someone you can respect; the rest you can forget.

Anyone who is starting a career as a cameraman might think this is false modesty, but that would be wrong. Camerawork can seem to be easy, very easy, but the hidden skill that goes into making it look like that is a talent in itself and what makes it work. No matter how experienced you are, or how talented, if you cannot be highly self-critical about your own work and its contribution to a production, it's time to move on and do something else.

The Book

I have always liked to pass on my experience and have given lectures and workshops in several countries so having done the Kyoto shoot, I wrote an article based on the experience for the Guild of Television Cameramen's magazine, *Zerb*, and this book came about because of that.

So that is the path I took to get here and my reason and motivation for writing *Through The Viewfinder* – which is based on conversations with some of the finest cameramen and other production professionals who stretch from the 1953 *Coronation of Elizabeth II* to the 2008 *Nelson Mandela 90th Birthday Concert*.

I have been privileged to have worked with all of them in one capacity or another – and learn from it you will, as these highly talented people are some of the best who have ever worked in television and they have provided you with an amazing wealth of wisdom within the following pages.

5 BILL BROWN – Cameraman

Bill Brown
Photo: Jeremy Hoare

> *Your prime role is to provide a connection between the story and the television set. It's only the cameraman that links the two together. If a cameraman's no use, whoever's watching at home knows it straight away.*

Bill Brown without doubt had a greater influence on me than any other cameraman; he was my mentor throughout my entire 23-year career in the Camera Department. In my opinion he had a way with a camera that was unmatched by anyone; his framing was immaculate, his timing superb and his social skills with artistes, directors, producers and technicians was outstanding. I tried to copy all with varying degrees of success and failure.

Bill was never less than a pleasure to work with as a camera assistant and some of my best days were driving him operating Camera One on the Mole crane. With Derek Chason swinging the crane arm we became completely intuitive to each other's reaction – exciting and wonderful on live television going out to millions of viewers.

I tracked him too on ATV's first colour production, Anton Chekhov's *Ivanov* for which a medical research company colour camera OB scanner had been hired in, the only such unit in the country. Bill operated one of the huge RCA cameras (nicknamed 'coffins') with a 10:1 manual zoom lens on a Vinten camera pedestal. It was the first major drama to go out coast-to-coast in the USA from any UK studio and was the forerunner of many things to come as ATV won several 'Services for Export' awards over the years.

Bill stayed a cameraman throughout his career and when ATV became Central TV and moved to Nottingham he went freelance but the industry had changed. It was not to his liking so he retired soon afterwards.

I came into television through sound radio, thanks to a friend of my wife's who, already working at BBC Lime Grove, suggested I applied for a job when I left the Royal Navy. Eventually I was granted an interview and taken on to work in radio at Bush House. I was quite interested in production at the time, but my year there, I believe, helped kill off the idea.

After working in the control room and the continuity suites in the Bush House European and Overseas broadcasting services, I would come back home not having understood one single word that was spoken that day. Indonesian, Japanese and God knows what . . . every language under the sun went out through those small continuity studios.

However the promise of a transfer meant I was shuffled up to Evesham for the trainee camera course, after which I went to Lime Grove Studios where I joined Crew 8. Jock Watson was my senior cameraman. Soon after, rumours were buzzing around the studios about the start of commercial television, with Jock and Colin Clews, another senior cameraman, trying to persuade me to go to commercial. I thought it a bit of an imposition. After all, I'd only just arrived at Lime Grove and here I was thinking of handing in my resignation. Mind you my salary doubled when I did eventually move. In fact I earned more in commercial television than maybe I would have done in perhaps five or six years working for the Beeb. Such was the state of finances in those days.

In the early days with the BBC at Lime Grove, we used to have a day's training doing different things. I operated a boom for instance, and then I would sit up in the control room with the vision mixer for a day. So whatever else could be levelled at the Beeb, the training was excellent. You had a pretty clear idea of what your job was and the way it mixed with whoever else was working in the studio. I found that a great advantage, all through my career.

The fact that I didn't go initially to ITV was probably one of the best moves I made, for in the short time between the rest of the crews moving on and me joining them came a spate of shows in Lime Grove – and I found myself standing at long last behind a camera. At one time this would have taken years to achieve at the BBC. I was employed purely as a tracker – but there I was on *Dixon of Dock Green* panning down from the opening shot of the famous blue lamp. I was in a state of absolute nerves I can tell you. The equipment was no way the fabulous stuff used nowadays, the camera was on a wind up pedestal thing called a Debrie with a handle for steering. If you happened to get your cable round the wrong way you were stuck, if you put it right the cables would act like snakes which meant if you knocked or hit anything you were knocked off balance; all sorts of hazards were there in my first few days in television. When I did move to commercial television I got fairly rapid promotion, progressing through the grades quite quickly, which was handy.

The man with the greatest impact
The person who had the greatest impact on my career was cameraman Jock Watson. He gave me an insight into working a camera that I never got from anyone else. With the BBC you were classified under the technical section and one of the fortunate things when we moved to commercial television was that we broke away from this rigid structure and became part of production, completely remote from engineers, sound and everybody else. Jock's strength was his picture sense that I believe none of the other cameramen had. By that I mean a still picture sense, a painting picture sense and a lighting sense all of which was achievable in the studio. It was all a big blow when he left and went into directing, Jock never enjoyed doing that after camerawork so left television.

He taught me one thing very early on: if you're behind the camera whoever is in front can't see you – so make yourself known to whoever you are shooting. Better still, if you've got some personal contact, other than through the lens or viewfinder, then you are halfway there, you don't need arguments. When we shot regular series such as *The Plane Makers* or *Power Game* I had a nodding acquaintance with quite a lot of the actors who would look at me and mouth, "Are we in the right position?" The answer was either a wink or a whispered "No!" You didn't have to speak if you had a rapport with them.

The greatest joy about being a cameraman was the fact that I could actually do it! I felt at ease either in the studio or outside, simply because I felt on top of the job and could do whatever I was asked to do. There were, of course, loads of hairy moments but basically I still felt in control of what I was doing. You had to be. Your prime role is to provide a connection between the story and the television set. It's only the cameraman that links the two together. If a cameraman's no use, whoever's watching at home knows it straight away.

Equipment likes and dislikes

My favourite piece of camera equipment has to be the latter-day hand held ones, if only because they gave you more flexibility. The favourite studio camera was the first Philips colour, the PC60. The old Marconi B&W cameras were cumbersome and that big beer handle focus thing was very awkward to use. As for the Pye, the electronic turret used to make a noise like a plane taking off every time you swung the lens. This made it impossible for use in drama scenes; as for the focus, well, it was always jumpy and jerky. I never liked the Pyes.

The need for teamwork

Teamwork is vital, just as much now as in the early days when, with a four camera set up. You have to be aware of what other cameras are doing. A good example was when zooms were eventually used for a two-handed scene, with maybe two cameras or even three covering it. The director would ask for cross cuts, either following or against dialogue; but whereas one camera could get it quite easily on the zoom, the other might be in a far more difficult position to get into. Even to this day, many directors don't understand why the pictures look different. Yet it's only because you might be working in the tight end of the zoom at one end of the set and the wide end of the lens on the other.

Even so, relationships with programme directors were, I think pretty fair; I usually got on with most of them.

Mind you, there was *that* programme we did for Associated Rediffusion, a kind of Gala Performance at Wood Green Studios, an old theatre. I was on the crane, Big Bill, the big crane. The opening part was to feature Tito Gobi singing, with Fistulari in the orchestra. Maria Callas was also supposed to be there, but she didn't turn up. Anyway, it was a huge high-powered event with the audience having to stick to the rules.

So off we go . . . the music starts. But though the event should have been introduced by MacDonald-Hobley – with the camera in one box at Wood Green trained on him in the opposite box – he was nowhere to be seen. By now the programme had started, with the call boy running around trying to get MacDonald Hobley to sit in his box – which he eventually did. "Good evening ladies and gentlemen," he says. 'Here we go' I thought as the music starts again. This time there was no Tito Gobi. The floor of the set was completely empty apart from a hanging gauze leg through which he was due to appear singing.

This was meant to be a big high wide and handsome shot. But nothing happened. The music began. Tito started to sing but the gauze leg didn't move nor did Tito appear. Lighting director Johnny Rook has got his arc on by this time and I was moving the camera, the idea being to pan down and around the back of the orchestra to pick him up onstage, but none of it happened. Then a huge camera shadow appeared all over the floor as I go sailing through the arc, down onto the floor. When I got round to the orchestra the crane came round and we nudged the conductor – who at Wood Green was in the pit – off the rostrum, so desperate was I to get down to the pianist. The whole show was like that, from beginning to end.

When the programme finished, I went into the control room, kept my mouth shut, got my jacket and crept off home. I've never been more cheesed off in my life as I was that day. The whole programme was an absolute shambles. If that was a Gala Night for Rediffusion, we did them a favour I think!

Current training

It seems to me that latterly there's not much camera training in telly – more a matter of either you can operate a camera or you can't. The emphasis appears to be more on 'keep it moving' rather than if you are trained or not. Basically you cover what's going on in front and that's the end of it.

However, my advice remains the same: you've got to know your camera and the limitations of the controls. Can you, for instance, get some smooth action out of it? Again, it's something that doesn't seem to matter nowadays, because there is so much hand-held stuff. In my days, flat floors, good dollies and good heads were paramount to getting steady and reliable camerawork. I believe it still applies, and that knowing your equipment, and how to use it, remains paramount.

Ambition, too, remains highly important. Okay, you go from show to show, but aim to make the next better than the one you've just done. It might be more demanding on you because the director might be worse than the one you've just worked with. You've constantly got to be on your toes, or the whole thing can slip away from you.

If only I'd have known . . .

What I wish I'd known when I started was much more about theatrics, what happens in front of camera. Coming from the country, it was like working with people from Mars! Here I was talking to the likes of Laurence Olivier in front my camera, names I'd only heard of. I would have loved to have known more about the business of staging theatricals, musicals - if only to give me an even bigger jump ahead.

The key to success means you've go to enjoy your work, and to establish contact with the people you are shooting is even better. First and foremost, they are the performers, the people switch on at home to see – and your job is to show them to the best advantage. You may not like them but if it's a singer, dancer or whatever sort of performer, you've got to present them in the best possible light. You can only do that through personal contact, and by that I really mean physical contact, not just through the lens of the camera. It maybe for only one show, which means that next day you've got to start all over again. But that same personal contact still applies.

On his likes . . .

Of the one or two programmes I'm particularly proud of, the best wasn't even a big production. It was called *About Religion* and it had a 25-minute live slot on a Sunday evening and Jeremy (Hoare) drove the Mole crane. We only used one camera, one shot, for the whole 25 minutes. Derek Chason was on the arm, and lighting director Jimmy Boyers, who normally didn't say much, came down afterwards and said: "Well done".

With light entertainment *The Barbra Streisand Show* was good to work on, so was *Long Day's Journey Into Night*, though unfortunately Laurence Olivier was quite ill around that time. But it was still a great production to work on, even though it overran by a week.

. . . and dislikes

I can't say I was jealous of not working on other programmes, even if

I had been given the choice to do so. I was quite happy with what I was doing. Quite frankly, there's nothing appeals to me at the moment, though I would sometimes like to sit behind certain directors on sports programmes, take their finger off the button, and occasionally whisper in their ear: "I'm a viewer, I would like to see what this game is about and what the sport is about". I don't want to see someone spitting or blowing their nose; I love to see, and be able to follow, whatever sport it is. I appreciate that cameras have got so good, and that at one time you couldn't get a close-up of someone halfway across the football pitch. But I don't feel they have any actual relevance to the programme.

Okay, so the final of the World Cup in 2006 may have used 200 cameras. I remember it was once the same at Wimbledon. We used to cover the matches alongside the BBC, and complain they had twice as many cameras as we had on each court. Yet I am sure what the viewers saw wasn't any better.

Those memorable moments

I once did a production at Lime Grove directed by Ian Atkins, whose dad was Sir Robert Atkins who used to run Regents Park Open Air Theatre. Ian was the technical director at Lime Grove and by technical I mean technical. I can't remember what the play was called, but it was the introduction to television of actress Jill Bennett who was a young girl then. I always remember her.

We had two BP screens, and, to cope with a constant changing picture, had a big cloth on the floor with camera lines marked on it in feet, and with six inch marks every so often. Each camera had a list of shots to tie in with this along a lens height and floor mark and which lens to use, 2,3,5 or 8 inch. After rehearsals the play was going out live on a Sunday night, with everything cut to these two screens. Furniture was moved a little bit inside for a change of scene. The director would come down on the floor measure the lens height and the position on the floor and and say: "Hang on a minute, you are six inches too low or six inches too high". We then went ahead with the play.

Sadly it proved a shambles. All that needed to happen – and it happened all the way through – was for the artiste to lean on one side. This meant walking around looking for marks on the floor, and the whole thing became a shambles. But it was the exercise of the technicalities of this that really

proved interesting. Ian Atkins never did it again of course; it was just a one-off one escapade.

We had an old dolly at Lime Grove that had a tiller accelerator thing on the back – some sort of electronic device. I was doing the *Grove Family* when I first joined Jock Watson's crew. He was in on this dolly, and whoever it was that was tracking him couldn't get the thing to move. So Jock got off, put him on the camera and said: "I'll show you how to do it!". But as Jock pulled the lever it whipped backwards, hit him in the stomach, causing him to knock part of the set down.

Then there was *Henry Hall's Guest Night*, the first show I worked on as a tracker at Lime Grove. It began with the countdown. "Five, four, three, two, one!" before the music burst forth into "Here's to the Next Time" followed by "Good Evening Ladies and Gentlemen, this is Henry Hall and tonight is my guest night". Then whoosh – all the lights went out and the studio was plunged into total blackness. I spent the next half-hour groping around under the audience seating trying to get a new cable out from one of the cameras that had gone down. We had huge cables then, and you needed some muscle to remove them. I was covered in dust and muck and never did see Henry Hall's guest night, never did see it at all!

Advice to get ahead for the ambitious cameraman
Get to know the cameras that are available. Get to know the equipment before anything else and then play with it. All the kids now have the advantage of taking their own stuff and seeing it on the monitor. They've got a huge advantage in being able to judge for themselves.

The old fashioned adage still applies: look at photographs, look at paintings and if you find out what has made them so successful then you're halfway there to doing it yourself. You'll know to how compose, or how to set up a picture whatever kind it is.

So that sums up my 50 years as a cameraman, a long time ... a hell of a long time!

6 THE TELEVISION CAMERA

Even after being a cameraman at ATV Elstree, the UK's foremost Light Entertainment studio for over 20 years, operating whopping great cameras the size of coffins to dinky hand-helds, from black and white into colour, I still didn't have much of a clue how the things actually worked. It was certainly necessary for a vision engineer to know but to the camera operator it wasn't then, but is more so now in this freelance world. Most cameramen are pragmatic and being practical is very much part of the job; the ability to at least have a go at fixing a camera when it goes on the blink is a prerequisite for the job, even it just means knowing which bit to thump. And at that I was good!

My rationale was simply that a camera is a tool to do a job with that is what it has always been since Fox Talbot, the inventor of photography, took the first picture of a window at Lacock Abbey in 1835. The purpose of any camera is to tell a story; no more, no less; the bottom line of all forms of photography.

Producer Rex Firkin with cameraman Dennis Bartlett on location for The Plane Makers *in the 1960s. Photo Jeremy Hoare*

Television Today

The relentless gallop to provide ever more channels continues unabated and we now have hundreds of so called 'quality' channels now, but with a few notable exceptions just a cursory glance will show just how much creative standards have dropped for the many.

The craft areas related to picture creation and sound are the worst to be hit and every night on the mainstream output, even in prime time, something makes me wince at what some camera operators consider a correctly framed shot, what some lighting directors think of as good lighting, and what some sound directors believe is quality sound.

In the past, the technical excellence of both picture and sound had a raw quality which was the best that could be achieved with the equipment available at the time; but it was used for adventurous ground-breaking and landmark programming, much of which was live and not recorded.

Today the technical quality is outstanding by comparison, but what is it used for? Junk reality programming has an amazing array of state-of-the-art kit, but it makes me cringe to see it used for such asinine shows. With lighting more suitable for supermarket shelving and continually crossed eyelines to confuse the geography for the viewers, it all adds up to a massive waste of resources.

But as a freelance cameraman you have to take an interest and understand whatever it is you're shooting. On a gameshow for instance, learn the game itself so that you can be ahead and offer up shots before the director has asked for them, it would be too late otherwise. Learn and anticipate what's coming next; it really is the only way, even if the programme is boring.

Whatever it is you're shooting, from junk reality programmes to Emmy and BAFTA award winning television, you can always be a better cameraman by understanding whatever it is you're shooting. Don't ever forget that.

7 IAN KEOWN – Cameraman

> *The brilliant thing about being a cameraman is you have that responsibility no one else in the industry, even the director, has. At the end of the day you're the guy who's got to deliver the goods. And if you don't get a kick out of that you should not be doing it.*

Ian Keown
Photo: Jeremy Hoare

I met Ian Keown when I went to Central TV in Nottingham; he had come from BBC Manchester. From the start, Ian seemed to have an enquiring approach with his camerawork, no way was he just content to sit and wait to be told what to do by a director. But no cameraman who is any good does that anyway.

Like many others, Ian came into television through an initial interest in photography, and in his case with a City and Guilds Certificate. Then later, with his BBC background, he jumped into the frenetic world of commercial television, a cut-throat business at the best of times. The BBC has been funded by the TV Licence Fee since its inception, not so commercial television which has had to survive with the income it generates from advertising and has done successfully now for over half a century.

Ian is still passionate about what he does and would dearly love to work on more drama but there is not so much of it about now. He is fully aware of the stress working as a cameraman, the frictions that can develop and also the essential need for 'closure' by not carrying grudges on afterwards. As he quite rightly says, "No one died did they!" How very true.

Thirty years on, and life's still fantastic for one freelancing cameraman – despite sliding salaries and tougher times

Ian Keown admits to a brilliant job: "You're the guy who's got to delivery the goods, I love the fact that when the red light's on it's all down to you"

The hardest decision I ever took was leaving the comparatively cushy life as a staff cameraman – a staff camera supervisor as I was then – in 1998 and choosing to go freelance without any pay-off. I tried and tried to get paid off by Carlton as it was at the time, but to no avail. I was feeling undervalued and not respected, and completely at their beck and call. When you freelance you're starting again from scratch, simply waiting for the phone to ring. But at the end of the day, you gain a bit of freedom. Whether anything has changed in terms of respect, I don't know, but I certainly feel in charge of my own destiny.

The industry was moving on anyway. Shortly after I left, Carlton virtually became a factory for *Crossroads*, which in theory would have been okay given my love of drama. But, quite frankly, you could tell it was never going to work, so I was glad to get out when I did. A whole lot of guys came out after that and, by then, I was already beginning to get established as a freelance cameraman. It also gave me the impetus to move down to London; I'd been in Nottingham for around 12 years. But London – whether you like it or not – is where everything is happening.

In May 2008, for instance, I was almost totally tied up with covering football for Sky, not so much by choice as drama is really my first love. But it's good work, it's regular – and I'm really enjoying doing it, it also helps pay the mortgage. It's hard to get into the BBC these days, though I have supervised quite a few blocks of *Eastenders* and would like to do more. I used to do *Family Affairs*, but sadly drama has become thin on the ground.

I have also been involved with Matthew Gladstone, a friend of mine, who's invented a Vortex, a sort of vertical tracking device, which takes the camera from 30 metres to ground level on shot – which nothing else can really do. You can sort of achieve this with technical equipment, but you've really got nothing which doesn't swing on an arm. But the Vortex is literally up and down. We've done tests on the remote head, which does a 360 at the top, as well as using it at a couple of gigs. We also used it for

the Marathon outside Buckingham Palace hoping it might develop into something. It's nice to be in on the ground floor of something new.

Learn to fit in whatever you do

I got into television almost by accident. I was training as an industrial photographer when I left school and, after getting my City and Guilds certificate in photography on a day release course, decided to move away from photographing bits of machinery. So in 1975 I applied to the BBC as a stills photographer on the set; I was quite lucky because my uncle worked for the BBC as an engineer/manager in Aberdeen. He was able put me in touch with a couple of people who said, "Sorry, though there aren't any photographers jobs, we're about to have boards for a trainee camera assistant, do you fancy that?" To be honest, I really didn't know what it was. So I looked it up – and it sounded brilliant. Mind you, it was a big shock. I'd been trained as a stills photographer and already I was thinking about moving. Luckily I got a job that same year with BBC Glasgow where I stayed for four years. I then got promoted to 'pool cameraman', as it was called in those days, at BBC Manchester where I stayed until 1984 when I went to Central in Nottingham. In 1998, as I said, I began freelancing.

One vital way to success, especially as a freelance, is the ability to get on with people – 'camerability' if you like. This means interacting not only with other members of the camera crew but, probably more importantly, people such as scene-hands and sparks, basically everyone who works on the show. I know plenty of people, probably myself included, who aren't the greatest cameramen in the world, but have an ability to get the best out of people, to motivate them. I couldn't do *Eastenders* by myself; the scenehands will do anything they can to help, such as moving a carpet or a lamp, simply because I ask them in a nice way, and I respect what they do. I have cups of tea with them, not because I feel they're any less than me, entirely the opposite. I feel that we're all in it together.

I've still got some very good friends who are directors in drama due largely to the relationship we've developed on set. Some directors are very inexperienced, or just seek reassurance. With the speed that something like *Eastenders* goes at, you are sometimes more or less a co-director. At other times directors are working away with artistes while you are lining the cameras up in places where you know it will work. So with drama, it's got to be a very close or trusting relationship. It's different with a live

game like football because there is nothing either of you can do. You've just got to accept what happens. Yet some directors get stressed, and in the heat of the moment say things they don't mean. You have to learn to shake hands afterwards, and not bear grudges.

I don't think I would ever be as close to any of the live directors as I am to some of my drama friends or directors. Remember, you put in a considerable amount of emotion yourself, whether it be artistic, sheer enthusiasm or just a keenness to get it right on your one and only chance to do so. This leads to lot of stress. But as long as everybody forgets about it afterwards, that's not a problem to me. But I've seen a lot of grudges being held. Yet we're only talking about making TV. No one died did they!

Be confident in your own ability

Obviously you have to have confidence in your own ability and be fairly relaxed about the fact that you can actually do the job. But if I had to choose one thing, it would be 'fit in', and sometimes know when to speak out and when not to – especially nowadays when you can't take chances. I well remember when I was a staff camera supervisor, having stand-up rows. I once had a director pinned to the door by his lapels . . . a bit extreme perhaps, but he was an idiot! You certainly can't do that nowadays. With so much choice about, a bolshie guy, no matter how good, will never work again if he upsets somebody by speaking out of turn. And that's a fact, it really is.

It's all very well a director handing you a shot card with a list of shots written down on it, but it's all down to you to translate what this sometimes meaningless gobbledegook actually means. Though the viewer probably doesn't appreciate it, you're actually helping them along with what they are looking at. With drama, for instance, your job is to translate either what is happening live in front of your face or what's written on your shot card into something that the viewer can enjoy without even knowing why. I also I like the interface between artistes, even if it's just putting them at ease and keeping their confidence up. That's so valuable.

The camera

The camera is the tool to do all these things – without even thinking about the machine on your shoulder, in front of you or on a pedestal. You should feel confident that everything's in the right place, leaving you to concentrate on looking through the lens. My favourite piece of camera

equipment must be the EMI 2001, probably because, for people of my generation, it was the first camera you used when finally you got to do a real job in the studio. In 2001, when I was at Evesham, I virtually trained on it. Aesthetically it was really a beautiful thing, a big square box in a way but everything was in the right place, it just felt good. Whatever dolly you put it on, whether it was the front of a crane or a low angle or whatever, you could always get to whatever you needed to get to.

It remains a symbol of British Television of that time and it was in my heyday anyway. As for modern technology, I have recently been using the quite awesome Canon 100 to 1 zoom lens. It's absolutely amazing, especially with something like football when you require a close up camera but also want the wide angle as well without the need for extenders in or anything like that. It's a big piece of glass, not much bigger than a standard sort, a little bit heavier, and it has got the stabiliser built if you need it. It's an unbelievable lens, but I'd still stick with my EMI 2001.

The camera as an extension of yourself
When you're having a good day, the camera is like an extension of yourself: you can't really analyse what's happening. But somehow your thoughts transfer through your eyes and hands and pictures just flow out, when you're really on song it's great. I've always called it Zen camerawork – it's probably the wrong use of the word, but to me it just means you're letting it flow out without analysing what you're doing. If you've got a talent or the ability to make it happen, it will happen. I get really frustrated with magazine articles and people who insist on making the job complicated by analysing it. All that stuff is irrelevant; I don't care what the maximum focal length of the lens is, or how many chips it's got, I don't care, I never have done. Even in my early days at the BBC, they crammed in facts to get through the little test they gave you on the training course. All I'm interested in – and what I've always tried to teach trainees – is getting someone to relax and to try things out. I'd far rather have somebody who tries something which might either be complete and utter crap but likewise be brilliant, than someone who plays safe and stands there all tensed up.

Don't cave in when you're right
The person who influenced me most, if I have to choose just one, was Gordon Penfold who basically trained me and, I suppose, formed my

psyche as a cameraman at BBC Glasgow. Though he suffered a bad back injury, he's now a freelance VT operator and I sometimes meet him if I cover football in Scotland. He was one of the finest cameramen ever.

There was also my crew leader at the BBC, Alan Hussey, who took me through what I suppose would be one of the most enjoyable years. This was when, as a young number four, you would get all the glamour stuff. I learned a lot from him during my formative years until I went to Central and met up with two other choices, Geoff Joyce and Don Perrin.

Geoff, I just thought, was the best crew leader ever; what I learned, or tried to put into practice and probably failed drastically as a crew leader was basically down to him. He's a bit of a hero. And Don, though always a bit unpredictable, was outstanding as a drama cameraman, I just wanted to be like him. I believe he advanced drama camerawork considerably at the time while out on location. He taught me a lot about macro focusing and foreground and moving the camera around. Just after I started at Central we were working on a drama series called *Connie*. He was the camera supervisor and organised a shot in which a woman appeared on a balcony and threw a champagne bottle down to this guy in the foreground who promptly caught it. Wow, I thought, 'I will keep an eye on what you do!' At his peak, Don was outstanding. I think you pick up a lot of things from a lot of other people. And that includes not caving in when you know you are right. There's a time to say, "No, I'm not doing it" and sticking to what you know is right.

It remains important to be a team member. I also think that in the current climate, especially with freelancing, there are a lot who don't, either pretending to be or preferring to be self-promoting instead. I think we have lost a lot of team spirit in recent times, certainly since I've been a freelance. So do to be careful unless you know people really well. There's not as much emphasis placed on it as was when I was training. Plenty of people would say it's important, but I have a feeling if they were honest, a lot of them would question that now.

It also seems to me there aren't any camera training schemes, or at least not any of any value. I know there's a lot of people coming out of colleges; I've met quite a few of them and, without being too cruel, very few of them know anything about the art of the television cameraman. They may know a lot about the theory of artistic directing or wouldn't it be lovely if they had money to do this or that or the other – leaving the camera as

something to stuff in someone's face or turn upside down or crash in and out with. This is not what I call television camerawork. Some guys have basically learned on the job, no matter what it says on their certificate. Maybe it's always been that way; you learn to get on with it. I'm interested, because I don't really know enough about training and would like to do some myself. I've got a lot of experience to pass on.

My only ambition soon after I started was to become a camera supervisor, and I wanted to do it before I was 40. Luckily I achieved it when I was 38, which left me thinking about what I should do next. So while I think it's a good thing to set yourself targets early on, perhaps to be better at your job or to make more money, don't be too disappointed in later life if that seems to be all there is. I don't want it to sound bitter and twisted because I worked very hard to achieve my ambition. I suppose the ultimate aim is to constantly get better; I will think of it like that from now on! After all, nobody can get it right every time. You have good and bad days.

Proudest moments

One of my proudest moments while working at Central was that I became the first cameraman ever to record video pictures from a British coalmine. It was a news job really, basically spending two weeks organising and going down a coal mine along with all the lighting equipment and setting it up. It was a mile down and then two miles to the face, so it was a hell of a trip carting all the stuff. The camera had to be in an underwater housing to avoid the possibility of sparks. It was an absolutely monster of a job but we got some quite good pictures out of it.

Nowadays you'd just take a little camera down and hang it on your helmet, that's how easy it is to get caving pictures. But mine was a tube camera, not a chip camera, and you had to set the stop before you went down; you couldn't get into any of the controls. I couldn't, for example, get to the zoom. All I could do was literally have available the thing that made it record and obviously frame the shot for which I used a little wooden stool. There was no metal tripod or anything. So it was hard work.

I Claudius is the absolute pinnacle of what I would have loved to have worked on. I think it was being made either in 1975 – the year I started – or in 1976. Jim Atkinson was the senior cameraman and I watch it quite often on DVD because it's so pioneering. The massive studio sets apart, it's brilliantly choreographed with all the actors and cameras continually

on the move, it's absolutely fabulous. That's what I would go back to doing, high quality multi-camera studio dramas, which in these days of hi-definition, would probably be even better. But that's never going to happen! I miss those days.

Over enthusiasm can lead to a fall

Never get too excited, especially as a young cameraman. When the Pope came over – I think in 1981 – I was the newest and very young fresh-faced member at BBC Manchester. I'd been told to get a shot of the car going past as the Pope was leaving the arena. It was one of the first times I had operated a handheld camera which, of course, was cabled back to the truck. Being enthusiastic, I thought it would be much better if I stood on a stepladder. So I duly found one, got myself ready and just as the car came along so did the crowd. As my red light went on so the crowd swept past taking my ladder with them. That is how I ended up lying on the floor with a shot of people's feet. So check it out first before you get too carried away. Mind you, the health and safety regulations wouldn't let you do it today anyway.

One downside of the job which automatically springs to mind was attending those awful conferences which we still have to on occasions. They're so tedious. You are just sitting there mid shot with some bloke spouting away for hours and hours. Then there are the game shows. There's one we used to do at Central, five shows a day, five days a week. I won't name it, but afterwards you had to sit in a darkened room to recover.

Nothing, however, compares to the news jobs when you've had to interview some poor person connected with a murder victim. Or you've gone to a car crash where they're scooping out bits of body parts. I don't know whether there is anything worse.

Too much today is based on money

What troubles me about the future is not only the rise of the accountant but the Health and Safety Executive. Now that should be a good thing because health and safety is important. But my experience of it nowadays is of people who have no idea about what we do, suddenly, after 30 years, coming up and telling me I can't do this without wearing a harness or I've got to wear a hat or cannot rig my camera there. Nor can I carry the boxes across in case I slip on someone's foot. Those are the sort of people that are

invading the industry, along with accountants who are making decisions about whether programmes are made or not, and not the programme makers. The technology, on the other hand, is fantastic. The hi-def aspect can be brilliant; they're making feature films out of it!

I am nonetheless concerned about British television. Some years ago, I wrote an article for the Guild of Television Cameramen's magazine, warning that encouraging viewers to send their tapes to the *Jeremy Beadle Show* could prove the thin end of the wedge. Look at what's happened. Every night the news contains footage from viewers with their little handheld cameras. Obviously there are certain emergency cases when this makes sense, but people are actually making films. I was at a concert at which the idea was to make a DVD for Marc Almond, a big artiste. Here were all these people, and I could tell by the way they were just standing there that they weren't camera operators. A couple of them obviously were, but I'm kind of concerned about the way standards have gone.

Tell Don Perrin that someone had said: 'You've done a great job and thanks for that', and he would reply: 'Yes, but they don't know how good you could have been!' That's true, even more so now. Most of the time you cruise through stuff relying on your experience because it's going so fast. But you're not getting the chance to show how good you could be. Sadly he's even more right now than he was then.

Looking back, I wish I'd known how undervalued the job of a cameraman was eventually to become, and that my income would continue to slide to the stage it has reached now. I'm not saying I wouldn't have done it, but I wish I had known the score then that so I could have made plans to save a bit more, or perhaps get a better job. I never thought I'd still be humping boxes up football terraces after 30-odd years. Even so, I don't think I'd have changed, even knowing what I do now, nor looked for a different job; I would probably have just made more provisions for later life.

It still remains the best job ever

To end on a more positive note; it's still a fantastic job, and better than almost anyone else has got. The only other thing I would love to have been is a pilot, but I guess that can be drudgery as well. I can't think of any other job I'd want to do. We keep thinking of all the down moments declaring, 'I'm going to change, get out of the industry, its rubbish', but what are you going to do? A) There's nothing else you can do that earns

the same sort of money even though it's less than it was in real terms and B) What else could you do that takes you to the places we've all been to and gets you in free at the same time. Every time I do a football match, people say: 'God what I'd do to do your job'. Well, it's not quite what they imagine; you aren't there to watch the game. But I do I know what they mean. They've paid however much they have to pay to get in and we are getting paid to be there. I did a series of operas last year. It was fantastic, and I got paid. How good is that? It's a great job and I love it. Perhaps not quite as much as I was, but still loving it nonetheless.

I must admit, too, that, even after all this time, I love the fact that when the red light comes on, it's all down to you. You've got control of the network. As someone remarked when I was working on a champions league game, "You know, this is going out to nearly a billion people right now".

The brilliant thing about being a cameraman is you have that responsibility no one else in the industry, even the director, has. At the end of the day you're the guy who's got to deliver the goods. And if you don't get a kick out of that you should not be doing it.

8 WHAT IS A PROFESSIONAL?

I don't like conventional dictionary definitions of the word 'professional', they don't actually explain the real meaning for a cameraman in everyday life to me. So I have formed my own judgment for the word 'professional' as applied to cameramen which is; 'A person who can be trusted to get it right and will deliver a good result and not just because they are paid to do so'. They arrive at a production and deliver the story, that's a professional in my view.

Have you ever been asked to operate a domestic camcorder while shooting a unique and an unrepeatable event? I have and wish I hadn't. When on my first trip to the USA, and because I was a cameraman, I was asked by people I was staying with to shoot an important lecture by an eminent doctor at a hospital in Staten Island, New York, but using their domestic camcorder which I knew could only produce a poor result.

Strange and problematic thoughts occur to any professional in this

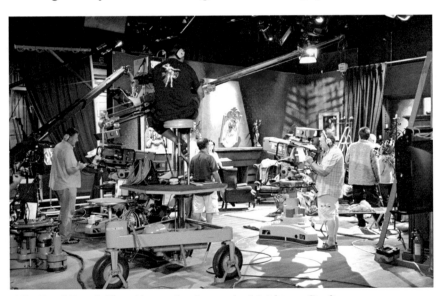

'The Basil Brush Show' in production at the Maidstone Studios.
Photo: Jeremy Hoare

circumstance; 'What if this thing I've been given to use doesn't work properly; will it record what I am seeing through the viewfinder; what will the sound be like?' Thoughts like these are stressful and it's not until you are in this position on a production of any sort that you can really understand the value of equipment reliability and dependability. After shooting the lecture, I couldn't even watch it played back, whatever I had done with the jerky zoom I knew the sound had to be very poor.

In a sense it is the justification for the higher price of professional equipment; you can trust it to deliver much more than the domestic version as it is made for the job. Using professional equipment with manual override controls relieves a lot of stress; you will be in control and concentrating on what you are shooting, not whether the kit will hold up and deliver. That will encourage you to try more creative techniques, to use the camera in a more adventurous way as a tool to tell stories with.

But never be constrained by the inherent security of professional kit, just the opposite, let it be a springboard to greater creative freedom safe in the knowledge that you should get what you see and shoot. The limit is your imagination, and only you know what that is, or do you?

9 PAUL HARRISON – Director

Paul Harrison

The great thing about a good camera operator is his intuitiveness, that he understands what I am trying to achieve. Some really good guys quickly switch on to my wavelength, this way I can describe a track, a crane shot or whatever it's going to be and they'll respond instantly. There's only a handful that can actually do this, and I work with a lot of operators!

I first knew Paul Harrison as an assistant stage manager, and also his father Les who was manager of the Drapes Department at ATV. Paul always had, and still has, a happy disposition, nothing much seemed to get him down which was a very good quality for anyone wanting to direct – which he very much did.

When he became a programme director he was always so enthusiastic it was infectious, so that as a cameraman he was someone you would go the extra mile for. Later when I was a lighting director I worked with him a lot and as budgets had been slashed it was always a case of making the most from whatever was at hand.

On one recce in Nottingham for the children's programme *Your Mother Wouldn't Like It!* he took me to two different locations where a song and dance number could be shot, then left it up to me to choose which one. I chose the seemingly impossible one to light of course, a huge Victorian railway shed full of iron columns, such a challenge with just the four lights the budget allowed. Somehow I got a good result out of the location and it was part of a show that both Paul and I are particularly proud of as it won the BAFTA Award for *Best Children's Programme* that year.

Paul is good for any cameraman to work with and is driven by striving for the best result that can be got on the screen within the time and budget. His career span tells us all that he has, and still does, succeed.

From filming 'Frost' with David Jason to working with a female camera operator on 'Ballykissangel', life has been fun filled for a man on a mission – helped by his dad!

Paul Harrison recalls how a stage managing role at 17 launched a directing career in which the cameraman's skill remains the key to "bringing my visions to life".

Of all the programmes I've directed, my favourite without doubt, is *Ballykissangel*. It was probably the happiest, and sometimes the saddest, programme as so many people from it have since died. Also my marriage broke up. But artistically, emotionally, visually and in storytelling terms that was one of the most rewarding ever.

It was while working on the second series of *Ballykissangel* my DoP – a gorgeous guy responsible for lighting and operating as well – told me his ex-wife had phoned to say his wife had attempted suicide and he didn't know where his kids were. This was at seven o'clock in the morning, just before we were about to shoot a huge all-day scene involving upwards of three hundred extras. This meant encompassing the whole village, starting at the top of the hill and working down. "I've got to go back to London," he said. "The Steadicam operator, however, knows how to light. She will be arriving any minute now and she'll look after you". I agreed he should go.

It was a beautiful morning in Ireland and while I was looking out over the water wondering 'what the f*** am I going to do now?' she arrived, strapped on the Steadicam and was fantastic, absolutely fantastic. She took perfect control and that day *Songs of Praise* were shooting us, and we were shooting a slave auction. What the viewers of *Songs of Praise* actually saw was my gay first assistant cueing action to a female Steadicam operator who was now on a crane shooting the slave auction. We had a great day, and I have to say that particular camera operator turned in a fantastic job considering she was thrown in at the deep end.

Some of the most fun I've had has been on *Frost*, and more recently *Diamond Geezer* again with David Jason. All the stuff I have done in the last five years has been with him – great fun based on good old-fashioned storytelling.

There are, of course, programmes I wish I'd never made, mostly American I have to say, I have to say. I wish I'd made *House*, also the 2008

Doctor Who series which was fantastic. I didn't like *Torchwood* however, because it didn't really go anywhere. While not my world anymore, the video work in *Doctor Who* really pushed the boundaries while the special effects raised the bar extraordinarily high. So, yes, that would have been huge fun to do.

Tragedy led to a fresh start

None of which would have happened if it had not been for my Dad. Thanks to him I landed up printing studio floor plans while Martin Baker was away. It was only later while a programme called *Virgin of the Secret Service* was in production that Sheila Atha, the stage manager, needed help on what was an incredibly busy show. With my contract, which was only a holiday one, finished, Percy Wellsburg who ran the department asked my Dad if he thought I would enjoy training as an assistant stage manager, a job which probably doesn't exist any more. My immediate reaction was, "What's an ASM?" but I took the job and Sheila, bless her heart, took it upon herself to train me in everything relating to stage management.

When *Virgin of the Secret Service* finished I went to say goodbye to Percy as I had no idea what I was going to do next – only for him to tell me there was a woman crying in his office and I was to go up to the rehearsal room for a show due in the studio for the coming Saturday. By then it was Wednesday... "The poor woman's husband," he told me, "has just died and she's fallen apart. Go and take it over". So I stage managed my first production on my 17th birthday.

Becoming a programme director

My reason for wanting to be a programme director was basically because I was terribly arrogant! It all began when Dad took me to the studio to see a live promotion spot for *The Golden Shot* directed by Pembroke Dutson. It went out live every Sunday afternoon but, being a stickler for the rules, Dad didn't take me until I was 12 so I was thus covered by insurance. I sat in the audience and watched people getting more and more frantic about something that actually lasted 30 seconds. But the big thing was it went out *live* – and I wanted to be part of it!

The result was I didn't do any schoolwork. I have no academic qualifications whatsoever, apart from two GSCs and a few RSAs. I just knew that's the direction I wanted to go, and Dad, bless his heart, got me

the job printing studio floor plans. But he did warn me I was on my own, and the great thing from a stage management point of view was that my role was a freelance one. And, apart from a very short period of time within ATV, I have been freelancing all my life. When Dad left two years after I joined I really was on my own!

Always trust a good cameraman

I've always felt a camera operator and a DoP are two different people. I realise these days a lot of productions will put the two together and a DoP will operate. But I often feel that's only a financial saving, and not a particularly good one at that.

The great thing about a good camera operator is his intuitiveness, that he understands what I am trying to achieve. Some really good guys quickly switch on to my wavelength; this way I can describe a track, a crane shot or whatever it's going to be and they'll respond instantly. There's only a handful that can actually do this, and I work with a lot of operators! I also need the operator and the actor to work with me as a trio, with a strong relationship between the former so that the actor knows what the operator is trying to achieve from what I have asked of him or her.

The DoP's role, in turn, should be to have a relationship with the operator in terms of what he is seeing and the picture that he's painting with light, and what is working for him. I love DoPs that really go out on a limb, though you can't do that a lot in basic story telling with, say, a programme like *Frost*; be too dangerous with lighting and it frightens the audience because it's not a style-over-content show, but strictly a content show requiring good solid pictures.

The operator and the DoP are the instruments that release the images stored in my head. They put them on the screen for me; though I do shoot some stuff on camera occasionally, I basically rely on them to give me the story. Their contribution is enormous. It also follows that the best type of cameraman is one who understands me and understands what I need. The worst type are those who say, "We don't shoot it like that!" which is one of the problems of being a guest director on a series.

There was a specific one – I won't tell you which one – which had been going for some years. I walked on to the set to discover they had really gone native and could be described as being a long, long way from home – they really had. They were all people I knew yet had become very strange

indeed. What normally happens is that when everyone leaves the set, I rehearse the actors; it's just me and them. Then I will bring in the DoP and the camera operator, show them the scene and discuss how I would like to see it look, having done the recce as well. But in this particular case the camera operator said, "We never put the camera here" – to which I said: "Well, today you do!" It proved a battle for five weeks; I'm sorry, but you can't let that sort of thing happen.

As you no doubt gather, I rely totally on camera operators and DoP's, it's their craft and skill that provides the pictures that bring my vision to life. But even though I do my homework very thoroughly, I'm always open to a better way to do a shot. Then I'll nick it and tell everybody it was my idea! But seriously, we all want to look good and it's the camera operators that make me look good. I mean that. They actually *do* make me look good!

10 JOHN GLENISTER – Cameraman & Director

Success as a cameraman means the right reaction skills, the concentration and the focus, in all senses of the word, to realise what's going on. And do relate to the people in front of the camera. For an inexperienced actor, or even an experienced one, to have a big baleful machine with a piece of glass staring at them is pretty frightening.

John Glenister

John Glenister was regarded by myself and the other camera trainees as being very firm but also fair. To be his tracker was a challenge for anyone in the initial training period, but he had a great knack of bringing out the best in people. I can vouch for that easily enough.

While a trainee I was tracking John on a drama at Highbury Studios and ended up with so many marks on the floor I confused myself totally. My confusion was not lost on him – so he guided me. It should have been the other way round, but he was always generous. But rightly, I did get a ticking off afterwards.

Being a cameraman was a stepping stone in John's career, his ambition was to direct as it is for a lot of cameramen. He succeeded and went on to be an excellent director of a number of classic programmes such as *Z Cars*, *Six Wives of Henry VIII*, Jane Austen's *Emma,* an autobiography of *1984* writer, George Orwell, *The Bill* and *Hetty Wainthropp Investigates*. Inevitably a lot of John's work was shot on film because that was the way it was done at the time. If he were working today it would be on video in one format or another of the many available.

A highly respected name through a lifetime in television, John has now retired but his two rather famous actor sons, Phillip and Robert, continue to keep the Glenister name on the screen.

His life is now very much tied up with talks to Women's Institutes, charities and so on, telling a few stories, including how, as a keen amateur photographer, he had visions of being a film cameraman.

John Glenister tells how back in the early fifties getting a job in film first meant getting a union ticket – impossible without having a job in the business first!

I got a job at the BBC, initially as a trainee telecine engineer. To be honest, I found it boring so searched the internal adverts until eventually a position for a trainee cameraman cropped up, just what I wanted. I became part of a camera crew, spending a year or two pushing cables around and gradually learning the techniques before becoming a fully fledged cameraman, which I remained for about nine years.

In 1955, like many others, I left the BBC to join the then newly opened ITV and, in particular, ATV. In two years I was a senior cameraman, a position I held until 1964 when fresh job opportunities were created with the start of BBC2. I had by then aspirations to direct and went back to the Beeb as a trainee production assistant. In 1966 I started directing.

The important people

Several people became important to me at different stages. First were two senior cameramen – the 'Kings' of camerawork at the BBC in those early days – Jock Watson and Colin Clews, both incidentally tempted away to start up new camera crews with ATV. It was Jock, on whose crew I worked with at the BBC, who invited me to go across, the first big step I took.

Watch out for the signal to move

While at ATV, I applied for several trainee director boards and failed every one. If there were six vacancies I came seventh, if there were three vacancies I came fourth, and I was getting pretty fed up. It was only after sitting at six of these that one evening while sitting miserably in the bar at Elstree, that James Ferman, then a television director, and eventually Secretary of the Film Classification Board, asked what was the matter? "I've just had another director's board and I haven't got it," I replied.

I will never forget his reply: "They they will never make you a director at ATV. You're much too valuable to them as a young and clever senior

cameraman. If you really want to direct, you'll have to leave ATV and go somewhere else". That was the signal I needed. I returned to the BBC.

My other great mentor was Lionel Harris, a theatre and television director, a lovely, lovely man, clever, very artistic but also a great technician. I'd worked with him an awful lot as a cameraman at ATV and knew him well. He eventually took charge of the *Wednesday Play* at the BBC, a prestigious drama slot, and offered me in my very early days of directing, the chance of doing one of the plays. It was a big step up in terms of being noticed as a director.

The hardest decision

The hardest decision I ever made in TV was probably to leave the BBC for ATV. If that had failed I'd have been out of a job. There were no other opportunities for studio technicians apart from the BBC – and they wouldn't have taken us back, feeling perhaps we'd slightly betrayed them.

The other big decision was making the move from camera to production. I hadn't been an actor, I hadn't been a writer, I hadn't, in fact, done anything in the production line so I was taking a bit of a risk. But it worked out well.

My favourite piece of camera equipment

I suppose, in an arrogant sort of way, my best work was with a couple of shows using the Transatlantic crane. One was a *Roy Castle Show* with Colin Clews, by then a director himself after being a cameraman.

The morning we started, the crane had just come back from location on the feature film *The Longest Day* still covered in sand from the beaches. But it worked well, and how exciting it was to sit on it and be taken 30 or 40 feet in the air to obtain some remarkable craning shots. It wasn't used very often in the studios; it was just too big to handle. The whole *Roy Castle Show*, which lasted an hour was on this single camera as one shot, apart from the commercial breaks. Even then, the camera would crane down to a frame to indicate the End of Part One.

All pretty frightening, because you knew the red light would be on for 20, 25 minutes, and it wasn't going to cut away as in most programmes. You had no time to think what you did next, you simply had to follow the action. It was a pretty good feeling when it was all over.

Likings as a cameraman

I suppose the thing I liked most about being a cameraman was the extraordinary range of people that you met: directors, scenic designers and lighting supervisors – all very clever people and all contributing to one successful whole.

Being a bit starstruck, it was always a great thrill to work with those who were basically just names, the Bob Hope and Bing Crosbys of this world; suddenly you were being introduced to them, shaking hands and working with them. These were very special moments, and there's a whole host of people that still leave me breathless.

Working with Bing Crosby and Rosemary Clooney was certainly a bit special, also working with Laurence Olivier before he became a Lord. He did very little television, hardly any in fact, until his later years, with Ibsen's *John Gabriel Borkman* his very first venture into virtually live television. It wasn't transmitted at the time but was recorded continuously. It was pretty thrilling to work with a man of such stature who took to TV very, very easily. For someone like him to seek your advice was, well, something rather special.

Tips for being a team leader

Being a team member is vital. I was a senior cameraman for a lot of my time, and therefore team leader. To ensure everyone was a 'happy bunny' I made sure jobs were shared out. When we did a fairly simple sort of chat-show, I would see to it that the more junior members would handle a camera, and the more senior become their assistants. This way they could teach at the same time and give the trainees a chance to handle a camera and learn some of the techniques. No longer did they feel 'also rans'.

Ambition and staying at the top

Ambition is important. One ought to aspire perhaps to being more than a cameraman – it can be satisfying, but after nine years I wanted to put all those skills that I'd learnt to even greater use, in my case directing. For others it might have been lighting or even just production as opposed to direction.

In my day you were virtually apprenticed, so you learnt all the things that you wish you'd known as you went along. Working with people who could do the job, and you respected, was for me far superior than sitting

in a classroom usually being taught be someone who hadn't quite made the grade themselves.

Success as a cameraman means the right reaction skills, the concentration and the focus, in all senses of the word, to realise what's going on. And do relate to the people in front of the camera. For an inexperienced actor, or even an experienced one, to have a big baleful machine with a piece of glass staring at them is pretty frightening.

I always made a point of making sure that all my crew introduced themselves, or I introduced them, to the artistes, cast, speakers or whoever we were filming. In later years I even put our Christian names on the front of the camera, just beneath the lens, so it humanised that big hunk of equipment. And it was big then, and at least if an actor, or presenter, could see the name of John or Fred or Jack, they felt that there was a human being behind it and not a Dalek.

I would have thought it still possible to stay at the top. The only thing that will prevent you is the same as with any job – age and ability. A very important part of being a good cameraman is remembering what you'd done during the rehearsal and reproducing it when it comes to the recording or the actual transmission.

Team spirit

One of the most exciting things was being part of the team that did *Oh Boy!, the* rock 'n'roll show in the early days. The most exciting part was that Jack Good, the producer, used to get the show going ten minutes before transmission time with a lot of hard beating rock n'roll. The audience were going crazy by the time it went on air.

The other thing that Jack introduced was to let the music play on even with an announcement about the next act, it would simply continue underneath. So for 30 minutes the music never stopped. It was great to be on the camera and feel this excited young audience behind you and great rock 'n' roll stars performing in front of you.

Just a few of my favourite things . . .

As to what programmes were my favourites, all were at the time, simply because I could eventually pick and choose what I did. With the choice of script, you immediately feel confident of doing a good job, whereas you never really get going when assigned a programme which didn't appeal.

I particularly recall working with Ron Travers, who produced *Z Cars*. We got on well, and when he was asked to produce the *Six Wives of Henry VIII* offered me three of the episodes – those on Catherine of Aragon, Jane Seymour and Anne of Cleaves. The series proved a huge success and from then I was recognised, and known, as a director who – well, had some sort of talent. It's all a question of getting the right job at the right time.

All three episodes won awards. The Jane Seymour one won the Italia Prize, the biggest prize in television at the time, while Annette Crosbie won the best actress BAFTA award for her performance as Catherine of Aragon. I seemed to do an awful lot of programmes with women in the lead – mainly because the scripts seem to be the most interesting!

Then there was Jane Austen's *Emma*, again with a leading lady of course. I'd never read Jane Austen at school, but when I did was struck by how funny Emma was. I had huge fun casting it and directing it, mostly studio-based but with a little bit of film. In those days classic serials were pretty all well studio based, working on multi-camera. Each episode took about eight days along with six days of rehearsal and a couple in the studio, for 50 minutes of episode. That was fun.

Orwell's '1984' tops the poll

I suppose my top favourite was the biography of George Orwell, shot in 1983 when the BBC decided they ought to recognise the coming of 1984 as a real year. One of my favourite writers, Alan Plater, was asked to write the script. Orwell moved from London to the Isle of Jura out on the west coast of Scotland, at a time when he was worried about the effect on his adopted son Richard of the threat of nuclear war. He moved into a desolate farm and remained there for three years writing 1984. Fortunately the farm house still survived his fears – so we spent five weeks on the island recreating those three years of Orwell's life.

Until then, I had been casting in London with my producer Norman McCandlish and had just met Ronnie Pickup who played Orwell brilliantly, absolutely brilliantly. We had a fairly rushed schedule, and the next moment we were aboard the train from Euston to Glasgow and the BBC office to meet the recce crew. From there we took a car to the west coast of Scotland, crossed by ferry to Isla on Jura and then travelled the 30 miles by Land Rovers till we reached a primitive stone road. It seemed to take

forever before reaching the farmhouse and decide what we were going to do in terms of shooting.

In all, the journey from Euston must have taken something like ten hours and as I got out of the Land Rover I turned round to everybody and said: "I don't like it," – just as a joke of course. Clearly it was the farmhouse where he wrote 1984, and we were going to use it anyway. But after all that effort to get there, I decided it would be quite fun to repeat what was swung on me when I was an assistant director. You spend hours looking for a location, eventually find somewhere you think is perfect only for the director to say, as I did: "I don't like it!"

Thoughts on cameramen, good and bad

Of course in my later years everything was done on single camera, pretty well all on film, in fact in the last 10 or 15 years everything was made on film. This is not the the same as working in a multi-camera studio with a crew. There is just one director of photography and an operator, that's if it wasn't one and the same person. The qualities you look for in a cameraman, film or television, remain however the same – the ability to frame pictures in the same way that you imagine them.

I think one of the biggest problems in multi-camerawork was to define the size and general composition of the shots. There was continual discussion about the differences between a close up, a medium close and a medium shot. Clearly a full length shot, for instance, meant a long shot, and was self explanatory. During my ATV days, we tried to define these so that crews and directors were working to the same standard of what a close up or medium close really meant; there was a continual problem on how much headroom do you give to a close up.

It's different with film, you've got a viewfinder or a video monitor to look at and can judge exactly what you want. Anyway it's the same cameraman so it's his personal style that runs through the entire film. With multi-camera work it is terribly important that each of the three or four cameramen conform to the same standards. If say a medium close up is called on three different actors on three different cameras the size of the picture has to be the same so that they match.

A bad cameraman is one who's sloppy with his shot formation. He is slow to move from one shot to the next so you are waiting for him, and doesn't come up with suggestions and solutions to problems – basically a

sort of dogsbody that does the work without involving himself or herself in the creative process of making the programme.

The best has to be a film cameraman I met while working on a series of the Maigret stories by Georges Simenon, in which Michael Gambon played the famous detective. This involved staying in Budapest for eight wonderfully happy weeks. I shot three episodes out there, alternating with another director who shot three in the first six series.

He was a Hungarian film cameraman who had worked on many, many Hungarian features, when they were at their peak. It was an extraordinary experience to encounter his creativity and knowledge and his suggestions of how we shot scenes and what sort of lenses we used. I just felt so comfortable in his hands, knowing that he was really taking full responsibility, along with appreciating what I wanted to see and show. His contribution was just amazing.

The was, however, one film cameraman, who I won't name, with whom I just didn't hit it off with. The chemistry was bad and whenever I suggested a shot he suggested an alternative, just for the sake of being different, or so it seemed as there was no real reason behind it. Even on a medium shot, he would still chop headroom which I hated, yet I couldn't talk him out of it. He insisted that was his style and he was sticking to it.

11 GLASSES

The insular world of the television Camera Department at ATV was, apart from a few notable exceptions, a very macho one when I joined. A lot of posturing went on to assert individuality within it, some of it totally absurd. Everything was picked over and commented upon, even wearing a new shirt would bring comments as fashion was a hot topic, at least for some. But I really sent them into the stratosphere when I committed a cardinal sin; I walked into the studio one day wearing glasses, the only one in the department of around 30 to do so.

As a kid I had to wear glasses, dreadful round National Health specs which later were made highly fashionable by John Lennon. Then in my mid teens my sight seemed to correct itself, I gave up wearing them, left school and started work in the post room. After getting into the Camera

Jeremy Hoare on location Photo: George Wiggins

Department as an assistant a few years later I was still okay, but it was when I started actually operating cameras I begun to realise that focusing them was becoming a problem. As my experience increased, I wanted to push my limits but was being held back by my eyesight and a reluctance to wear glasses as I guessed that it would mark me down as being not quite up to the job.

When I was in my mid-twenties, I knew I had to face the reality and accept it. So the dreadful day dawned when I wore my glasses at the studio for the first time, and it was even worse that I could have ever imagined. The sight of me wearing glasses brought sympathy from a sensitive few but hoots of derision and disbelief from the most unkind of what I previously thought had been friendly colleagues. One asked where I'd parked my white stick. Looking back it seemed unnecessarily cruel to do this to anyone and my opinion of some cameramen was changed forever; I can easily remember who they were even today.

That first dreadful day over, I started to relax and made a goal for myself; I had to be the best cameraman at the studio, it was the only way. My confidence slowly built up over a period, although even some programme directors were unsure at first whether to give me shots which were difficult. But all of this conspired to make me better. I just had to be as I had been regarded as virtually disabled.

Even for anyone with 20/20 vision, before you get used to it the very camera itself almost becomes an obstacle in the way of telling stories with it. But in a never to be forgotten moment, and because I could see properly with glasses, one day I went through the barrier and came out the other side, I could now really use the camera! I had crossed a psychological threshold and could throw a camera at anything and come out of it with success; neither it nor my glasses were a barrier to my being creative. I was getting praise from other cameramen and directors I admired who would never have said anything without telling the truth.

I had confronted my major demon of being the only cameraman in a department wearing glasses; nothing held me back from that moment. But did I actually become the best? Vanity tells me that I would like to think so but in my opinion no, though several I rated highly told me that I had become that.

In today's politically correct world, such prejudice as I encountered because of wearing glasses would, I suspect, be against the law. If you need

to wear glasses then you must do so, confront your demons, and be a better cameraman than you ever would without them. I did, and it worked.

12 JOHN WATT – Lighting Director

> *Live multi-camera production which I was sort of born into was quite something, and I also enjoyed the team spirit of working with a crew. It's about the only team game that has ever interested me – I have always been a loner.*

John Watt

I first met John Watt when ATV Elstree was going to close and TVAM was taking on people for its opening, so I applied to be a cameraman as I wasn't keen to go to Nottingham in that capacity. John and the ex-ATV vision controller Jim Reeves conducted the board I attended at 'Eggcup Towers' as it was jokingly called then, now the MTV studios. After the board was over, I told them both that I had enjoyed it – to which John looked surprised and responded: "We'll have to make it more difficult then!"

When I went to Central in Nottingham as a trainee lighting director John was my head of department. I could not have had a better one, he encouraged and coaxed me into being adventurous in what was a new direction for me. Having been in the Camera Department for over 20 years, at the age of 43 I found the transition hard and initially wondered if I'd made the wrong decision. It was John who pushed and supported me through a bad period in my life for which I was very grateful.

He was made Chairman of the Society of Television Lighting Directors which I joined as soon as I could and found out on numerous occasions what a great raconteur he is. In the summer of 2008 John was awarded a Lifetime Achievement Award at the inaugural Clay Paky 'Knights of Illumination' event, a complete surprise to him and well deserved.

My interest in television came about when, at around 11 years old, I went down with a childish disease, chicken pox or something. Because I was confined to home, my mum brought me a book from Boots Lending Library; she was posh, you see, and she didn't go to the Public Library! It was called *Amateur Dramatics* and I have still got it. It devoted two pages to lighting, which looked interesting, and I began finding other such books. So when my parents told me to get a proper job and "forget this lighting nonsense" I succumbed instead to amateur theatricals in Basingstoke where I lived and whose theatre, the Haymarket, is still there. It was a number three, at least, if not a number four, touring house so both local amateurs and travelling companies of one sort or another used it. I was the electrician.

After my National Service, I went to work for ABC in Manchester as a camera trainee and blithely said that I wanted to be a lighting director. Everyone laughed a lot and said: "So does every other cameraman." But after about three years with ABC that's exactly what I became. Many of the programmes, at least those I have worked on, have been near misses and probably best forgotten. But if pressed, the first production that I ever worked on purely as an oik bashing cables – as opposed to one I actually lit – was a play called *Underground* which was part of the Armchair Theatre series. The storyline was that an atomic bomb had dropped on London, with the entire play done in a studio using two underground carriages dragged up to Manchester.

The opening scene was of the bomb going off in which real rubble was tipped down an actual working escalator over the trains and, because it was pre-polystyrene, this was made up of real bits of brick and concrete. So that was a memorable production. I worked on many other Armchair Theatre productions and I don't think I have ever enjoyed such an adrenaline rush. With some 20 million people watching, the plays always got featured in the following morning's papers as being very much avant-garde productions. They were certainly a milestone both in the public perception of television and in my own life too.

Light entertainment was at its peak

Probably one of the most memorable productions I did for Central was a special starring Cleo Laine of whom I'm a great fan. And although it now seems old hat, *The Price Is Right* was one of the big-time game shows brought in by William G. Stewart; the buzz we got out of that and the excitement that was generated by him in the studio was really something else. But in those days emotions were built up even before we started recording. *Theme Dreaming,* a dance special with Wayne Sleep particularly springs to mind. I also did a lot of dramas but the one I remember particularly was *A Kind of Alaska* with Paul Schofield and Dorothy Tutin. This was a two-hander lit entirely with bounced light, the only time I have ever done that. Yet it seemed to work.

Given the chance I would loved to have worked on anything written by Dennis Potter – and 180 degrees around from that anything featuring Liza Minnelli in her heyday. She was 'Miss Showbiz' then and I sometimes feel pure light entertainment like that doesn't exist any more. *Dancing on Ice* may have a lot more kilowatts but it's not quite the same. During my 16 years at Yorkshire Television there were periods where each of us did a drama a week, single plays or series. "Well you're doing *The Main Chance* Watty", the governor once said – that's 13 in a row fortnightly; you would do *Emmerdale Farm*, as it was the called then, on the weeks in between because it was being shot like a drama. You'd spend a day to build, two days on the road and a day in the studio and so on producing two episodes a week, or how ever many it was then.

Co-operation not capitulation

I always found the process of multi-camera production absolutely the type of thing I wanted to do. If I was still working now it would still be the thing that pleases me most. I realise that it is arguable artistically whether it produces the best results, but it certainly produces the most adrenaline as far as I am concerned. Live multi-camera production, which I was sort of born into, was quite something, and I also enjoyed the team spirit of working with a crew. It's about the only team game that has ever interested me – I have always been a loner.

The main thing I want when working with a cameraman, either multi-camera or single cameraman, or both, is co-operation but not capitulation. I also seek sympathy with lighting, which to some extent is to know where

the key is and why, and knowing there's not a shot to be had from every angle in the book. Remember, their contribution to the success or failure of a programme is as equally important as everyone else's after the performer. The worst type of cameraman is one who is egotistical and self-important.

One shot that I've remembered for the last 35 years, before, sadly, I was in lighting, was a show at Coventry Cathedral with Duke Ellington, involving a suite – a religious piece called *In The Beginning*. In those days a feature of any religious programme, be it from a church, cathedral or whatever, was what I think Americans call 'beauty' shots. There would always be long meandering passages or bits of the choir where a camera had to find a shot during a very long piece. Ronnie Baxter, who later became a director, decided to do a long pan down of one of those huge columns you get in a cathedral. Down and down he went for what seemed like minutes, got the camera horizontal in the end, threw focus and found the camera was looking through the tracery. And framed in the middle of it was the drum kit with the high hat in the middle of the frame. Not only that but it was on the last phrase of that bit of music. If there is a God then he was with Ronnie Baxter that day!

More succinct was when The Queen opened the Humber Bridge at a time when cameras weren't as small as they are now. One cameraman, Harry Wright, had special dispensation to walk backwards as The Queen advanced down the line shaking hands with the dignitaries. However, somebody stood on his cable, and nobody's ever forgotten just how big a close-up Harry got of Her Majesty. It was quite something!

Thirdly, during the days when it was rare to go out on location for single dramas, the designer had built a lift shaft in the studio, with the opening shot looking up with a camera on an up-pan wedge. This would have been achieved using a big EMI 2001 or something similar, creating the impression that this was at the bottom of the well, i.e. at the bottom of the lift shaft. A caretaker then opens the gates two floors up to climb down a vertical ladder to clean up in the bottom. But what nobody had said at rehearsal was that before doing so he threw his bucket and broom down the shaft. Exit cameraman – it was a nice galvanised bucket too!

Electronic drama is on the wane
I feel now that drama only exists on film, or what pretends to be film. In other words, pure electronic drama, outside of the soaps doesn't seem to

exist. I always believed there was a possibility for another genre of taped multi-camera drama which would be a much cheaper to produce and might well have an artistry all of its own. But it seems to have died at birth.

Both from a lighting and camera point of view, I hate impossible points of view i.e. when a camera replaces a person in a conversation. I've always felt that the viewer – or audience – should feel they're just that: that they are looking in on a scene that is being played for real. I feel that once a single camera is used to replace whoever's not speaking or replace the listener, in a simple two-hander conversation, I get a sense of disbelief. I hate those shots, too, where the camera is in a cupboard in a fridge or listening through a window. Okay so they might come about through a director's whim but I feel they get in the way of the story. Surely the centre of our business is telling a story; documentaries, magazine, chat and news show have still got sort of a message to get across. These things get in the way.

Let's have more simple treatment
The essence of portraiture in television composition hardly exists now. I really do feel that that has been lost right across the board. On the LE front, where it still exists, it's very equipment led, everything is possible and everything seems to be included in a show with a big enough budget to buy it all. I yearn for a simple treatment with a bit of class.

I agree pictures that come out of today's cameras defying the light levels are remarkable. If acclaimed LE director Jon Schofield, who I was working for then, didn't get rocked off his heels when he walked into the studio, he would say: "You haven't got enough light on this Watty; I've just got to feel it!" I am quite 'green' now and think of the megawatts of juice that we used to waste, never mind used; all that has changed. I know some LDs are depressed about the colour rendering of LEDs, and realise it's got to be the way that light is produced because of the fuel consumption. But people it seems are struggling to make them work at the moment; maybe the technology will improve.

Retirement is not much fun
I'm bored being retired! Everyone says you miss the people more than the job. Okay, sometimes you look at what's going on and think you're better off for not being there, getting frustrated with what takes place. Then you

see something nice and think, "I'd like a bit of that." But I am well out of date with some of the technology. I'm sure people of our generation think we had the best of it – and in many ways I'm sure we did. Yet people coming into the business now think they've got the best to come. I hope for their sake they have.

13 DAI HIGGON – Cameraman

> *So the basic advice for a would-be cameraman is to get a feel for the job. Visit art galleries and learn some basics. This means studying the framing, the lighting and whatever else there is in the gallery. Then apply it as well as you can.*

Dai Higgon
Photo: Jeremy Hoare

Dai Higgon was a big man – and a very good cameraman – who came into the studios after a long spell on OBs. It was rumoured that he could lift a Pye Mk3 camera on his own which nobody else could; I certainly couldn't.

When I was on his crew we got the *The Englebert Humperdinck Show* series, and it was Dai who pushed the boundaries of multiple images by designing and getting made Perspex lenses which fitted onto the front of the EMI 2001s in use at the time. Today it would be done in post production easily, and at no cost apart from time, but Dai did it in the camera and while operating on the Nike crane. On this series I operated camera four which was high up on the lighting gantry. I always had a few shots which gave the geography of the set but during the time I wasn't actually doing much I read art books to expand my knowledge of composition and lighting after I'd got the sparks to rig me a reading light.

Dai went on to become a location manager and whenever he set up a location shoot, the crews knew they would be well looked after. He was instrumental along with Dick Hibberd in forming the Guild of Television Cameraman, a great voice now for cameramen worldwide with a very active Forum that is a goldmine of information for members.

Married to vision mixer Carole Legg, together they have organised an annual ATV Reunion Lunch for many years, which is a way of keeping in touch with many people as well as being a great event.

My first interview after applying for a job with the BBC was in Cardiff. I got through it okay, then travelled down for another in London where, though non-plussed at first, I managed to answer all sorts of questions. A few months later I had a letter saying I'd got a job.

I duly turned up at the BBC in White City on 13 December, 1954, joining the crew responsible for George Orwell's *1984* on the Sunday. As I wasn't involved at that point, my first week at the Beeb was spent doing nothing. I then worked on the *Grove Family*, although basically about two months was spent looking round the place. After that, I joined Colin Crews' crew and was with him for about five or six months. Colin was a very, very good cameraman and he ran a tight ship. He was the kind of guy who would give you a rollicking then forget about it – a valuable sort of lesson.

The other great influence was Ron Francis who was the most naturally artistic cameraman I've ever met. The trouble with Ron was his lifestyle; he didn't get much sleep in those days! One thing I learnt from Ron is putting artistes at ease; after all, they're in a strange studio with an equally strange bunch of guys. It therefore helps for a senior cameraman to have a rapport with them. You get a so much better a performance this way. The same sort of rapport is needed with the director. I always tried to have a few joint meetings before the show simply to get a feel of his, or her, approach to the shows. I then conducted myself accordingly.

Get it right and you're laughing
A good cameraman should always be a team member; if you work together you all get used to the same sort of headroom, so shots don't jump cut-to-cut and you get a smooth flowing show. If I was working, say, on a drama, with the sets very close together and very little room, my normal lens would be a 2" lens or 35 degrees. I would make absolutely sure the camera was balanced up around a sort of mid-shot position, likewise the pedestal – that would take care of the camera. If you worked with bags

of room, I would consider a 3" lens, which is 24 degrees, and again I'd balance the camera as if I was focused on the same sort of mid-shot, with everything else in balance. Balance to my mind is absolutely critical, so spend ages on it. If you're not relaxed, particularly during a long day, the camera's bound to move, whereas if you are relaxed and the camera is perfectly balanced you're laughing.

This means even when you relax tension on the panning handle it won't drop or anything. I remember once taking over a camera at the Royal Show at Kenilworth. It really was back heavy, and after about two hours, I'm making like 'Heck!' Normally when I took over – particularly with an outside broadcast camera for instance – I would zoom the lens, with all its heavy glass, onto what I'd call the normal sort of shooting range, and then balance the camera again. I remember with the old Mark 2 heads, I would damp the tensioning right down so it was very, very stiff; of course when the mark 3 heads came in, my tension was very, very light because, being perfectly balanced, that was the way to work with it.

So the basic advice for a would-be cameraman is to get a feel for the job. Visit art galleries and learn some basics. This means studying the framing, the lighting and whatever else there is in the gallery. Then apply it as well as you can. Otherwise just make sure you get everything right, especially your balance. Sorry to harp on about that, but if you do things will take care of themselves, especially if you've got the knack. Oh yes, and always be a couple of steps ahead; expect something to happen. You're then ready to shoot. I remember once going into a studio watching cameraman Keith Farthing running the wrong way round the pedestal after being released to a particular set and promptly tying himself up in the camera cable – which meant running back again! He just wasn't thinking. And that happens.

Things I've been proud of
When I was doing outside broadcasts working on the 80" lens, which is point 75 degrees. I could follow a golf ball so closely that if it stopped spinning you could read the name on it. I was quite pleased when a director who had been observing our coverage of the Alcan Trophy and was about to direct the open golf in Porthcawl, Wales, said: "I'll tell the boys how to do this". When Taff Harries went up to Caernarfon Castle and met the Welsh crew their first question was: "Are you the bloody Welshman who

follows the ball in close up?" Taff had to admit it was me . . . and that's the best compliment I've been paid!

Englebert's foldback sound was shattering

I was also pleased with my crane work particularly on the *Englebert Humperdinck* shows. The Nike crane was a beautiful bit of equipment and I loved working on it. I remember on one *Charlie Drake* show Charlie was sitting on a sort of large rocking chair, supposedly like a baby in a nursery. My job was start in a wide shot, crane in, crane down, zoom in, pan up, tilt and focus a lot. We did about four takes because Charlie wasn't happy with his stuff, and Bernard Saunders came up to me and said: "Tell me Dai, how are you doing that?" I remember saying: "Bernard, if I started thinking about what I'm doing, I'm going to cock it up and you'd better run from the studio!" If you think about it, it was really a fantastic thing we all did - and did it automatically. If you started thinking about what you were doing, well . . .

Take, too, a simple thing like talkback. When I was doing Humperdinck, you'd not only have vision coming through, Colin Clews calling directions – or whoever it was directing at the time - but you'd have the boys in the back talking to you and you talking to them. Then there was the Humperdinck foldback sound itself which was shattering, absolutely shattering. My backbone used to tremble. I had two huge speakers either side of me, and I was right in the middle. I could feel my whole body vibrating with the noise.

Looking back now on the Humperdinck shows with their incredibly complex Perspex optics to create multiple image shots, it seemed a distinctly Heath Robinson-ish set up. Today you'd just do it on a computer!

14 THE FRONT LINE: BING CROSBY

There is no doubt that a cameraman is the front line on any production, always to be pulled in two directions at the same time. Firstly from in front by whatever it is being shot, and secondly from behind by the director, crew, tea lady etc, all adding their comments.

But the very fact of operating the camera means you also actually have the final say in what appears on the screen – so your own input is vital, and that can sometimes be a problem if you stand your ground and do what you think is right. Even if it means disagreeing with one of the world's all-time greatest singing stars, Bing Crosby.

It was a hot July day and I was operating a camera on the *Bing Crosby Christmas Special* being shot multi-camera at ATV Elstree Studios. The singer had demanded a monitor with a constant feed of the UK Open Golf Tournament at the side of the set which was hardly surprising given his well known liking for golf, but he did amaze the crews by not knowing the words of his classic song *White Christmas*, needing 'idiot boards', or more politely 'cue cards', to perform it.

Bing Crosby
Photo: ITV / Rex Features

We were getting to the end of a long day and had time to do only one take on another short song which was to be all on one camera, mine. It started with a very wide shot and Bing walking from the cyclorama up to camera. So very conventionally I started with the camera at minimum height on the pedestal then craned up as he walked forward into midshot while maintaining correct headroom. We did a rehearsal of just the opening, no time to go through the whole song, after which Bing complained to the

director while indicating to me that the camera should stay high all the time. The director then told me to stay high to ensure I was in no doubt. But I didn't agree.

With very little time left before the whole studio went into overtime, the record VTR rolled. At five seconds to zero I pushed the camera down to minimum height; on zero the track started and as Bing walked towards me singing I craned up, just like the rehearsal. We got to the end and he looked daggers at me but it was too late. The director hadn't even noticed.

With crews wrapping all around us, the tape was played back and we all watched, me wondering if I would still be working the next day or looking for a new job. When it finished Bing turned to me, smiled and nodded a silent, 'You were right'. I had made a decision that I was right and he had wordlessly admitted he was wrong.

Standing your ground can make you very isolated but it is sometimes vital if you have anything to say with a camera, telling the story as you see it. Never flinch away from that responsibility.

15 GLYN EDWARDS – Director

The quality I look for most in a cameraman is that of an artist, a man that has vision and soul. Their job is to interpret what they see. This means not only a complete understanding of the equipment but an artist's eye in framing a shot, rather like a musician being in tune – in harmony, if you like – with the larger picture, or larger event, in which they have played a key part. An intelligent cameraman needs to be a fully rounded human being, with a dash of artist and a soul.

Glyn Edwards
Photo: Jeremy Hoare

Glyn Edwards was one of three trainee programme directors when I first met him. They were all very different, Glyn being the wacky one with obvious connections to showbiz; it was wearing a different colour shoe on each foot that was a giveaway, it fitted in well with the world of *Punch & Judy* that was, and still is, his life-long passion.

Glyn was a director on *Family Fortunes* amongst other programmes and always had an easy-going approach which went down well with the crews. Coming from his *Punch & Judy* show background he knew how to handle not only an audience but also a camera crew with relative ease, and was liked for his no nonsense approach to directing – nothing was too precious, it was only television after all.

I subsequently really enjoyed working with him as a lighting director as I had much more responsibility and control over the pictures. One children's series was *Chish & Fips* about gnomes at the bottom of the garden, which necessitated having studio sets designed by Tony Ferris with doors 18 feet high to give the right scale with the actors. This was mostly studio based but we did some location shooting at night so I had to light an entire street for the first time and I was lucky to have a good charge-hand electrician who nudged me in the right directions. The series was fun as Glyn and I formed a good understanding between us and at

all times was prepared to listen. Some directors don't, they always know best; Glyn was never like that.

Glyn left television and returned to his former career as a *Punch & Judy* performer. Funded in part by the Arts Council he has toured Europe, the USA and Japan: "That's the way to do it!"

> *None of them knew what Sting was going to do, but he worked out that these were intelligent good camera persons*
>
> *Glyn Edwards is today a sort of globe trotting* Punch & Judy Man *with a small wooden-headed cast he can keep under control! That's been his life since leaving the wacky world of television.*

Was it possibly better in the past? I really don't know. What I do know is I wanted to be a programme director, I guess, as a means of self-expression – a way of kind of communicating my vision through a medium, which, at the time, required an awful lot of technical equipment to do it.

Nowadays you can pick up a webcam and broadcast to the world, or immediately blog your way into the hearts of the nation; in the old days you had to have a position of some authority, and a programme director was a pretty good platform for that.

As a teacher, I originally worked in a London school which had a closed circuit television network – very advanced for the 'sixties – that connected all the schools. This involved making schools programmes for the Inner London Education Authority's TV service – ILEA TV as it was called. I then applied for a traineeship at ATV network. After a long complex procedure, I went through an eighteen-month traineeship and was duly dubbed a producer/director at ATV.

How I came to meet the comic genius Spike Milligan
Undoubtedly, the favourite programmes I worked on were the two series of *Tiswas*. It was probably the nearest thing you could have to being let loose in a sweetshop and doing exactly what you liked. The other programme I most enjoyed directing was a documentary on my particular subject – Punch & Judy. I did this for the 325th Anniversary Year of Mr. Punch, a network documentary that went out on Bank Holiday Monday, at a time when populist documentaries like that were popular.

Given a choice, I would like to have been at the BBC and would have given my eye teeth to work on the Spike Milligan *Q* series. I did actually make contact with Spike, when, quite out of the blue, while I was doing *Tiswas,* he sent me a fan letter, which was addressed, 'To the Producer of Tiswas'. It said: "I think your programme is the best programme for children on television, and it's getting better all the time. Love, Light

and Peace, Spike". This was probably my proudest achievement. So we contacted him and had him on the programme a couple of times. It really was quite exciting; I suppose I was star struck, especially meeting someone of that degree who helped shape British comedy for ever.

The qualities of a cameraman

The quality I look for most in a cameraman is that of an artist, a man that has vision and soul. Their job is to interpret what they see. This means not only a complete understanding of the equipment but an artist's eye in framing a shot, rather like a musician being in tune – in harmony, if you like – with the larger picture, or larger event, in which they have played a key part. An intelligent cameraman needs to be a fully rounded human being, with a dash of artist and a soul.

They must, however, remember they are a team member. If you stick with the orchestra analogy, there is a soloist, there is a conductor and, however good you are, there's the third trombone. Your role as the third trombone it is not trying to take over; people naturally want to listen to the entire piece. I guess a sporting analogy would do just as well, in that your role is not trying to hog the ball. But if you're striker and somebody gives you the ball it's you that gets the goal.

However, the cameraman's contribution to the success, or failure, of a programme remains crucial. Television is a purely visual medium which is viewed through the cameraman's eye. To go down the analogy path once again, think of a television programme as an assembled jigsaw in which the cameraman might be responsible for a certain number of pieces. But they all have got to fit perfectly; if they are slightly crooked, the wrong bits, or they are upside down then you will notice immediately. They are crucial to the finished look of a programme in just the same way as the cinematographer in Hollywood is a crucial component of major movies.

How I rate the types of cameramen

The best type of cameraman is the one with the intelligence to understand the bigger picture and has the talent to not only do their own part to 100th degree, but see what else they could contribute that the director might not have thought of. This could shape, and actually have a bigger impact on, a programme purely by tactfully pointing out other ways something could perhaps be covered. This could completely turn around the director's vision.

Conversely, the worst type of cameraman was the one who thought, he or she, knew everything and would let advice go in one ear and out the other. At the end of the day, they would always frame things that bit too wide for safety, leaving everything slightly framed loose and sloppy. Okay, so you couldn't get it wrong, because someone wasn't going to go out of shot. But equally it wasn't a particularly good shot. It was more like a wedding video. I had one cameraman who was like that, was also bumptious, and, I have to say this, suffered from a Napoleon complex. I tell you, a small film cameraman with attitude can be hell!

A hard day's work

On a lighter note, my hardest day in the studio was working with Thames Television on a half-hour series of studio dramas in which the senior cameraman had been fired, and for what reasons I don't know, but had come back as a freelance. As it was his first day back, he was determined to run the studio himself. Instead of cabling the cameras in the way I wanted to see them in the control room – cameras one to four monitored left to right – he cabled it the old way with camera one in the middle and two and three on either side. This meant we had to swap camera cards around, and every single shot was questioned. "Wouldn't it be better on three, shouldn't we be doing that on two?" and so on.

It inevitably became a day-long wrestle to maintain the director's supremacy in the studio, with everyone waiting to see if I was going to manage to keep this rogue camera person in his box. It became like a spectator sport for the rest of the studio, with the poor director sitting there thinking 'I've got the producer and executive producer and the head of the studio all sitting watching this on the monitors you have in the offices, all round the building.' All right, I got my own way but this is the sort of cameraman you don't want.

In the end, I went to the head of light entertainment and said: "I do not want to work with that person again," and fair enough, he was taken off the rest of the series. In the olden days, we were so unionised that this couldn't have happened. If someone was rostered on your show you were stuck with them, whether they were a total prat or not.

How Sting won me brownie points

An illuminating experience came with a music series for Channel 4. I

had to cover an acoustic session by Sting, who had agreed to do a set in a small studio. So I went out with a vision mixer I had never met before to meet three cameramen from, I think, Tyne Tees Television who as the local station, were coming out to cover it. None of us knew what Sting was going to do, but I worked out that these were intelligent and good camera persons. The vision mixer was excellent, and my job as director really was to give them the framework in which they could get on and do their stuff.

So I suggested: "We will rotate and get some close ups on lead, you know on his face for the vocals, who's doing the wide shot, who's looking for interesting close ups, and I'll tell you when we change. I'll also tell you when we are looking for fluid movement shots as opposed to 'we're just going to cut round this'." The session, of about 45 minutes, went like a dream. This got me a huge deal of credit from the executive producer of the series.

But while as director, I did take credit, my job at that point was to get out of the way and let the people who'd got the cameras and who were going to do the camerawork, get on with it. It was like being the conductor of an orchestra. We weren't going to play the instruments, we were just going to shape the artistes who were, and that was an illuminating moment I guess.

Cameras and crocodiles don't mix!
I was on Tiswas in the old days when they had just begun to bring in hand-held cameras, though the studio cameras still had pedestals. This meant we used to have three pedestal cameras and a hand-held. It was also in the days when it was acceptable to have live animals in the studio, in this instance baby crocodiles – around two-and-a-half feet long – which sat quietly in the corner with their handler. At least they were quiet until we came to the item with them in it. Of course, the lights came up on them, and, having woken up, they started to move forwards out of the light.

The cameramen were all jumping up on their pedestals so they wouldn't get their ankles bitten. My handheld camera person, whose job it was to find interesting quirky shots, was in the meantime taking shots of the baby crocodiles and cameramen trying to whack them away with their rolled up newspapers. Fine, until the moment came, of course, when all the other three camera guys were up on the pedestals, leaving the handheld guy

in the middle of a group of crocodiles who were all advancing towards him. That was the point when we had to cut away from the shot as he scarpered for it. I suppose that was sort of heroism you couldn't do these days and it was live!

Horses for courses

In the end, it's all a matter of horses for courses. There are cameramen who are right for soulful artistic performances, there are news cameramen who, like the war correspondent cameramen, walk blindly into the face of danger, and there are cameramen who are good for sports; they all have different mentalities and you need the right kind of cameraman for the right project. This is probably self-explanatory, but doing a drama with an outside broadcast cameraman is probably about as useful as doing a football match with someone who normally expects to shoot ballet.

How does TV avoid being drivel?

Television does not seem to have come to terms with the fact that the means of distribution of a programme has changed dramatically. You can now photograph people on your mobile phone as well as having programmes delivered through all kinds of satellites and other cables. The old concept where television was a unifying event with only a limited number of programmes, which you all sat around and watched, has gone for ever.

The fact you can now have them on demand means television has become shallower and wider as opposed to deep and narrow, as it once was. Either this it means it will never return to what it was once like, or means someone will realise we can broadcast for a niche market: live plays, for instance, might come round as a kind of niche channel, providing proper drama as opposed to, "Let's open it up for television". By that I mean something that in truth should only last an hour at the most, is strung out over two-hour into a bloated sub Hollywood movie with lots of fairly meaningless exteriors and a slower plot. You know what's coming long before the first commercial break.

At some point I suppose they'll manage to crack the idea that, if you can get that level of self, why not get some attention seeking moron to actually run the reality television drivel where you watch people such as in Big Brother? After all, exploitative broadcasters are already encouraging people to be voyeurs looking at sad basket cases, so why not put some

of these same people into actually making the programme, thus moving it to another level of bad taste. With the intelligence governing what can, or can't be, transmitted having been replaced by the lowest common denominator, it will simply all become drivel made by the very people who are currently in it. But perhaps that is just my dystopian view of what it might turn into.

Remember too, this country has the largest number of closed circuit surveillance cameras. Someone sooner or later is going to work out how to do something with that. Whether it will involve some sort of some bizarre treasure hunt or bizarre pseudo paintball assassination squad, I don't know. But in some dystopian science fiction television of the future, it will involve the massed number of surveillance cameras we now have.

16 EMI 2001

The camera that you will read about many times through this book as being the favourite of all time for many, as it was for me, was the EMI 2001. It was made in England before Japanese manufacturers realised what a lucrative income making professional cameras would provide and so started their world domination. Any operator who used one quickly came to know how it could be made to do anything they could think of or were capable of.

The reason as to why it was such a favourite and became the 'cameraman's camera' was its balance and size. With the lens set back into the body because the iceblock and four tubes (RGB plus Luminance) were near the back, the optical nodal point of the camera was close to the centre of gravity, which made using one instinctive. Because the configuration also made it compact, if the panning handle was shortened the camera

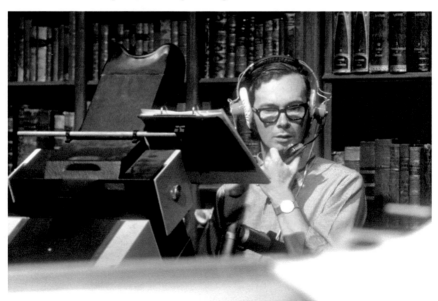

Jeremy Hoare operating an EMI 2001 camera on Hamlet in 1970.
Photo: George Wiggins

could be squeezed into very small spaces. On sitcoms and dramas the wing cameras could be inside the set so closer to eyelines, whereas with a conventional camera design with the lens stuck on the front the eyelines would be more less flattering.

I believe the very design of the camera contributed to the making of drama more telling and powerful. I can honestly say that any success I achieved as a cameraman was in part due to the EMI's design because I could put this camera anywhere my imagination wanted to take it.

Later on we had the technically superior Phillips LDK5s but with a huge lens stuck on the front, and to me they were ungainly and cumbersome. They were no doubt fine for OBs but their configuration was limiting to the creative freedom of a cameraman in a studio environment. You could actually set up a shot which conventionally would have been a pan but because of the lens length it became a crab. Fortunately they were mainly used for light entertainment where their design was not such an encumbrance.

Nowadays the classic EMI 2001s are to be found in museums – almost like some of the cameramen who operated them! – though some operators from that era are now working very successfully with HD cameras.

Today's generation admire their kit, and rightly so as it is fantastic, but they will only be able to guess at the difference of having such a beautifully ergonomically designed camera as an EMI 2001 to use. Cameras today produce vastly superior technical pictures, but to me they sometimes resemble a Christmas tree of bits stuck together – so I really admire cameramen who can get good results from them, as they most certainly do on a daily basis, which is how they continue to get work.

The EMI 2001 cameras I used were delivered to ATV Elstree in 1970 where they continued to be used there until finally being retired in 1991 on the BBC soap *Eastenders*, the very last of the 300 that were bought by the BBC and ITV companies.

17 PAUL FREEMAN – Cameraman

> *I honestly believe if you think there's a shot to be had, you've got to go for it. There's no point in not doing so. And despite the odd exceptions, most people appreciate that. After all, we can all take the easy way can't we?*

Paul Freeman
Photo: Jeremy Hoare

Paul Freeman was a bit different to other trainees when he started; it was something to do with his attitude, which some could consider abrasive, but really was not. He had opinions and wanted to get the best from a situation, great attributes for any cameraman. It was a great help when I had him assisting me as I knew he would be a real asset in whatever I tried to do.

When Paul went freelance I knew he would go on to do good work – which he has done many times over. He also has an enviable reputation for being highly adventurous and pushing people and boundaries to greater heights, and even his early work with the Technocrane on the sitcom *Drop The Dead Donkey* is still remembered by many from years ago, a real accolade.

Paul today is a very much an in-demand cameraman enjoying the fruits of his success, and while he has mellowed, as we all have, even now he is not content just to accept what is offered. He still pushes boundaries and long may he continue to do so. He is a real example to many for not merely accepting what is put in front to you, but finding a more telling way to shoot a story.

Going one step further for that perfect shot has paid off handsomely for one freelancer who always takes the most difficult route – even when it meant defying a Royal command!

Paul Freeman reflects on the switch from the safe old days of union-backed jobs to surviving as a freelance – and the chances you must take as a cameraman.

It was probably an early love of photography that led me into television. Even at junior school, aged around 11, I went around taking photographs and getting people interested. I was eventually interviewed for a job in cameras at ATV Elstree and though I didn't get the original job they wrote back when a vacancy cropped up. So that's where it all started way back in 1978.

Influences
There are two people I really think of in terms of camerawork. One is definitely Alan Beal who I worked with an awful lot at Elstree as a tracker. I still work with him, and have been doing so for 20 odd years during which I've learned a lot about studio discipline and the way to behave and use talkback.

The other person would be Geoff Joyce who had an amazing influence on my career. I always looked up to him, deciding that if I ever became a senior cameraman it would be based on the way he behaved. Except, that is, for his white socks!

The hardest decision
The hardest decision I took was leaving the company system and going freelance. I had enjoyed working on some lovely productions but I had to make a decision about my future. Although I had been part of a very successful crew system, there was nothing I could do to change it to suit me, at least not within the company. So I decided to work for myself. This turned out to be a good decision – and that was 17 years ago.

Let the camera tell the story
Being a cameraman means every day is different, with never a dull moment. Even when you work on familiar things like *Hell's Kitchen*, which I'm doing at the moment, there is always a different issue or there

are always 'fires to put out' as I say when I turn up. Yes every day is different. Beats working doesn't it!

I see the role of the cameraman as being a facilitator in that a director will come up with an idea and we find a way of actually achieving it. Our job is to help enhance the production either by a camera angle or a piece of equipment. Bearing in mind we work in a visual industry, I think the cameraman's role is probably the best apart from the director. It's all about pictures, and if you like pictures and those pictures tell a story, that's what it's all about.

My favourite equipment

Technocrane is my favourite piece of camera equipment. Basically a 50 foot telescopic crane, it has the ability to rack starting at the minimum 20 foot length up to 50 foot; the range of shots you can get with it are absolutely fantastic. It's a great crane in terms of teamwork as well. There's the crane operator – the cameraman basically – then there's two grips on the back who swing it as well as the guy who also co-ordinates the racking of it.

A real team effort

When I was younger, I played football, a lot of cricket and I was always part of a team. That helped me to become a team player; it was so much like television. To be a team member is vital particularly in television in as much that everybody in production is important from the producer right down to the guy who sweeps the floor. Everyone has got to be pulling in the same direction. I don't like the idea, as sometimes happens in modern television, that there is almost a break between production – a line drawn if you like – and the technicians.

Working with directors

The relationship with the director is to help him make a scene work. Whether it's a studio or a multi-camera shoot in a jungle somewhere, you know you've both got to be able tell a story. I think the relationship with the cameraman these days is slightly different: we are more camera directors in a way, a sort of middle position that we have somehow achieved while directors tend to be busy on other matters. This means relying on cameramen to sort things out – particularly on the technical side, and the

positioning of cameras. We tend to have more of a film cameraman's input in our relationship with directors than we ever did in years gone by.

Industry needs to tackle training
Current training schemes? There aren't any! It's very sad, and we're now certainly lacking ped operators in the UK. After all, we're all of the same age. There are one or two coming through but without the experience such as I've had, and I do think the industry needs to do something about it. Already you see stuff shot on PD150s that's out of focus so they make it black and white. Once that is going on you don't know what you are going to do; I don't think anyone really cares. I'm also appalled sometimes when you get a good picture with crap sound and vice versa.

Staying at the top and ambition
I can stay on top as long as directors want me. A lot depends on where you set your sights. I don't particularly think I've got a massive ego, I'm just lucky I do some very nice projects. Most are great fun but I don't really think I would want to end up doing conferences. Once I'd got to that stage I'd hang my boots up!

While ambition is important it mustn't get in the way of getting on and getting the job done. Okay, you've got to be ambitious if you want to get there, but I don't think this should be to the detriment of what you are actually trying to achieve. We have all met those where sometimes the focus lies in just wanting to get somewhere. That's pointless, because you have got to do your time, haven't you? Ambition is important, but it's not as important as some people think.

My tips towards achieving career success include keeping your eyes and ears open and your mouth shut. There's an awful lot going on, particularly on the studio floor, so try to listen and watch how people behave. There is a studio discipline, which again we are in some respects losing slowly. However it remains important.

For instance, I've got a young lad training with me gaining work experience. Although the production company have agreed for him to be there, I still inform the floor manager and ask their permission for him to be there. All too often while I've been in studios rehearsing a scene when very senior people from management have simply walked in with a group of guests! You can feel the artistes are uncomfortable. They don't know

who they are. That sort of thing is appalling. Once you've learnt the ropes the rest comes more easily.

Being freelance

Survival as a freelance means not taking the easy way out. For instance, I took 14 camera units to Borneo to shoot *Survivor*, all basically single camera units. Each day, however, we had to shoot a multi-camera set-up so the plan was basically to hide the individual cameras where you couldn't see them.

That was the most testing thing I've had to do – and means taking chances with weather conditions and so on. I was not just stunned at how the gear held up, but was absolutely gob smacked that, by at the end of a 10-week shoot, all we lost was one lens pack. But then I was helped by having a team of assistants who were just brilliant.

While from a health and safety point of view, I agree our hands are tied I must admit to taking the most difficult route when actually operating a camera. People always have a go at me because of this. Okay, so I will move half an inch to get a better eyeline, I'm sorry, but I'll also move sets and props – because that's what we're there to do. I have a reputation because I'll go that one step further.

'Go for it' is always the best advice

Martin Baker had a good reputation while at London Weekend and we did three projects there, on all of which I was his senior cameraman. His biggest compliment was to tell me: "There are several people like yourself who will always give you a 110 per cent." To me, I am still just doing what I am paid to do.

Even if I do a successful recce for a job, I will always ring up the director later and say: "I've just had an idea, why don't we put the …" It's not trying to clever, just doing your job and I get so much out of it.

When I did the *Royal Variety Show* for Martin in 1999, cranes were not allowed because they were too distracting for the Royal family – perhaps because the show was so poor they would end up watching the crane swinging around instead!

Anyway I suggested we put a crane in there, even though Nigel Lythgoe, the other producer, said: "They won't allow it". My idea, however, was to put it on the stage. Everyone thought I was mad, but we put it backstage,

and got the most amazing shots. All of a sudden you got this reverse angle. It was only a small jib, but it looked brilliant. And this was all because on the way home I had been thinking 'they haven't done it for years' so spoke to Gavin the director who said: "Let's do it!"

I honestly believe if you think there's a shot to be had, you've got to go for it. There's no point in not doing so. And despite the odd exceptions, most people appreciate that. After all, we can all take the easy way can't we?

Know your sport for the super shots

The great difference about shooting sport is that it's live: it's happening in front of you, is not rehearsed – and certainly not like shooting an opera. There's nothing planned about it. Remember you're in a fixed position, and while obviously they do use cranes and Steadicams, generally the main camera is fixed, which means making the most of the position you are in.

Thanks to Sky Sport it's now rather like a machine you just switch on. When I used to cover football I made a name for myself on camera three – the 'personality' camera – mainly because I was a football fan and understood the game. Knowing the players, too, is half the battle.

These days it's been so diluted that every camera has a much simpler role in among, for instance, 24 cameras. Even with 25/26 cameras on it, the director of a huge event like the World Cup Final will probably only actually direct four cameras. This is because they are the main cameras: camera one is the one you can't do without for the wide shot, two and three are the close up cameras. All the other cameras are re-play cameras anyway, so as a cameraman – particularly on cameras two and three – will just have to use his initiative if an incident happens in front of him.

All this means knowing when to crash in for a close-up, or which close-up to go for; there's a sort of pattern to it really. If there has been a tackle you will find that the two cameramen will come to an arrangement and, as there is a goody and a baddy, one of them will go with the bloke who is lying on the deck and the other one will go for whoever has kicked him. So if the commentator decides that it is a bad tackle, the first person you want to see is the bloke who has made the tackle. If the commentator is saying it's a dive, we will want to see he bloke who pretended to fall over, that sort of thing.

With sport you have to have your wits about you all the time. This means listening closely to the commentator because he is, in a way, the director. It is what he is seeing and how you interpret what he is seeing that defines the cameraman's role. You are capturing that one moment in time, even if it is being recorded you are doing it live. You cannot get them to do it again.

Teamwork, oddly, suffers with sport
Some cameramen are very good at rugby, rugby league in particular, which is a sport I know nothing about. In that respect, I suppose, specialists are needed within most sports – those, I would argue, who understand roughly what is going on. If I were a director that is certainly how I would want to crew it.

I'd hate to pigeonhole people and say I want a football crew, but there are certain guys out there who are fantastic, that know football, that know rugby. Likewise there are probably folk who do basketball.

Motor racing is another sport I have done, but, once again, requires listening to the commentator as is not always the lead car that is important. The story could be the battle between cars six and seven.

It's a bit like golf, one of the few sports I have not done a lot of, but the guys who do it all the time know the personalities and don't have to guess what club a particular golfer should use. I have just worked on a documentary on Peter Allis about commentating, in which he described how the original BBC golf commentator on radio obviously got some binoculars for a commentary in which he reported: "Oh yes, he has got his five iron out, he is going to use a five iron to get him onto the green." When challenged later in the club-house about how he knew it was a five iron, he replied: "Because I told you so!" Who is going to question that?

What is interesting is that those who do sport are not so much a team as in a studio; they are all individual players which is slightly bizarre seeing that they are involved in such a team thing. I have even heard stories of cameramen who go in the VIP café and say: "I had a better replay than he did on the 18-yarder than he did behind the goal, while he used such and such a camera . . ." My view is, get a life, the money's the same!

18 JOANNA LUMLEY – Actress

> *My favourite type of cameraman is the one who offers his own solutions, who knows the script and can interpret the mood of the scene. Friendliness, humour and patience comes into it too – along with the hands of a wizard. He must be fit, in the old-fashioned sense of the word. In the new sense too, if possible.*

Joanna Lumley in 'Sapphire and Steel'
Photo: Rex Features

While actress Joanna Lumley is now best known for playing the champagne swilling fashionista Patsy in *Absolutely Fabulous*, her career has been a catalogue of charismatic glamour girls through the very best of British television and film making. She played a Bond girl in *On Her Majesty's Secret Service,* Purdey in *The New Avengers* and Sapphire in *Sapphire and Steel* which is where I met and worked with her.

After a long day in the studio it was usual for the camera crew to retire to the bar for a 'swift half' before going home, the banter was all about how we'd done through the day, the highs and lows of the production. After successfully embarrassing the director into buying a round we were usually on our own and Joanna was one of the very few actresses who would join us and was always very welcome. She was delightful to chat to and we all felt pleased that she chose to do this. *Sapphire and Steel* was a somewhat bewildering production for all of us to work on and Joanna's easy company made a great end to a studio day.

Why close contact with the camera has paid off for a popular British actress – 'It makes all the difference between a masterpiece and a film...'

Joanna Lumley believes a performer's duty is to work in harmony with the guy behind the lens: 'Endeavour to do your best for him and he won't let you down ...'

From day one, I've always tried to suck up to the cameraman – first of all because I never knew where the DOP was, and now to check to see if, between us, we've got it right. After all, the cameramen's role is massively important; they make the difference between a masterpiece and a film . . .

I try to make sure I keep in close contact with the cameraman throughout the shoot. They may have your name glued to the side of the camera to remind them who you are: this is good manners on their part. In turn, your duty is to know his name, and to greet him as soon as you arrive on set. Endeavour to do your best for him and he won't let you down: expect the best from him and if you have earned it you'll have it.

My favourite type of cameraman is the one who offers his own solutions, who knows the script and can interpret the mood of the scene. Friendliness, humour and patience comes into it too – along with the hands of a wizard. He must be fit, in the old-fashioned sense of the word. In the new sense too, if possible.

I find it's all a matter of give and take; if a performer asks to rehearse a complicated move it's great if the cameraman finds time to run through it with you, especially if he can tell you what lens he's using and where the focus difficulties are, etc. The best are those who respect the director, are sympathetic to the actors, and loved by his team. The worst are those who are frankly snobbish – having just come off a superior film with huge stars – or are dismissive, incompetent and blame it on others. Others are just lazy or uncommunicative.

Changing your performance to accommodate a cameraman's wishes on a shot is easy-peasy. Filming is a team effort, and the closer the team is the better the outcome will be. I can always find a way of acceding to the wishes of the cameraman; after all, they have to do the same for me. I've always been lucky with the cameramen I've worked with – including Jeremy when we worked on *Sapphire and Steel* with David McCallum.

As science fiction, the end result was brilliant. What fun we had all those years ago! Stacks of blue screen and, "Steel! I think I'm getting something . . ." In a way it was the forerunner of the *X-Files*.

The funniest memory I have was when John Schlesinger farted because he was laughing so much directing me in the film of *Cold Comfort Farm*. No-one said anything as the camera was still turning, but gradually the dolly began to wobble and the whole thing broke down into hysterical laughter as the cameraman slid off his seat crying with mirth!

106 Through the Viewfinder

19 DAVE FOSTER – Cameraman & Director

> *My top tip for success as a cameraman is a feeling of involvement with the actors, in that if you are moving in a group, you find yourself a position that contains it. You're not just sitting there and watching them and framing it.*

Dave Foster

Dave Foster was one of four senior cameramen when I joined the department and was very enthusiastic about what he did with a camera. I well remember tracking him on a *Connie Francis* show at Wood Green. I drove the Mole crane and it was not an easy rehearsal with many changes so although I had my notes for reference there was also a lot to remember for the live transmission. Somehow it went well and Dave was generous enough to be full of praise for his crane crew in spite of what had been a difficult day for all of us.

He moved on to directing not only classic programmes such as *Sapphire and Steel;* he also directed ATV's last full OB which was the British Grand Prix Formula One race from Brands Hatch. On the pre-race day I had a go on a camera on a fast part of the course and found out just how difficult it was to maintain a correct frame of an F1 car at speed. Fortunately I was allotted a camera on a rostrum overlooking the pits for the actual race. Champion driver Graham Hill came up to be interviewed before the start but didn't complete the race as his Lotus-Ford broke a half-shaft.

In Nottingham when Dave directed, I was a lighting director and found out just how aware he was of the problems confronting me on the *Murphy's Mob* series. On a location night shoot I had to light a house on a housing estate of which the interior was in the studio. I managed to get the sodium street lighting to match for the doorway shots which pleased and surprised him – me too.

Dave is now involved with his local community and still shoots video – although with his own camera now.

It was 1946, television had restarted and I had just left school. So I phoned the BBC only to be told they had stopped taking junior trainees and to come back when I was 21. So, after National Service, I applied again, and went for a Board only to discover it was for radio! But, being a brash young man, I told them: "I don't want to go into radio, I want to go into television!" Somewhat dumbfounded, being radio people themselves, they agreed, arranged for me to come back in a fortnight's time – and I became a trainee technical assistant on Colin Clew's crew.

I started work as a cameraman in 1952, turning to directing in 1967. Producing came in almost as a sideline – simply because I loved working out budgets, even devising a graph to help me keep a tight rein on expenditure. It was all quite simple: I drew a straight line over the entire period and after the first few weeks when you'd spent everything on sets on so on, and with the line inevitably way out, you made sure that over the next 12 episodes you finished back on budget.

My hardest decision in television was probably leaving the BBC for commercial television, especially as we didn't know then if it was going to be a bust or not. But if I had stayed in the BBC I doubt whether I would have had the chance to direct. I'd got the wrong background, I was a sort of grammar school oik.

A camera's for film, not the stage

The drama director Quentin Lawrence probably had the greatest impact on my career. He was responsible, after all, for using television cameras in the same way as with film. The tendency then was for a lot of theatre directors to go into television and simply see a shot as a box containing actors. Quentin Lawrence, however, tried to arrange everything as one whole picture. He was very exact.

The most frustrating production funnily enough again involved theatre directors. It was a play, and one of them, during a particularly moving

performance, arranged it so that the actress giving it was facing into a fireplace. There was no way you could see anything more than her ear – and I nearly had a row about that. It was not that it was avant garde for the time, he just hadn't planned it very well. It reminded me of what Quentin said about matching over shoulder shots, namely: "If you take the line across the mouth of the set and put your actors facing across the arrow of that line, you can get it." That is what this chap hadn't done. He got one facing out of the set and one facing in; no way could you get anything but the back of the head.

Angle yourself to get the best shot
What I liked most about being a cameraman was the fun of it all. I used to do a bit of painting and loved making shapes and pictures. I think that helps. Though you should do as you are told most of the time, do try to contribute something. You can, of course, just take a shot – CU Fred, point the camera on Fred, etc – but at least try to get on his eyeline. Get yourself craned up, or down, to get a better angle that matches the other camera's point of view.

Alternatively arrange the background of the shot by moving the camera sideways so you obtain a more pleasing picture. Watch out, of course, that you don't get a plant growing out of somebody's head; by moving the camera six inches one way or the other, it becomes a balanced shot.

Becoming a team member was the sort of thing that appealed to me; the idea that the action was live and you were working as a part of a gang and doing the job properly. If you were doing over the shoulder, like matching two shots, you'd try and get them on the same focal length lens so the perspective's the same. A thing that still annoys me intensely is when you get one set of over-the-shoulder on a wide shot and then you get the reverse on a telephoto, and it doesn't match up.

Placing the camera correctly
To get the best out of a camera make sure it is in the right place at the right time. Somehow you get an instinct of where the shot is and by moving yourself left or right and slightly in or out, you can make the picture more agreeable.

One cameraman who joined us from outside broadcasts just stood there and from wherever he was in the studio simply pointed at the person he

was asked to shoot. We didn't think much of him – until I went to do an outside broadcast with him when I was a director. He was a wonderful outside broadcast cameraman. He would latch on to whatever the action was and adjust with it. He was no good in the studio but marvellous on outside broadcasts. A matter of horses for courses.

Let actors become part of the team

How important is ambition for a cameraman? It's not that important, providing you really want to do the job and want to make the best of it. Whether you call that ambition I don't know. When I started directing, the director of light entertainment, Francis Essex, said it was a pity cameramen always seemed eager to direct, There ought to be a way of keeping them in a job they were doing okay with in the first place! I'd done several of his variety shows as a cameraman when I applied for a director's job and I think he was sorry I wasn't going to be there to help him get his programmes together.

Top tip for success

My top tip for success as a cameraman is a feeling of involvement with the actors, in that if you are moving in a group, you find yourself a position that contains it. You're not just sitting there and watching them and framing it.

The thing that annoys me most at the moment is the zoom. Fixed lenses were fine because you had to make the shot fit the frame. But as soon as you start zooming in you just squirt and come in and out without really worrying about the size. I think people have lost the idea of using the lenses, a wide one to get deep perspective and a long lens to get the compression. Instead there is a tendency simply to just sit where you are and quickly take the shot on the zoom. This is not helped by a zoom being more difficult to handle than a camera with just a panning handle and a focus handle. This means you are so busy holding the whole caboodle, you are less inclined to move the camera to make the shot more pleasing.

While some of this is now driven by budgets and time constraints, I recall rows with one particular cameraman who, when it came to rehearse a moving shot which we had already set up, it was suddenly altogether different. I discovered he hadn't made any marks on the floor. He had set it for a wide angle lens and just left the zoom where it was, then tried to

do it in a mid range lens. Of course nothing looked the same. That is the sort of sloppiness you can get with a zoom.

To be fair, I love zooms – I simply blame those who use the zoom rather than move the camera and choose the lens to create the effect they want. With so much single camera drama now, it still bothers me that they shoot stuff in studios with one camera at a time yet have have three cameras there.

My favourite piece of camera equipment was probably the last B&W Marconi MkIV cameras we had at Wood Green. They were compact, nicely balanced and ergonomically were easy to use. They also had good viewfinders.

Sapphire and Steel *set a trend*

My proudest achievement as far as shooting a programme is concerned must be *Sapphire and Steel*. It was not just much more fun, but had a good cast too. Also we were creating specially devised effects that hadn't been done in television before. Unfortunately a new head of drama decided *Sapphire and Steel* was too flippant so things were put back in the schedule for another year.

This meant we had to lose Joanna Lumley and David McCallum for the last few episodes. In addition, the things we had in one shot which involved draping black drapes all around the studio, then doing the shot, a star background, chroma-keyed in. By the time it went out we could have gone into editing and done it with masking in five minutes!

How I helped Cliff Richard get the best from his wiggle!

I also enjoyed doing the live variety shows. You got a great buzz from an audience, especially the build up. I think *Oh Boy!* was one I enjoyed as much as anything. Director Rita Gillespie pushed the thing to its limit. Bill Brown and I would take alternate shows to try to see how many shots we could get in. It was the fastest thing going at that time and was very exciting.

I taught Cliff Richard how to stand still in close-up yet still wiggle! It was one of his first programmes on *Oh Boy!* and he doing his usual weaving about. But every time Rita wanted a close-up he was diving out of it – so I went and had a quiet word with him: "Look you're in close-up here. When that red light comes on just imagine your head is in that sort of frame".

He cottoned on quickly and as soon as he knew the shot was there, he still did his weaving act but stayed within the box. That's my great claim to fame!

One thing I was sad to see go was the BBC's *Black & White Minstrel Show*. I think it was beautifully done because it was shot on one camera and everybody moved to and fro, in and out. Now all they do is complain it was all white men blacked up, which is a shame; they don't see the very great craftsmanship and skill involved.

Cameras as part of the action
What really started television camerawork going was the live *ABC Armchair Theatre* dramas when they began using cameras in among the action. They would have a huge set and move around with the actors giving a great sense of fluidity. Great directors came from Canada, and with Ted Kotcheff and the like having come from film they used the television camera more like a film camera, even though it was multi-camera shooting. It was a most exciting use of cameras, which gradually moved to everyone else. At the time we were doing plays where we had one camera on each side of a group, picking up close-ups in a wide shot. It made a lot of difference because we hardly ever moved on those, you just got yourself into a position to find a close up and that was it.

Content counts over high definition
Now having reached 75 I have got as far as I want with making programmes, but still take an interest. Wide screen I think is good though for general purposes almost too wide. An aspect ratio and high definition is nice but unless the content in the programme is good to go with it, high definition is a waste of time. It is the content of the programme that counts more than the picture quality. I like BBC4 but I must admit I don't watch much of ITV these days which is sad as I spent most of my working life in it.

The digital quality has allowed programme makers to do things that you couldn't in the analogue days and with less frustrations with the gear. So I'm hoping they will be even more adventurous.

20 CAMERA BALANCE PAN & TILT HEADS

Near the end of my trainee period and when still 19 years old, my senior cameraman, Bill Brown, asked me quietly one day if I felt confident enough to operate a camera on a live advertising magazine show from the Hackney Empire Studio. I said "Yes please!" and so got to operate the least used camera, Camera 3, but it was a start. One of my very few shots was a pan along a line of products roughly the same size stopping at each one as the presenter talked about it, then moving on.

I had watched other cameramen struggle with focus doing this shot so took a bold approach as luckily the products were roughly the same size. I shot it using a long lens from a distance having first got all the items placed on an arc so they were equidistant to the camera. Then there was no need to alter focus so I could concentrate on getting the pans correct while listening to the voiceover. Today the concept of product type items on an equidistant arc to the camera would still hold true, even if different sizes as they can be accommodated on the zoom.

Sort out the camera

But before I could do that, I had to get the camera right. Two of the greatest aids to achieving creamy smooth camerawork on either a pedestal mounted studio camera or with a lightweight on a tripod are firstly correct balance and secondly correct setting of the head friction controls.

Some operators prefer the camera front-heavy to create a tension on the panning hand at level while others opt for a neutral balance – but whatever you prefer, get it balanced to your taste first. Then set the pan and tilt head frictions. I have seen many operators fiddle for ages with these controls trying to get both pan and tilt to their liking and without success.

The quick and easy way is to adjust pan and tilt individually to start with. Then do a series of 45 degree diagonal movements in cross patterns and you will soon find out if both frictions are in balance. If not, adjust the one you least prefer. Look through the viewfinder on the long end of the zoom to do this, with no picture you're kidding yourself. It won't take long to get the head just right for you this way.

This is also a good way to try out such equipment in showrooms and at trade shows. I came across one top-of-the-range head at a trade show which I could not get right using the method above; to use it would inhibit my courage to be bold in using the camera, I would not have been able to get past it to tell the story.

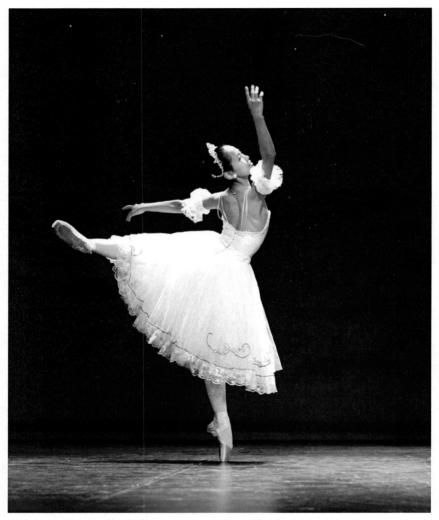

Balance: 'Cinderella' ballet in Kyoto Japan. Photo: Jeremy Hoare.

I had an experience of this not long ago when operating on a ballet, I just could not get the head right. This seemingly small niggle was a problem for the entire shoot as it inhibited me from being as free and fluid with the camera as I should have been and it showed up when I watched it back later. Whatever you're shooting, get the balance and head frictions right then concentrate on the pictures, it'll make you a better cameraman.

21 PAUL ANNETT –
Cameraman & Director/Producer

Paul Annett on the Eastenders backlot
Photo: Jeremy Hoare

As a producer/director, you have two right hands. One is your assistant director, your first AD, and the second is your cameraman, or the first is the cameraman and the second one is your AD. Each are of equal importance and all of us, however good or bad we are, rely to a huge extent on that support. You see things in one way, but they can second guess you. Which is why a cameraman's role is so extremely important.

The crew I was assigned to after I had completed my training was Ron Francis's and the first show I did with them was a *Beverley Sisters Show* at the ATV Hackney Empire Studio. During the afternoon tea break senior tracker Paul Annett told me that this crew had a different approach to life than the other three – it was far more laid back and therefore very different. How right he was!

As well as studio programmes, we were often sent out to assist on OBs when required and Paul and I were sent to assist on an interview programme at 10 Downing Street with the Prime Minister, Sir Alec Douglas-Hume. We had a scanner parked at the back and went in through the garden; it was a disappointment not to go through the famous front door. Once we'd rigged the cameras we wandered off exploring and opened a door, it was the Cabinet Room. No sooner had we taken a look than a security man found us and told us in no uncertain terms to get back where we should be or we'd be thrown out.

Paul was always going to be a director and after making the move has continued to be very successful. He currently directs and produces the BBC's flagship soap, *Eastenders* and has done so for around 10 years. His son Jamie has followed in his footsteps and also directs it.

Working on *Eastenders*, Britain's most popular soap, virtually means being responsible for the production which is shot a block at a time – tackling four shows a week in effect. This means consulting on the scripts as they come in and being aware of any problems. You must also be *au fait* with the casting – both the regulars and the newcomers – and, finally, shoot and edit four shows to go out on BBC1.

I produced the show all last year and am now directing again; prior to that I was producer/director, which means I was doing both roles, which I enjoyed. It's now come back to more or less doing the same again with the help of a script editor.

I always wanted to be in the entertainment industry, even as a child, and my family – at least one side of it – were sort of associated through the theatre. My grandmother was a very well known film extra when I was young. I still see her today, bless her, in the odd Gainsborough films which crop up on TV.

Early days

When I was 18, my parents, who socialised a lot and were quite pubby people as many were in the fifties, met a chap who, though he ran the advertising side of ATV, mentioned the company were advertising jobs for camera assistants. I knew absolutely nothing about cameras whatsoever, and had even less interest. But at least it provided a chance to get into television. I always acted as a kid and had taken part in a lot of amateur productions; I even made some television appearances professionally when I was in my early teens. I was fascinated by it all, so off I went, shooting them a line about how much I loved photography – and landed the job!

I quickly found you can apply yourself to anything and rapidly learned what to do. It's really not that hard, more basic common sense – and there are an awful lot of very good people around to help. If you watch the good ones you always learn. And so I became moderately successful

– well as a tracker, let's face it, for a longish time before becoming a sort of junior cameraman. I knew in my heart, however, that wasn't where I really wanted to go.

But I was in television and surrounded at all levels by actors, producers, writers, set designers and directors of all sorts of things. I was very keen on set designing at the time so it became a bit of a toss-up whether I should direct or design. I then realised I was severely colour blind – something which I never told anybody even after I had started directing. Fortunately I'm good on tonal values. When I have costume or set meetings I can give an accurate description, even though I can get confused over the colours. It doesn't really worry me at this stage I have done pretty well with this encumbrance for many years!

Jack Benny helped me take off
After several false starts, I finally became the promotions director at ATV, and what a wonderful opportunity it gave me for a year – I made sure of that! I think I spent the entire budget for filming in one year on what should have stretched for about four. The poor soul that followed me probably had nothing left to spend at all! But this was the late sixties, an exciting time with all the big American stars over here. The first film interview I did was shot on 35mm, which is a big camera, at the Dorchester Hotel with the legendary Jack Benny. There we were, with this enormous piece of equipment, in Jack Benny's suite. He took one look at it and said: "What's that? Back home we have these little tiny things, and you have brought this thing, I'm not doing a feature you know!" He was just a very dear droll man, and that's how I started.

During my year as promotion director I made a lot of films, including a terrific one with that wonderful singer Dickie Valentine. It all got noticed and I was determined it should act as my CV. The big break came when one of the producers at ATV, Josephine Douglas, and I, along with my ex-wife went to a New Year's Eve party. Josephine's husband Christopher Doll was producing a film about the making of the movie the *Battle of Britain* financed by United Artists – who had suddenly realised America was not actually in the war at the time and nobody in America would care, or know, about it. So with $17million invested in it, our film was suddenly quite important. Christopher saw my films and hired me and the next week, more or less, I was off. For a year-and-a-half I made

the documentary, working alongside the likes of Freddy Young, a great cinematographer, on one of the last great big budget feature films of the sixties. Then it was back to ATV Elstree to direct a series called *Fraud Squad* – my very first show which became number one in the ratings. That was just an extraordinary buzz.

Some iconic programmes

I have certainly been privileged to have been behind a lot of iconic programmes. *Poldark* was a terrific historical series for the BBC; considering I was really an ITV kid – it's odd that most of my important work has been for them. Then there was *Secret Army* about the lives of a group of Belgian resistance members in World War Two, a series I also wrote for, and I loved doing that. I also began *Sherlock Holmes* for Granada, directing many episodes. I enjoyed this very much, especially working with actor Jeremy Brett who was an extraordinary man. These helped set the scene for the future – and I just love doing *Eastenders*. Okay it's a soap, but by reaching so many millions of viewers it means your work is actually being appreciated, or not appreciated, by an enormous audience. People talk to you about it all the time when they discover you do it. They also ask why don't you do this or what did you do that for – for a lot of people the characters are that real.

Get input from those around you

As a producer/director, you have two right hands. One is your assistant director, your first AD, and the second is your cameraman, or the first is the cameraman and the second one is your AD. Each is of equal importance and all of us, however good or bad we are, rely to a huge extent on that support. You see things in one way, but they can second-guess you. Which is why a cameraman's role is so extremely important.

I've been lucky enough to do some feature films where they talk about your 'cameraman' and that's the lighting guy. Now it's important to have a good relationship with the lighting man, but they are kind of distanced, and they're a bit remote. They've also got their own team, made up of their best boys, or their number one and their gaffers which is actually nothing much to do with you as a producer/director, whereas the cameraman has to be there all the time. You 'look' through his viewfinder, he is your eyes.

Long before we had video assist, and particularly with filming when you

didn't have monitors, as a cameraman and operator myself, I used to watch the film cameraman. I'd look at the beginning of a shot which I'd set up, and I'd look at how he had ended it, and I'd just watch him throughout the shooting of this developing shot, as it were, together with watching the artistes. You had to split your vision between the two things so that you know it started off right and it ended up right, but you couldn't see what was happening in the middle until you saw the rushes. Fortunately we now see the monitors and about 14 people scream when you're out of focus or there is a lens flare. So that's fine, I don't get hated so much!

When directing, especially with a soap – or anything really – I rely on my cameraman's input. I'm not saying I will necessarily use his ideas, but I am certainly not vain or stupid enough to reject them. I have pretty good ideas myself, I work everything out beforehand very carefully in my mind, and I know the effect that I want to achieve from the scene so I've got a ground-plan always to come in on. I can give that to the cameraman, some of whom are very sponge-like and will absorb it and interpret it beautifully, and that's great. I have worked with cameramen who I gave my ideas to and most of them were used, but there are others who said: "But yes, but wouldn't you like to do this as well?" and "How if we tried this?" and I've used it too. I was really excited when I looked around as I planned a sequence to know the operator was right there with me. Quite often in television nowadays you find you are talking to the actors and also describing the shots and you look around and everybody's gone for tea.

Many of the best actors, too, will offer something back. Take Francesca Annis, for instance. I did Agatha Christie's *Tommy and Tuppence* with her for London Weekend some years ago and we became great friends. Here was an actress who would happily accept direction and hopefully offer some good ideas as well. "That's wonderful and can we also do this?" she would reply. That's what I mean when I say giving something back. It can be quite draining if it's just always you and nobody gives you anything back.

The more the cameraman – who should be enthusiastic, vigilant and aware – can do that so much the better. I like my cameramen to be continually looking for shots; I was, after all, a cameraman myself for nine years, even if it was not my chosen career. Not that I am ungrateful. It means I can walk into a studio almost anywhere in the world and shoot a scene. Just by picking the script up, I know how to shoot it and how to

get an interesting effect. That's what my incredible apprenticeship gave me – the knowledge and confidence. And because I'd worked with actors before I can combine the two.

Needs of a cameraman

A good cameraman should also be reasonably active and agile! In the early days we used to have lunchtime drinks and some of our senior cameramen used to knock back the booze a bit. How they ever got through the afternoon I don't know. Mind you some of the shows then were fairly damned static. But today, because I am pretty demanding, I like different angles, movement development and that kind of stuff; they would never be able to do it, never. I like agile, responsive cameramen who are bang up to date with what they can do with the equipment too.

The worst type of cameraman is one that is always sitting around drinking tea and not really interested; you practically have to bark at him to attract his attention. There are still a few of those around though I can't believe they're as bad as they appear because they wouldn't be working. Some of them are just extraordinary. I will say: "That was terrible", and they will say, "Yeah!" I've had that – believe me – and they still get employed!

But even so it seems that once you get into the right little circle as a freelance cameraman you get quite a lot of work. They are often very pleasant, but they're just not very good – and very slow. If you've got a cameraman who is up to your speed, it's because you are bandying ideas. But when you turn to somebody who just smiles at you with a benign expression you can't help but think; 'I haven't got through to you at all'.

Even with a soap the choice of crews is limited. There are about three, of which the senior ones are excellent. But if you ask for those you prefer you are not always guaranteed a particularly uniform crew. You may have someone good at the top and maybe the same with number two, but then it can rapidly tail away.

I'm not, of course, vain enough to think it's all down to me. Ultimately, it relies on teamwork to hold it all together, shoot it and, most importantly these days, deliver it on time. The costumes, make-up, design, wigs, all come into it; so, too, playing a very important role, is the soundman, an area that I feel we're sadly lacking in. There are good ones but I've still to find a really excellent one who's going to be interested – but, let's face it,

they sometimes seem on another planet. They always were and probably always will be!

Yet sound is vital, you need to hear the words after all, and sometimes when you go into editing you wonder 'where the hell was the microphone when we were recording this?' It's the sound crew's responsibility, but this doesn't stop my editor complaining the sound is completely hopeless. This means laying the sound over since you don't have the luxury of post syncing, we have to grab takes and literally mouth fit the words, which you couldn't do before.

Women work in a different way

Though there are plenty of women coming into the industry as camera people, I find they work in a completely different way. I don't know whether it's an emotional thing or what, it's not that they are all terrible – they're certainly not – but there's a different feel to their work. Maybe I have been doing it so long, or too long, but I'm used to men being cameramen. They've obviously got to learn because so many women want to work in television. Often with a documentary not only is the solo camera a woman, but it's produced and directed by a woman as well. Let's face it women are taking over television, if they haven't already. There's no question about it, and many of my colleagues feel the same way. This includes the technical side, though curiously you don't find many female sound people. I don't know why that is, but I've noticed there are more and more girls becoming camera operators – yet it's quite a tough job. You've got to be quite strong. We used to lug huge pedestals around, and while they're not quite as heavy now they're not that much lighter either. Maybe having female operators, shooting, directing and everything works well with documentaries. They all become very emotionally involved with one another – perhaps that's what it is. But with regular drama, when you've just got to knock it out, I'm not so sure. There are exceptions of course. Maybe it's just a case of gaining more experience.

22 HELEN KINGSBURY – Camerawoman

> To be a successful as a camera operator, you should appreciate how very lucky you are. It's fun, creative and it's physical. It's a good all round job, and not many people get the chance to do something they really love.

Helen Kingsbury
Photo: Jeremy Hoare

Helen Kingsbury was a regular visitor to the studio long before joining the camera department as she worked for her father's very successful prompting company, Portaprompt. She operated prompters on a variety of programmes where a one was needed when the presenter or performer did not know the script. With the turnover of programmes at the time, she visited often and invariably sat with a delighted camera crew during breaks as she was very sociable.

When Helen came into the camera department I was pleased as I thought it would broaden things out having a female in a crew, which it did in spite of some objections from a couple of rather bewildered members. She proved herself worthy of her job because she had to, but then she wasn't alone there as everybody had to, the fact she was female made absolutely no difference in that sense. If she had been awful as a camera assistant, it would have been hard to have thrown her out as it might have been construed as sexist but the management would have got rid of her nonetheless. The camera department had frighteningly high standards and people were taken on their merits, no guarantees, and no tribunals afterwards, they didn't exist. Helen passed her initial phase and became a respected member of the Camera Department which was good for all of us.

After a while in the camera department in Nottingham, Helen got married and had children so returned to Portaprompt, but this time as Managing Director.

The Guild of Television Cameramen held a poll amongst members on what female camera operators should be called and whether the name then be changed to reflect this. But they themselves have no problem with it so it has stayed the same.

Being a female in a man's world is no deterrent when a will to succeed lies within a camera grasp . . .

Helen Kingsbury tells how an early love of camerawork took her from helping out at her father's firm to joining a sceptical crew to become just one of the boys!

I chose my parents wisely! They not only met at Pye TV in Cambridge but, after working first at EMI on cameras, my father set up his own business making caption roller machines.

The venture grew so big that the product could be seen in studios worldwide. Later, in the seventies, when Autocue also started making caption roller machines, my father got his own back by starting Portaprompt, making prompting machines for presenters. It was then, after working for him as a schoolgirl in the summer holidays – unpaid, of course – that I joined as an operator.

For a lot of the time at Portaprompt I worked in studios where I looked around and thought, 'Ah, cameras, that's the sort of thing I would like to do'. I had a reasonably artistic eye so chatted with the cameramen who allowed me to play with, and eventually operate, the cameras in rehearsals while they used my prompt machine.

That is basically how my career took off, along with a chat with the head of cameras at ATV, Reg Clowes, in the bar. A couple of months later I had a call from him – and, after some initial chit-chat, I realised he had offered me a job! I started as a trainee at ATV Elstree in August 1982.

Initial ructions quickly forgotten

Apparently this caused ructions, with one senior cameraman saying to Reg: "Look, I don't know how to deal with a woman on the crew." Some others later confessed they were also against me joining.

Being a lone female I felt it was good for me and for the people I was working with. I was very happy in a man's world talking about sport or whatever; likewise the chaps became grateful to have somebody they could talk to about cooking and more feminine things. Before that they always had to be slightly posturing, in a mannish sort of way.

At first I felt I shouldn't be carrying a handbag. So I carried everything in my pockets. The trouble was that come the evenings I used to leave

my handbag behind in pubs and other places because I was so used to not having one. In the end I thought there wasn't much point, so I started carrying one at work. I also used to dress in quite a masculine way, but I changed that as well, nobody minded. I think once I had established myself I could become more of a female once again.

Some of the guys would even unburden their personal problems, probably because I was the only female that they came into contact with on a daily basis. I used to go shopping for clothes with them as well. I was, and looked, sometimes like a Mother Hen. After all, I was a couple of years older so naturally I felt a bit motherly towards them.

Working with a director

As for the relationship with the director you are there to do his bidding – and quite reasonably so. Sound people always thought they were important – and again rightly so. But a cameraman or woman appeared to be even more so at the time, which meant that though the director had made a shot list, in his mind he still allowed for some latitude. This gave you the chance to say what you felt was a better shot. And they would take it if it was possible – so the bond was quite considerable.

Ambition counts

Ambition for a camera operator is as important as in any job. There is not necessarily a career structure but it should be everybody's aim to get better and better, and camerawork is something you learn more about each day.

Because I had worked in television before, I knew I was going to join a department full of characters. I wish now I had known a bit more about the difference between drama camerawork and the stuff that I had worked on before, basically as a prompter on comedy or game shows where people were speaking to camera. So drama was a new world for me.

To be a successful as a camera operator, you should appreciate how very lucky you are. It's fun, creative and it's physical. It's a good all round job, and not many people get the chance to do something they really love.

I left the camera department after six years when I had my babies, probably the hardest decision I took – if there was one during what was an enjoyable and fun time. But in those days it would have been difficult to have carried on even on a part-time basis; in fact part-time didn't exist.

I went back to Portaprompt when my parents, who were considering retiring, brought my brother and I back into the business. I am now managing director and my brother chairman. I suppose I'm also financial director as I look after the accounts, a role I took on about ten years ago.

That great camera again, the EMI 2001
Looking back, I would, like many others, opt for the EMI 2001 as my favourite piece of camera equipment. You could simply open the side and could do things to it; it was part of the camera department rather than the engineering department.

Also, with all the heavy glass lens inside it, you didn't need all that inertia for throwing around a camera with a great big piece of glass on the front. Even nowadays, when you have these tiny little things at the back, you still have those bloody great lenses. They're fine on OB's but in a studio, I'm pretty certain I'd be going round in circles along with the momentum.

The camera department
I particularly liked the crew system – especially when we moved up to Nottingham. At Elstree you were always in awe of these characters. These were very, very skilled people, and it was a very structured hierarchy in those days.

But in Nottingham there were around 12 of us, all more or less the same age, who had not just moved up, but were great friends, and have remained so ever since. That part of it doesn't exist any more unfortunately; there is no crew system anywhere. I was glad I was there at that time. It was fantastic.

Teamwork, still a priority
You still have to work with everyone. Funnily enough even freelancers have to be mellower and certainly fit in as team players. They haven't got jobs for life, and if they're obstructive they won't get used or employed again. So, in some ways, people have to be even better team players.

The difference is that in the past the job involved a certain discipline. You were obliged to do your best for the sake of your colleagues. The crew system was strong because you were loyal to colleagues, some of

whom you didn't get on so well with. Referring to the many characters about then is almost a cliché nowadays; those same characters wouldn't be able to blossom in quite the same way now.

The role of the cameraman (or camerawoman) today
The only cameramen I tend to see nowadays are on outside broadcasts, often a sporting event, so it's pointing. I'm sure a lot of drama is done on single camera now, so we rather churn it out, if that's the right expression.

However, I do meet cameramen, not much younger than me, who have never worked in a studio, never worked in a multi-camera way at all, and never touched a pedestal. Yet these are top camera people, at least they say they are!

23 PUT DOWNS AND ANTHONY NEWLEY

I was still a trainee tracker when scheduled to work with a film unit for a day at our ATV Wood Green studio on the Anthony Newley show, *The Strange World of Gurney Slade*. Being largely a location production it was shot on 16mm film; the studio sequences from Wood Green used a blimped Arri BL mounted onto the manual Vinten Pathfinder dolly, which normally had a Pye television camera on it. As the sole tracker I was very much an outsider as they were far superior 'film' people (or so they thought) and I was a merely a 'telly' person. They made it clear from the start that I was being tolerated.

One shot involved a track-in from Long Shot to Mid Shot. We set it up, rehearsed it and I put my marks on the floor for the start and stop points then we went for a take. "Camera! Action!" I pushed the Pathfinder in on cue and timed it correctly so I ended on the right part of Newley's dialogue although I was about an inch to the right of my mark but directly alongside it, normal and acceptable in television. A second after getting to the stop mark, the camera operator shouted "Cut, no good!" stopping Newley mid-sentence.

The cameraman turned round and without looking at the floor said to me, "You're off the mark, we'll have to do it again!" He was actually right but this was normal because unlike film, television hardly ever uses tracks or rails (which would guarantee a set re-position) so I mumbled something approximating an apology and he said in a flamboyant Prima Donna manner, "Okay then, I'll just have to unlock the pan if that's the best you can do!"

That made me silently furious because no television cameraman to my knowledge before and subsequently since has ever locked the head controls where a mis-frame could occur. It was and is normal for a cameraman to make small adjustments; actors are not always good at hitting marks, so compensation in framing is often needed.

The only occasions I used to lock the tilt as a cameraman was before starting a tracking shot either up or down a corridor on a programme like *General Hospital* which had many scenes set in them. I would get to know

Anthony Newley as Gurney Slade. Photo: Rex Features.

the dialogue so that when the actor was about to move I started tracking and once rolling would then unlock the head to regain full control. This brief locking ensured that the camera would not jerk either up or down as a mis-frame when the initial pull happened, I then locked it back just before the move ended to avoid a jolt.

On *Gurney Slade*, we did another take and I hit the mark exactly but the operator said nothing to me. We moved on to the next set-up but at the end of the day's shoot, I slunk out of the studio and went home more than a little upset. It could have put me off for life as I was still an immature trainee and probably over-reacted as one does at that age.

A lesson learned and not forgotten

But it did have a plus side as later when a cameraman with a trainee alongside the pedestal assisting me, I would always let them know what I thought of their performance but also made sure that I never undermined their confidence as the film cameraman had so nearly done to me. Never forget that this industry runs on inherent skills and often leaps of faith, so the truly creative people will always rise to the top no matter what put-downs have been showered on them along the way. Also remember to be nice to people on the way up, you may meet them again on the way down.

Thankfully, after *Gurney Slade* I found out that not all film camera operators were the same. I worked some time later with the excellent DoP Frank Watts on a promo shoot in a tiny studio in the basement of ATV's Great Cumberland Place office block and he was good enough to show me how a blimped 16mm Arri BL worked which more than compensated for my first experience. I thought better of film people after that.

24 JIM O'DONNELL – Cameraman

The role of the cameraman is to tell a story. If a director's got an idea of how to shoot a script, say a murder mystery, then your job is to add to that, so that the picture, the angles, makes it fulfil the script. This means it's vitally important to be a team member and even more so in multi-cameras. You should know how you fit into what's being shot, keeping an eye, if you like, on what the others are doing.

Jim O'Donnell and his cat Emmy
Photo: Jeremy Hoare

Jim O'Donnell was another one who made the move from the post room and became a camera assistant to start with before going on to become on of the country's top lighting cameramen.

Even in his early days as a cameraman, he would also try to find a better shot if possible, something he continues to do. Now he is as much as involved with lighting as operating the camera, it's the thing of being in charge of the whole picture that Jim relishes. This is no ego trip, it is what most people want to do but he has done it with great success.

Well placed to have an untrained but very keen assistant if he chooses, Jim is confident, patient and generous enough to take a gamble for the lucky ones this way and helping them to take their first steps in the business.

Today Jim lights and shoots a host of productions from children's shows to major network productions with great panache and will do so for a long time to come.

Forget working on big time productions or even with 'Mickey Mouse' studios to gain experience, it was his love of the camcorder that counted when a top cameraman bought a number of them and branched out on his own.

Jim O'Donnell recalls his own childhood dreams and working on an eleven week children's series which he describes as "bloody hard work ... and not funny, funny as such, more mildly amusing, smiling"

I was watching television at about 14 when I turned round to my Mum and Dad and said I wanted to be a cameraman. I have no idea why I said that, I haven't a clue. My fifteenth birthday was December 19, so I left that term – and by January 1st I was working!

I'm not sure who, but either my Mother or my Father had already written around to see if they could get a job for me – with ATV offering a job in the post room if I came for an interview. I went with my Mum and Dad, and got the job. Then a couple of months later, with Christmas over, I started work at ATV House in Marble Arch.

By the end of my three-and-a-half-years there I was doing call boy type work at Elstree Studios where I went for an interview for a job as a camera trainee. I didn't get this, but Alan Beal did. When another job came up about two months later it was agreed it should automatically be mine. So I joined the camera department as a trainee when I was around eighteen-and-a-half. I still can't believe I went for an interview for a job when I was only 14. It was sheer luck really; if my Mum or my Dad hadn't written one little letter . . . Bang, my whole life could have been different; I could have ended up being a dustman or whatever!

As for those who had the biggest influence on my career, I thought they were all good at their job when I was with ATV. But Bill Brown was the person who I really looked up to. He was one of the best guys there and also a really nice bloke. Obviously there were others in the camera department whose style I liked, the way they worked, the way they operated – just the way they did things. There was one other guy, Chris Martin, who I really liked working with. He had fresh ideas and really tried to do things in an energetic sort of way.

My hardest decision was leaving ATV. After all, I had worked on big productions, everything from Barbra Streisand shows to major dramas working with one of the biggest and best companies in the country – all so

different from the facility company I joined in London – Molinaire – which had two cameras in a small studio with a concrete floor because the lino floor hadn't been laid. I had no idea what I was letting myself in for; facility companies were new and no-one knew much about them except they were doing things outside the BBC and ITV. It was a big decision to go there – it was pure Mickey Mouse compared to where I had come from.

Camcorders changed my life

Oddly the one item that changed everything for me – my favourite piece of kit if you like – had nothing to do with broadcast companies. I'm talking about the camcorder, the lightweight camera, without which I would never have done what I eventually did – buy a number of them and start my own company. It has kept me employed for 25 years.

In the ATV days, you couldn't even go out with a single camera unless you had a crew. Then suddenly this small camera comes along with a recorder on the back. You're now in charge of VTR, of exposing the camera and quite possibly lighting it as well. You are doing everything. You didn't need an engineer around any more, nor a VTR man, carrying a VTR recorder. You could simply carry on doing your day job, operating the camera. Previously this would have been a four-man job.

Role of the cameraman

The role of the cameraman is to tell a story. If a director's got an idea of how to shoot a script, say a murder mystery, then your job is to add to that, so that the picture, the angles, makes it fulfil the script. This means it's vitally important to be a team member and even more so in multi-cameras. You should know how you fit into what's being shot, keeping an eye, if you like, on what the others are doing. If it's a single camera set-up, you're still a team member but you have much more control over what's going on. People rely on you a lot more for instructions and you are expected to give all the answers. You are much more of a team leader.

Your relationship with a director should, of course, be paramount. If you and the director don't get on or there is friction between you – no connection – it can be really boring and you don't get the best from a shoot. However if you click with the director you can get a great relationship and that means better pictures, better everything. If the director doesn't tell you what he wants and you can't take the story along, it just doesn't work.

Learning on the job's not enough

The only experience I have of current camera training, such as it is now, is through the people I work with. It seems a lot of them have worked in the stores with a company like Metrovideo, a facility company, which provide camera equipment. This way they help put cameras up and learn how to operate menus as well as being taught about lenses and how the equipment all goes together. But they don't have any real experience of actually filming or shooting. You then find yourself telling them things like "You don't stick two videos out of one socket because the levels all go down and we all think it's a bit dark." Yet, God Bless 'em, they want to learn, so you find yourself explaining why everything looks a bit gloomy and if you have two videos you need two different monitors.

Having said that, it at least means everybody has an equal chance of being successful, and remaining so until you retire. Unfortunately, you don't always have to be particularly talented. I see some who are talented and have never become successful. Luck plays such a big part; I see others who know bugger all doing big jobs and you wonder how the hell that person ever got there . . .!

Nothing beats a good gaffer

I would have loved to have known a bit more about lighting – which I now do a lot of – when I first started. However, if you try to do lighting and camerawork at the same time you end up spending too much time. If you have got 30 people out on a shoot with you, it maybe takes one-and-half-times longer to do something, so in the end it's not so cost effective.

What I find is, first of all I have to have a good gaffer who can watch the monitor for me and point out things when I'm shooting and lighting. Also if I've got a good assistant I will say: "Right put the camera there, I want a two shot, it's going to be low there" or "Put it over there" and walk away and start lighting it. I'll always compromise the shot for the lighting. The trouble is that, and I talk from experience here, is that quite often you end up with someone you don't want, and not totally on your side. You can say a million times: "Look there's this angle here, look, see that window? Just get a bit of that window in, it gives us a sense of light source." But when you do the take, it is not in shot; things like that, though minor, still piss me off. After all you've lit a certain way and you

want it to look like it's coming from that source or whatever – yet the cameraman is not really doing what you want him to do. If I was on that camera I'd bloody make sure that window was in shot. It might not be a perfect frame, I might have to come round a little bit, and frame up a little bit, but to me that overall picture, with the frame not being absolutely right, but with the window at least being in, adds to the actual lighting. It may not be perfect but is more pleasing than with the window not being in shot. That's why I like to light and operate.

Lighting without operating

Once on one job, shot on film, I asked if I could operate the camera, but was told: "No, we want to get an operator in." So for three months I stood behind this film camera. Not only couldn't I see what was going on, or get my hands on the camera, but couldn't see the direction it was going. So there I was looking at this video assist, thinking it's just a guide to the frame, it's not a guide to lighting! And without such responsibility you can create a load of problems.

Quite often all the director wanted was a simple shot yet this operator, who works on major feature films, would say: "Why don't I start here and do this and do that?" and I'm thinking, 'It's only a little set, for f*** sake, an ordinary set for a little location, so how the bloody hell can I light that?' I've got the proper kit but how am I going to manage? It's so difficult. Basically, he put me in a situation of following the camera, rather than lighting the scene and shooting it. While the director's saying: "That's a good idea", I'm thinking: 'Hang on, where are we going to put lights, we've got to reach some compromise here." I don't want to be stuck in a position where someone is suggesting something that is not really feasible, especially when I have to finish at 6 o'clock and there is no way you can.

Being in control is essential

I really don't like doing just lighting, though sometimes you just can't help it. For the last couple of years I have done *Peep Show* for Channel Four, in which the actors consider each other's point of view; you couldn't light and operate on that. It's absolutely impossible because the operator has to be really hot, red hot, and you sit on the iris control on the camera, but it is so difficult to light.

You're so much better off looking through the viewfinder to check if a window is in or people are getting shadowed. Lighting and operating may be harder – you never get a break because you are either shooting it, prepping the scene or lighting it – but most importantly you have control, and that should be so with the camera operator.

You have, after all, got the director's brief, you've read the script – so you have already got in your head whether you should go, perhaps, for a dark look. More than that, you are in control of the angles and the lighting. Do I enjoy it? Absolutely, because when I am not doing it I feel frustrated.

25 TRAINING AND AMBITION

Rather like anything else in life itself, to be successful as a television cameraman you need ambition; it is the driving force to whatever you do in this industry. I don't know how people exist without ambition, it focuses all I do. What must existence be to have none? I cannot even to begin to imagine life without it.

I started at the very bottom in television during the mid fifties as a post boy at ATV in Kingsway, but it was a way in. I was late once on the early 8am shift and found to my dismay the spectacle of the great UK showbiz mogul and ATV managing director Lew Grade on his hands and knees sorting his own post out from mailbags he'd emptied on the floor. "Got to get my letters boy!" came the terse admonishment through a cloud of

Jeremy Hoare instructing University of The South Pacific students during a Camera & Lighting course in Suva Fiji. Photo Chizuko Kimura.

cigar smoke, an example of how to run a television company I've never forgotten. He could have sacked me but not doing so Lew ensured I would give a lifetime's devotion; he was right.

Surviving that, at weekends I was expected to work unpaid (bus fares and meal expenses only), at the company's Wood Green and Hackney studios as a callboy, today's stage assistant or runner. This was where I learnt the reality that television is not for dreamers but people really prepared to work hard – glamorous it certainly isn't. Back then, there were only two channels, BBC and ITV. The rising strength of union power through those years ensured that a virtual closed shop existed.

Today, those who whinge about lack of opportunity should realise that there has never been an easier time to get into television. There are no barriers; with network, satellite and cable channels plus umpteen independent production companies – it must be possible for almost anyone determined enough to get into television; if they are willing to start at the bottom and be prepared to work hard.

Media courses
Should any aspiring cameraman have talent, personality and aptitude, they are assured of a rocky ride for their future. Talent invariably rises to the top no matter how hard a struggle it might be. The proliferation of television and media study courses offering a 'Television Degree' probably generates good money for people who run them, but has led to an unreasonable expectation of being welcomed with open arms in an already overcrowded industry. Pretty paper diplomas to frame and hang on a wall may impress the family and friends but it is contacts, talent and determination that are the keys to success in this business.

Skillset and NVQs
I refused to be associated with Skillset and NVQs not long after their inception by being the first out of 20 potential assessors at a meeting who mentioned the dreaded 'C' word, 'Creative'. They also took two years to decide if someone was good enough or not, a waste of time in my opinion as it is possible to determine whether someone could have the aptitude to do the work in about one minute by putting them on a camera and seeing how they react. There is no way they could get it right, but aptitude will shine through if it's there.

When you are a Cameraman

It can be tempting when operating a camera to believe you are working in a bubble, one of your own self-importance. It can seem like that and it is something most will go through; I did, and then like myself and many others, come out the other side. Those who don't emerge from this rite-of-passage will quickly achieve a reputation for being difficult to work with and selfish, and however well intentioned their motives, they are wrong and probably won't get much work. There is no room for inflated egos in today's overcrowded freelance world.

There are a lot of people who can be involved in creating the pictures that end up being transmitted, and while the cameraman is the key to that, the rest of the team are just as important; never lose sight of this fact.

The production

Firstly, and it is easily forgotten, the show's original creators, be it a prime time drama or the Olympic Games, they both indicate a path to follow that a director will ignore at his peril.

Of more immediate concern to the cameraman are those he is directly involved with, directors, producers, vision mixers, vision control engineers, lighting directors, sound department, sparks and at a remove, but always kept in mind, the VT editor.

Taking the viewpoint that there is some sort of order implying proximity, in a multi-camera studio environment the vision mixer is at the initial point of impact as to the cameraman's skills. On location, the director is closest to the work you are shooting, evaluating it for content and whether they want you on their next shoot as well.

A Vision mixer does not want to wait for a cameraman to reframe slowly if the actor's next line is a cutting point. So vision mixers become acutely aware of who is good and bad in terms of speed and framing as well as personality. A skilled vision mixer is a blessing to any production; an odd word from them over talkback while VT is running can guide a cameraman very well. Any cameraman given the chance of vision mixing should jump at the opportunity as it will give them a far better idea of overall production values.

Many cameramen aspire to be directors, and some achieve that, so if ever the chance to direct comes along then take it, you will very quickly learn that making a programme is not just about getting the best shots as

cameramen often tend to think at first; there are so many other factors that go together into making good television. The director in some ways is like a circus ringmaster, they try to keep everything going and most will do anything to ensure that happens. You can help make it a reality by your own attitude and application of talent to drive your ambition, which will make a production better.

26 CHRISTOPHER FRYMAN –
Cameraman

Forget the attitude of "Let's shoot it because maybe we'll use it", and instead think "Is this a shot we really do want?" It's more interesting, anyway to spend time getting ten really good shots rather than shooting like a madman and getting fifty shots of which many will be of no use at all.

Christopher Fryman editing on his Mac laptop. Photo: Jeremy Hoare

It was after I left the camera department and working as a lighting director that I met Christopher Fryman while visiting Japan where he lives in its most beautiful city, Kyoto. We have a lot in common and I got to know him well as his camera career had paralleled mine. While I was at ATV in the London, he started with CBC in Toronto as a copyright clearance clerk, it was a way in at least. During lunch breaks he would sit in the studios thinking just how much better the job a camerman's was than his.

After six years as a cameraman at CBC he moved into film, turning freelance in 1968. He has since lived in Australia, Papua New Guinea and Japan, not only as a cameraman but also running a successful company in Japan making programmes and commercials all over Asia as a producer, director and editor.

His proudest programme achievement was in the late 1970s when he shot a film about monkeys in the mountains of Japan for the BBC's *Life on Earth* series with David Attenborough. For this he used a 16mm mute Arri ST and a mountain climber as an assistant, not a technician. The film was a great success and Christopher has a glowing testimonial letter from David Attenborough recognising his creative input.

Having given up television, he now plays jazz trumpet very successfully in several Kyoto bands ranging from Glenn Miller to improvisation, studies classical composition and has written pieces of music. Inevitably some of his music has already found its way onto his own MySpace page and other people's productions.

A devoted cameraman, with a string of successes, takes a single-minded attitude to producing documentaries in a digital age.

Christopher Fryman believes that the cameraman is a leader in a sense, a kind of chief of the technical side; everyone has to follow the camera.

There's an enormous difference between working on documentaries and being in a television studio. There is only one camera to start with. And you're on your own, unlike my days of working in the studio when there was always someone around to help with a problem. But with documentary filming, there's nobody. The director doesn't know anything about it – you're the cameraman, so get on with it. This means becoming self-reliant and independent, gaining courage because you're the only one able to create the images.

Remember, too, the term documentary has a wide meaning, so the corresponding ability of a documentary cameraman must match this. You might be working on a wildlife project one day or even one week, the next on a music programme or a social issue. If you're shooting wildlife, you've got to have plenty of patience, which, I guess, applies to everything you do. Wildlife depends on what you are shooting; to film birds for instance, you have to use a hide, disguised so that they are unaware you are there. Just sitting around for a long time, simply waiting for things to happen requires a lot of patience. You can't play music, you can't really do anything - yet when something does happen, you have to react quickly without a lot of noise so as not to reveal your presence. While not an expert in wild life, I have filmed bigger things than birds – such as elephants!

Try to discover different angles
Talking of being adaptable, filming a day in the life of a Japanese businessman, or salaryman as they are called in Japan, took a different kind of patience as well as stamina. We arrived at the man's house early morning, around six, to shoot a scene of him getting dressed, having breakfast, and leaving by train for Tokyo. We actually had a longer working day than he did. We were up at five am, stayed with him all day and then went back with him after he finished work. This was after midnight so there was an awful lot of running around involved: you had to think on your feet in order to shoot images in a way the editor could cope with.

We needed to find different angles, so it appeared as if you were following someone on a train – adopting a kind of hurry up and catch it style of shooting using a handheld camera. If you're lucky enough to have an assistant who can carry stuff around have him set up a tripod when possible. Subconsciously it gives stability to the image. If you are shooting handheld there is a certain degree of movement however good you are. If however, the image becomes rock steady it has a whole different feeling for the audience.

Case out a location first

Even though a single camera is much more appropriate today, it still depends so much on what you're doing. I automatically case out a location. Once, while filming in a stockbrokers' office, the director came up with the idea of having a moving camera go through the desks and chairs, which were all over the place. It was just an office after all, and not that visually interesting. With that in mind, especially with a director you like – and hence going to co-operate with – I would listen to everything he said, filtering out things which I felt were unrelated.

But there are pitfalls as my office story proved. I was a pretty good handheld cameraman, in fact a lot of people said that I was so good you wouldn't know it was handheld. However I remember being very surprised hitting a chair while walking backwards. I knew it shouldn't be there because I'd automatically checked out those kind of obstacles, even making a note of any big things I might bump into. In this instance I had pushed an empty chair towards the desk so it was out of my way. What I didn't realise was that somebody had come along and moved it!

Feel for a subject, a snapshot's no use

Architecture likewise, takes another kind of patience. I take time just looking at a building or a structure, whatever it is, before shooting. Okay, so it's a building and doesn't go anywhere, but I like the angles, not just the camera ones but the lighting as well – the angle of the sun perhaps – so very quickly you get some instinctive understanding of what the building is all about. Maybe I'll think about taking what I call abstract shots, the design of the side of the building, or a portion of it, even some part that, in its own way, becomes a composition. This helps convey not a snapshot picture but images that bring some feeling to a building or structure. I think

it was easier in days of film because it was more relaxed. Then there's patience with yourself ... I tend to run around very quickly doing lots of things. But when it comes to serious shooting I want to know what I'm shooting, not just put the camera up and film. I need to have some idea in my head first. If it's a documentary you have to follow what is going on. You don't really have control a lot of the time.

In the old days – about 30 years ago – you might have been allocated more time. But not today, people don't have that luxury. I remember having two- to three-week shoots: now they want to achieve the same in two days because of money really, in which case I don't think it's improved anything. The habit now seems to be to capture images as quickly as possible. This began when video was a novelty, leading to the notion that as it was so cheap you didn't have to think about it in the same way as with film. "Let's shoot this, let's shoot that," was the cry, "Maybe we're not going to use it but least shoot it anyway, the editor will fix it later."

It's not a studied approach. After a while I got fed up with it. It didn't provide time to look around and think about where I was. I think the expression 'wallpaper shooting' stemmed from that kind of shooting.

Follow the discipline of film
I often long for the discipline of film – to know that every time you pushed the button it was costing real money. This meant that, unless the programme had a fantastic budget, the tendency was to think more carefully about each shot. That was the discipline of film, and a good one to develop. But now, with a shot not costing anything extra, where does this same discipline come from? It has to come from yourself or the group you're working with. I think you arrive at that stage by being quite discriminatory about what you decide to shoot. Forget the attitude of 'Let's shoot it because maybe we'll use it', and instead think, 'Is this a shot we really do want?' It's more interesting anyway to spend time getting ten really good shots rather than shooting like a madman and getting 50 shots of which many will be of no use at all.

Some say the quality of directors has plummeted because anybody can be one with video, but I still think it requires co-operation between him, or her, and the cameraman, unless the director is doing all his own camerawork. It depends on their attitude, too: it's all too easy just to push a button to correct the colour if it goes wrong. The audience is not going

to know the difference. That's how good the technology has become. But it means people get lazy.

Creativity can be lost
On multi-camera shoots, even I find that rather than trying to get four cameras set up correctly, it's now possible for computer editing software to solve the problem in post-production. I remember my assistant, who became a cameraman shooting television product commercials with 35mm film, telling me couldn't tell where his shots were used, they'd done so much modification in the computer. So what was he doing? I agree that with advertising photography the art director takes over and provides you with a brief "Shoot that!" But it hardly leaves much room for the creativity of the cameraman does it? In the past that hasn't been possible with moving pictures but it is now. Some commercials are made without even shooting anything, just using existing photographs for a 30-second commercial.

There's also a tendency nowadays for too many people to rely solely on interviews which was once rare with documentaries. Maybe talking heads are crucial, but I've always felt that somehow if an interview is used it should be edited to a few seconds, just to give a clue to whose speaking. I know a lot of people will run an interview for a long time. But it begs the question: what then is the role of a documentary cameraman?

Penny pinching can cost quality
The financial change has been enormous. When I worked, for example, with National Geographic their luxurious budgets enabled you to spend maybe three weeks in exotic spots like Thailand. It doesn't happen now. They don't have that kind of money. I don't know why, but then everything changes. The material is all going to a multitude of channels. There's just too much going on, with not enough money nowadays for people to go for.

It seems you get very little lead time to set things up, and when you arrive you start shooting as soon as you can. This means they get you out and back as fast as possible because the longer you are away the greater the cost. There are, I agree, still large budget programmes such as the BBC series *Planet Earth*. But though, in one sense, it looks as if there are even bigger productions than before, there are fewer of them. This means that in between there is less work around, and fewer medium-

budget documentaries. Basically you have the top and bottom end, with not much in the middle.

I suppose cameras generally have become lighter, smaller, and are less obtrusive, though the downside is that they can float around easier. There are so many choices too. The image quality with the small cameras is getting so good that there's really not much difference between them and the big ones. So it's partly a question of what you want to work with. The idea of being able to put small cameras in any place you want certainly paid off with the Olympics. Remote cameras, too, have had a remarkable effect with filming wild life as well as on sports and exposé-type of documentaries where secret filming is needed.

What I also like about the idea of a small camera is the ability to put it right there and just to shoot, maybe using the table instead of a tripod. And having little flip out viewfinder screens has made a huge difference. The Steadicam equipment used to have a screen, but doesn't now which means the Steadicam view itself can be simpler and easier. Like a FigRig wheel, the screen's in the camera so you don't have to worry about having an extra piece of gear.

Drama deserves more creative input

This is not so much the case with a more creative and artistic production. With sometimes three or four cameras working on a drama, each has its own possibility of shots within its own angle. I can remember checking on and off the monitor what the other cameramen were doing, so what I was doing would match in some way. If the other cameraman was doing a close-up, often you want to have the same size close-up. You could push the button and see the output of the switcher. And though you couldn't see other cameras you could see the switcher – the idea again being of the awareness of your surroundings, and of where things are.

Sometimes we had discussions about shot sizes with the other cameramen, talking about the definition of what's an extreme close-up and what's a close up, what's a medium close-up, things like that. In the black and white days there was a tendency, depending on the show, to move the fixed lens cameras to make the images more interesting. If it was a dolly shot with a wide lens it was as if the viewer was moving closer to the subject. If it was a zoom it was like bringing that up to you; it had a totally different feel and the perspective didn't change.

I remember the first time zoom lenses came in the studio everybody went: "Wow!, look at that, that's fantastic, just turn this handle and wham, we've got a close up." We were doing things deliberately like fast zooms, bam! – right in close-up to shock the audience. Or we would go the other way round by starting up really close then zoom back fast to reveal all the studio in one go. After a while, of course, we got tired of doing that.

Filming a documentary about music is not as easy as it may sound though I've filmed a symphony orchestra using just one camera – but even so it required quite a bit of thought beforehand. This was when a director from Finland Television came over with a symphony orchestra, wanting me to shoot their two-and-half-week tour in Japan. I was told I couldn't film them performing, but was free to go to rehearsals whenever I wanted. So I went up on stage among the musicians, and shot the action with a continuous moving camera. This way we could take chunks of music and use them anyway that was wanted. I couldn't find any other way to do it: if I were to chop things up it would be quite difficult for the editor, but if you try to get what they call B roll footage you can get different kinds of shots and angles. I used to spend time – aside from shooting what the director had been asking for – thinking and trying to shoot other kinds of things. This way they had something to make the editing more interesting or smoother in case the camera came up with problems.

Sometimes I think a cameraman has to think like an editor. Maybe people don't consider this very much now, but when I was younger I would come across those who would emphasise this. After all, if you can gain experience of editing so much the better; it's not so much a case of liking it but understanding another person's job. This makes life easier for everyone.

Beware the pitfalls of multi-skilling
A lot of the more simple documentaries are achieved by virtually a one-man band. It's called multi-skilling. While I don't disagree with it - it's obviously going that way – I do think the teaching methods are not quite right. You can only teach camerawork in a studio, which is comparatively simple when it comes to music or drama but not so with a documentary say on wildlife; you just have to let someone loose with a camera and learn by experience. One other way is to let them study the original footage, comparing this with the finished product, and getting an idea of how the editor had made use of the shots.

I realise that with video being so cheap the shooting ratio must be so much higher and that the original footage of a one-hour programme might be a hundred hours. Even so, for educational purposes, just use a section of it. Mind you, plenty of people need to be taught what they are looking at; it doesn't really sink in until they have filming experience themselves. You must somehow try to have an open mind – with lots of "Ah Ha" moments, until suddenly cottoning on. One basic principle that still applies is steady camera work. An awful lot of people seem to have no idea about that. That goes against production right away, unless a handheld style has been deliberately chosen.

Feel what you're filming

What you may have read in a book or been told, may intellectually sink in, but your body should share the experience as well. It's rather like putting a toe into a tub of cold water; you don't really know what it feels like until you do it! You can imagine it, but that's all. I once stood underneath a waterfall, like the ones we have in Japan, just to meditate. Five seconds was quite sufficient ... stamina, too, is important. You have to be healthy fit and alert, with a willingness to put in some effort.

Then there's concentration: I've met people who only saw what they imagine is the glamorous side of making movies. In reality, the days are long, you have to get up early in the morning and you might miss meals. I've often missed mid-day ones because there was simply no time for lunch. You have to shoot on or you wouldn't get the job done. I don't mean an organised shoot with actors, I'm talking about a documentary when you're out with a team of three or four people, sometimes more. To be fair, the directors spend out a lot on shooting in distant locations so don't want to waste time eating. I am a bit like that myself sometimes, but it does reach a point where it's all too much. Once, after a series of days without lunches, I told the director: "I'm sorry we are going to sit here another 20 minutes and allow everyone to just calm down a bit." He was okay with that. We had a big team, including the lighting people and I could see everyone was getting very tired.

The cameraman is a leader in a sense, a kind of chief of the technical side. The lighting people and the sound people all recognise the cameraman's role in that kind of situation. It's not so much that the cameraman's the leader, but that everyone else has to follow that camera. So although I've

never considered myself a particularly good leader, maybe as a cameraman
I was not too bad.

27 INTERACT WITH THE TALENT: LULU AND LET'S ROCK!

As a cameraman I enjoyed working on a series of retro music shows called *Let's Rock!* which starred Lulu, Shakin' Stevens, a whole host of talented wannabes, and some great looking dancers. Produced by Richard Leyland and directed by Ken O'Neill they were recorded in Studio D at ATV Elstree, now BBC Elstree, and pre-sold to the American market but ended up being shown in the UK in graveyard slots which meant hardly anyone saw them go out.

On *Let's Rock!* I always operated Camera 2 on a Vinten pedestal; this was the close up camera alongside the wide-angle shot from Camera 1 mounted on a Chapman Nike crane to my left. On the first recording day, at the finish of camera rehearsal at 18.00 we had not even seen the last section but this was nothing new and we could busk it.

After supper break, recording started at 19.30 and we did well until near the wrap at 21.30 when

Lulu in 'Let's Rock!' Photo: Rex Features

Ken asked for the cameramen to show anything for the end sequence as we were running out of time, as ever. I'd noticed (it was hard not to) that Lulu had good legs, so on the only take and making sure it could not be cut out by being under the credits, I offered up a shot of Lulu's feet. When I was cut to by the vision mixer, I panned up Lulu's legs all the way to her face, in time with the music naturally, something now out of fashion.

Maybe I'd gone too far

A week later, and unusually for this type of show, all four cameramen attended an outside rehearsal in a rehearsal room. As soon as we walked in, Lulu rushed over and asked in an anxious voice: "Who did the pan up my legs?" My heart sunk and I thought I might have gone too far as she seemed serious about it. The other three cameramen each in turn said it wasn't them so I had to own up. This vivacious woman had been, and still is, a real star and household name, so fearing the worst and that she might be deeply offended, I heard myself saying, "Actually, I did that." Lulu's anxious face broke into a great smile and she roared out, "It was great! My agent told me and I saw it afterwards!" Then we both collapsed into laughter, she with the satisfaction of realising I found her legs attractive enough to do it, and me with relief that she'd liked what I'd done.

Through this we came to be friends while on this very enjoyable series and as a little conspiracy between the two of us I did the same slow pan up from her feet to her face on every show, it was our little joke. I don't think anyone else knew or even realised.

Having been fortunate enough to work with so many world famous stars through the best days at ATV Elstree, Lulu was one of the few who stand out to me as still being a normal person with her feet firmly on the ground. We all know with today's celebrity culture of those who rise up into the stratosphere of fame and let it devour them but Lulu has avoided this while still retaining a lot of the same personality and charm as when I first saw and heard her singing her original and greatest hit, '*Shout!*'

A year or so later, I was walking through Hampstead on a miserable cold wet day when from a line of stationery traffic I heard a horn sound. I looked up and saw a Rolls Royce and there was Lulu driving, frantically waving at me so I went over. She lowered the passenger window and we had a brief chat about what we'd both been doing until the lights changed and she had to move on.

Do talk to people in front of your camera, they usually appreciate it. Developing a good working relationship and being friendly with Lulu helped make me a better cameraman on that series than I might have been. I had a direct involvement with the leading star, but it really is very important to interact with performers and other people in front of the camera, no matter who they are. You might like them, you might not, but as a professional cameraman you owe it to the production that is employing you.

28 TONY FERRIS – Production Designer

The best type of cameraman is one who is calm, listens, explains and who searches – and finds – the shots the designer has given him to play with. To be fair, the vast majority do just that and see the shots at the set model stage. I honestly can't think of a cameraman that I haven't had a good working relationship with. It must be something to do with the fact we're visualisers.

Tony Ferris
Photo: Jeremy Hoare

Production design has always been an important yet relatively unsung part of television. Traditionally it has involved creating sets for actors and performers to work in front of. But ever increasingly it has been shooting on location and making that work within the context of the story whether drama or entertainment.

I always liked working with good designers and Tony Ferris is someone I had a lot of involvement with when I was a lighting director. We were both on *The Upper Hand* sitcom series and set a visual style which helped make it a top-rated ITV show. He stood his ground when he thought his design was being compromised, for instance with ceilings on sets for this series. They looked good in the wide shots but made it impossible for me to put lights in places I needed them. Inevitably a compromise was reached, but that is true for a lot of television.

Together we also did a series of 30-minute musical programmes, *Album*, showcasing the talents of Ruby Turner and Natalie Cole amongst others. This was successful, so when it came to planning series two we decided to overlap our responsibilities; I would design some elements and Tony would light some sections. Sadly this never happened; the stars could not be booked so we didn't get to do this, which was a pity as I think it would have been a unique way of working.

The creative springboard for a designer is everything, a 'eureka moment' can happen anytime. That has to be tempered by the budget available

– which can on some programmes be minimal. But Tony is a talented designer who always makes the best of what there is, and bring it in under budget, no mean feat.

There's no tweaking allowed when designing a set: get it right and there's nothing more rewarding says a man who took his cue from a Perry Como show.

Tony Ferris is a Production Designer who warms to cameramen: "Visual people who speak the same language and understand what a designer is on about".

I can probably blame my brother for my interest in TV! That and, after graduating from Art College with a degree in product design, and wasting four years trying to establish a design company. The idea was to develop, manufacture and retail an emergency housing system I had designed for disaster areas. However, the only disaster was the economy and my place in it.

In the meantime, my elder brother, with whom I went to Art College – both of us being good at the subject – landed a job, both through luck and talent, as an assistant designer at Thames TV. It was then the mid-seventies. He was going places and having a lot more fun. So I applied to the BBC, ATV and YTV and got an interview at all three. I was subsequently faced with a choice of either being an assistant designer at the BBC or a scenic draughtsman at ATV.

The choice was a no-brainer: ATV was a creative fun palace on a human scale while the BBC felt like 'The Ministry of Telly'. That's probably a little unfair, but that's how it struck me at the time. If I was going to get noticed quickly, ATV was the place to be. I was very lucky and within 12 weeks was upgraded to assistant designer and a couple or so years later became a designer.

The reason why had already been flickering in front of me most evenings! Television design was then an invisible art. Nobody ran any courses and, like so much in general design in those days, people assumed design just happened. Today it's high profile.

My eureka moment came when I was watching a cheesy *Perry Como Christmas Special*, a big budget production which opened with a tight shot of him walking across a huge studio floor marked out as a street plan. There were shops, houses and pavements and as he walked down the marked out streets houses started to morph, the street and window lights came on and people emerged from the buildings as snow began to fall. It blew

me away completely and made the connection that somebody actually designed and worked it all out. Talk about being slow on the uptake! I've been immensely lucky to work in a field I've loved. It's never felt like a job and while there might have been times I've looked forward to the end of a trying day I can honestly say I've never ever thought 'Thank God it's the end of the week."

It's great to be among creative people
From the start, production design always felt right. It's a great buzz being among creative people and working at speed. I like the fact that every production, no matter how similar, is different. Each time is like designing a prototype that is also the finished article and has to be right first time. Unlike many other disciplines in television, there's no tweaking allowed. It's incredibly rewarding to create a design and scale model of a set and seeing it come together in a studio a few short weeks later. It's an adrenaline rush and ego boost when artists, cameras and the rest of the crew start playing with it and throwing compliments around. I always act cool; you need to make it appear easy!

I've especially enjoyed working on sitcoms: they often require a fair number of sets so the turnaround is tight. You need to operate at speed and I like that. I like the fact the shows are in front of a live audience. Well most are alive, but some might be better described as comatose, courtesy of dreadful scripts.

Some big-time successes:
I've designed sets for some of ITV's and BBC's most successful shows like *Kiss Me Kate* with Caroline Quentin and the very long running ITV hit *The Upper Hand* which ran for nearly one hundred episodes. I also designed for the very successful ITV series *Barbara*, a tried and tested formula in that every gag was secondhand and borrowed. The viewers lapped it up and it was pulling in an audience of about eight million when ITV killed it off. They felt it didn't attract the 'right kind' of audience would you believe! I doubt they would say that today.

The productions I liked designing for the most were big scale light entertainment shows televised from some of the UK's biggest theatres. I've done venues like The Birmingham Hippodrome, The Belgrade in Coventry and The Dominion in London. The last featured the Beatles

producer George Martin on stage and his orchestra. It starred Jose Carreras singing Andrew Lloyd Webber songs: a little guy, but he can sure belt out a song! As I'm drawn more to drama these days, designing for something like *Life on Mars* or *Doctor Who* would have been huge fun. It must also have been nice, too, to work on *Hotel Babylon* but these days, as with so much on TV, only American production values really blow me away. The standard of talent available may be the same, but they have the budgets. Is this where I came in? Bring on another *Perry Como Christmas Special!*

Keep the cameraman in the picture

I've always believed it important to keep a good dialogue going with the cameraman or DoP. I'll always run set models and studio plans in front of them well in advance of planning meetings. Being visual people, who speak the same language, they'll understand what a designer is on about, but are also grounded as to technical restrictions. They'll often see the picture before the director, who might be more focused on getting a performance. That's perfectly understandable.

All of which means their contribution to the success or failure of a programme is vital. If the cameraman can't hack it, we might as well all go home. We've all seen a cameraman rescue a director, but never the other way round. In my experience cameramen are generous, which is not always the case with directors. If a cameraman sees a director struggling, they'll offer a lifeline. However, in the days of assured employment, if they detected arrogance, then the director might have ended up as dead meat. These days it's unlikely to happen. There would be a lot of biting of lips and bending of crew's ears instead. Even the best cameraman is looking to the next job.

The best type of cameraman is one who is calm, listens, explains and who searches – and finds – the shots the designer has given him to play with. To be fair, the vast majority do just that and see the shots at model stage. I honestly can't think of a cameraman that I haven't had a good working relationship with. It must be something to do with the fact we're visualisers. I can't necessarily say the same about sound, but that's another story.

My chat about blues with Tom Jones

In my very early days at ATV, I used to sneak into studio D to watch big light entertainment shows being recorded for the USA. Bill McPherson

was the designer and he always produced fantastic sets, but then I guess he had a terrific canvas to play with in those days. The best designer I've ever come across was Henry Graveney. We all acknowledged him as the master, he made it look so easy and I suspect for Henry it probably was. The story went that the BBC rejected him because he was only architect trained. Their very great loss.

The first show recording I ever watched in a studio at ATV was a big American one – and Gene Kelly was sauntering across the studio as the guest star. Not a bad career start! I also had a memorable chat about blues music with Tom Jones in the Central TV bar in Nottingham. I'd been told that he'd spent part of the day locked in his caravan while a crazed, drunken secretary banged on the door demanding sex. He kept the door locked.

29 CAMERA SET-UP

While this is not a technical book, here are just a few basic and practical things that I think are necessary for any cameraman to know about and use:

Pan & Tilt Head
Level with the bubble.
Set frictions by using a diagonal pan movement.

Tripod/legs
Set for the shot, not for comfort as some lazy operators do.

Handheld
Use the widest lens for the least wobble and try not to shake a camera around as if it's being operated by a gorilla with migraine – many sad cameramen think it's actually good and 'trendy'.

Steadicam
Although everyone should try it if offered the chance as it might be just your thing, it is a dedicated skill best left to dedicated experts.

Pedestals
Maximum camera positioning flexibility in the studio and on appropriate locations for a creative cameraman.

Remote Jibs – the way now
Huge range often making dynamic pictures in the right hands.
Can easily induce overuse by cameramen and directors, think of the viewers.

Crewed Cranes – the previous way
Good with a competent crew
Very flexible
Manpower a problem

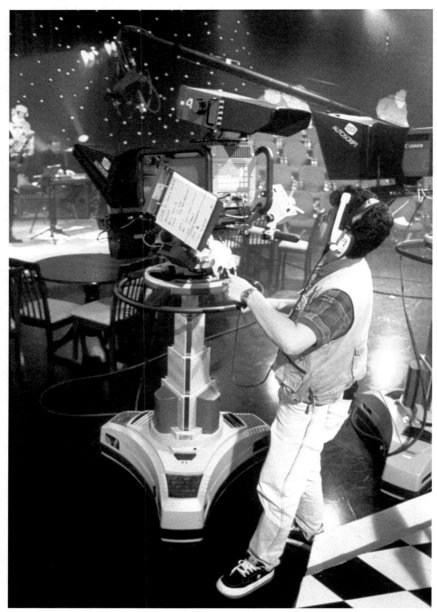

Cameraman in a studio in Kuala Lumpur Malaysia. Photo: Jeremy Hoare.

Lighting

Spend a day in any good old master art gallery, a great way to learn about lighting, composition and everything to do with picture creation. On location, augmenting the ambient light and adjusting excessive contrast can often be the best way to go.

Sound

Learn how to deal with it, it really is important.

Booms and how to deal with them, there are some still in use.

Clothing

When working with actors, don't wear things that are too bright (red in particular) as movements you make in their peripheral vision can distract them.

Do wear comfortable clothes, otherwise it can become distracting which will not improve any cameraman's performance.

That's it – the technical bits are over.

168 Through the Viewfinder

30 MARTIN CAMPBELL – Director

> To be honest, my reason for wanting to direct was that while there were some good directors at ATV a lot were bloody useless – and I thought I could do better. Commercials, which attract so many entrants nowadays, have revolutionised camerawork to a large extent, sometimes to the detriment of movies.

Martin Campbell

Martin Campbell came from New Zealand in the 1960s and was a keen assistant when he joined the Camera Department. Then, once he'd discovered his goal was to be a feature film director, he set about it in a dedicated way and first directed classic television drama such as *Edge of Darkness* for the BBC, then two James Bond films, *Goldeneye* and *Casino Royale* as well as *The Mask of Zorro*.

Of all the people I've met, Martin was always the most ambitious and that has carried him further than anyone else I know. He realised early on that having knowledge of cameras and what they could achieve was just part of the process, so bought a 16mm Bolex and started making his own films to learn more. He loaned me the camera when I had an idea to shoot a documentary in Portugal; it was not a success but I learnt a lot through doing it.

In his spare time, Martin got to know scriptwriters and also worked in drama schools to learn about actors and staging. He got me to light *The Miracle Worker* at Mountview Theatre School, which was good for me to do, although the control board at the time seemed a real hazard.

I also did some lighting for him on a 16mm B&W sequence in a church cemetery at night in winter shooting a spooky scene. I hadn't lit anything on this scale at night before and it was a real challenge with the few Pups I'd borrowed from the studio. This sequence appeared in a horror feature film being seen on a TV set by a woman on her own at night.

Setting your sights high can lead to disappointment but Martin has proved that anything in this business, absolutely anything, is possible if you are determined enough.

From map maker to James Bond and multi-million dollar budgets – not bad for a man with a mission to become a director

Martin Campbell still relies on cameramen who are like-minded and can work at speed – while lamenting the era when the BBC guys were the best.

When I joined ATV way back in 1965/66, the first James Bond film *Dr No* had already been released. It had a huge impact at the time and not for a second did I think I would end up directing them. I was just a cable wrangler – or tracker as they're now called.

Being in the film industry is certainly tough. You're dealing with studios, and the budget for my last Bond movie, *Casino Royale*, was a $150m – this is the kind of huge amount you work with. In fact they got quite a big tax rebate, I think it was $134m in the end. But with such budgets, there's a lot of pressure to deliver on time. If you can't take the heat then get out of the fire, you're finished. Though I now have a small place in Mayfair, I don't live in London any more, but in Los Angeles.

All of which is a long way from my days in television, which began when I deliberately went to work for Hunting Surveys, an aerial mapping company, knowing full well ATV's Elstree studios was just down the road. My job was creating contour maps from three-dimensional aerial photographs. Anyway, I made it clear that I was bored rigid and if anybody knew, or heard, of jobs going at the studios I would appreciate it.

By luck, my girlfriend at the time came in with the *Daily Telegraph* containing a camera assistant job vacancy. I got a hearing and by some miracle, as I had only done a bit of photography, got one of the jobs; I think there were only four or five on offer at the time. Maybe it was because the head of department Reg Clowes or someone took a liking to me.

It's all changed now. Television nowadays seems to adopt the lowest common denominator. In the eighties, when I worked for the BBC it was fantastic. You had some sort of control over programmes and there was a terrific sort of freedom. When I directed *Edge of Darkness*, I just took off for four-and-a-half-months and shot it all over England – and never once got a phone call from the BBC. Not once! I just went off, shot it then when I got back edited it. But those days have long since gone.

Cameramen should communicate

To be honest, my reason for wanting to direct was that while there were some good directors at ATV a lot were bloody useless – and I thought I could do better. What's interesting is that Brian Grant did a bit of directing, and while I don't quite know what happened to him, another, Geoff Sax, went on to do rather well too. I spoke to him while he was shooting possibly *Storm Breaker* while I was starting pre-production on *Casino Royale*; he's the only other one I know of from those early days that really made in-roads into directing.

The first and foremost thing I look for when booking a cameraman, for film or otherwise, is their lighting ability and the movies they've done. I also look for somebody who can do it reasonably fast because I want to get it done fairly quickly. I need to get on with them, too, as I know exactly where the camera should go; I work all the shots out myself to a large extent. Really it all relies on decent lighting, compatibility and speed – plus the creative input: I want suggestions, I want to hear their point of view. What you don't want is somebody who's going to argue with you all the time as you've a very specific concept in your head, and that's what matters.

It's down to the script

Though this creative process is obviously a factor you can still land up with a badly shot film but, thanks to really good characters and a strong script, it will still prove a big hit. In other words, even if it had been shot beautifully, it doesn't automatically mean it will be an even greater hit – and that's the truth of the matter. Ultimately, it's all down to the script and the story and the characters, that's really the number one; script, script and script. Photography plays an important role but I don't think any movie has really stood or fallen because of it.

I agree that with a film like *Citizen Kane* the photography was outstanding, and so was Orson Welles. But at the time it was a badly reviewed film. All the friends of William Randolph Hearst (the publishing magnate whose life it was said to mirror), and other very powerful people, made sure it got a drubbing in the press. Yet it remains one of the greatest films ever made and photographically Greg Toland was a hugely talented guy. What they got away with in the use of black and white and deep focus, using wide-angle lens, was absolutely extraordinary.

Commercials are trendsetters

Commercials, which attract so many entrants nowadays, have revolutionised camerawork to a large extent, sometimes to the detriment of movies. Jerry Bruckheimer for example shoots every movie he does like a commercial. Take *Pirates of the Caribbean* – where the story makes absolutely no sense, but the look of the film is very commercially orientated. Both commercial directors and cameramen are used.

It's the same with *CSI*. Look at the way that's photographed. It's all Jerry Bruckheimer black and blue light, with bags of back lighting, blue light, filters, and plenty of slick commercial type images. This, and the need for fast cutting, means he hires a certain kind of operator.

Personally, I've used the same cameraman for nine movies – Phil Meheaux who shot *The Long Good Friday*. He came, as a lot of these guys did, from the BBC, which had a wonderful set-up whereby they had their own camera crews and cameramen. That's all changed now because everything is freelance and based on money. I had Andrew Dunn on *Edge of Darkness*, yet another from the BBC stable of successful cameramen.

Then at ATV there was Ron Francis and Bill Brown who I remember with such affection. I remember everyone very, very clearly from that era. But then, it was one of the best times of my life.

31 RON FRANCIS – Cameraman & Director

> *Be willing and show interest in the production. This means, among things, you don't turn up late and keep people waiting, be contributive and show interest in what you are doing, I know there are a lot of boring programmes in which there's nothing to be interested in, or about, but that's no excuse for doing a bad job.*

Ron Francis
Photo: Jeremy Hoare

Ron Francis had a certain panache, and way of operating a camera, that few could match. My admiration for him grew when as a post boy I worked unpaid in the studios as a callboy during my weekends off.

One clear memory at that time was Ron operating Camera One on the Mole camera crane for the weekly peak time *Saturday Spectacular* broadcast live from the ATV Wood Green Studio. Something had gone wrong with the shot and Ron at maximum height on the Mole swore like a trooper, principally at himself but clearly audible to me some yards away. I wondered if the viewing millions heard it; probably not, as microphones were not as sensitive then, and being a true professional he would certainly have known that.

Ron was my first senior cameraman after I finished the obligatory ATV nine-month training; I was delighted to be assigned to his crew. On location for a drama about a nuclear bomb threat in London, he mounted a studio camera on an armoured car which then travelled for as far as the cable allowed, he was certainly an adventurous cameraman.

Ron mixed with the actors more than many other cameramen and was anxious to become a programme director. When he did I worked with him in that capacity too, he was both sympathetic yet very demanding of any cameraman. He went freelance and directed numerous commercial network programmes, series and soaps; *Coronation Street* was just one of many.

A move from radio into television in its early days led to a successful career as a top cameraman and eventually as a director of major networks soaps.

Ron Francis says that being willing and showing interest in the production is as relevant today as it always was. He is heavy on professionalism which means not arriving late and keeping people waiting.

I started in radio at BBC Broadcasting House in the control room on December 5, 1950, two floors below ground. Then, around late 1951, I spotted an internal advertisement for people to transfer to television so I said to my mate: "Here, why don't we apply – go into television, wear them brothel creepers and all that gear!"

Though reluctant at first, I eventually signed up and off we went to the BBC Training School at Wood Norton Hall near Evesham from where we were called back for an interview for television.

We mugged up on the television training manual – a very basic one – and the following day we were accepted. However as the course ended just after King George IV's funeral there was a query on who was going to pay our return fare, television or radio? As it happened it was radio because the last thing I did was the King's funeral from Windsor. On March 17, St. Patricks Day 1952, I went to Lime Grove. It was a completely different world, much more laidback and certainly more exciting visually. You weren't an engineer any more, which, to be honest, I never really was. You were more hands-on. I joined Colin Clews's crew as a trainee and was with him until 1955 when we were invited to join what became ATV. And that's how I got into television.

It was good working on live 90-minute plays at Lime Grove with no more than a just an interval of perhaps five or ten minutes. Hairy stuff, but brilliant training, too – a bit like doing an assault course in the services. You do the heavy stuff and then never have to do it again; it certainly helps get you towards a professional attitude that you don't quite get if you can always do a retake.

I spent 16 years as a cameraman from 1952 to 1968, ending up as a senior cameraman, some of that time working live, though by the time I came off cameras they were mostly recording.

My two true mentors

My choice of mentor must be senior cameraman Colin Clews. He was so well thought of at Lime Grove, that even with the rather strict rotational system, his crew was always being requested by particular producers. So much so, they switched things around so as to use Colin's crew.

He was the true professional, a brilliant cameraman, with a frightening live broadcast style. I not only waved him about from the back end of a crane I was operating for ages, but also got on well with him. You naturally form a very close relationship with the guy on the front who feels that movement coming from the back. You have a sort of affinity – and I used to say I could tell from the hairs on the back of Colin's head whether I was getting it right.

There was another guy I admired, Laurie Dooley, the number three in Colin's crew. I was assigned to work with him as a trainee. He'd be on a Debrie pedestal and I'd be pushing the thing around and marking up, and clearing cables. He had a very professional attitude. If there was a prop table for instance in the way of one of our camera marks for the final run, he would tell you to knock it over. "If you don't," he would say "it will be there on transmission." That sort of professional attitude was very important to me.

I never found it hard switching to Independent Television, it was such an exciting change. Also we were going as two complete crews, Colin's and Jock's, and the money was a helluva lot more! As for choosing to become a director, I kept trying for ages. It was through sheer perseverance that I succeeded. Once I put the rejection memo on the side of the camera, so people could read the damned thing. I was 40 by then!

Likes and dislikes

I can't really say I had a favourite piece of equipment or camera, though I did like working on the Mole crane – at both ends – though I've worked on big cranes as well. The Vinten motorised dollies which we used to have were alright but the Mole had a freer movement. As for cameras, they all had good and bad points. What I really liked most about being a cameraman was much more about being at the pointed end.

Being a team member in the days of the crew system was great. You had a sense of belonging, the sense of being part of a team. But when the crew system started to disintegrate – it doesn't exist at all now, of course

– there wasn't that same sort of team loyalty. Which is a pity because I think it was very important, bringing a sort of pride and some degree of competition as well. "He's got that show has he" we would say of a rival team leader. "Oh he bloody well would, wouldn't he! He's always got on with so and so hasn't he." We would console ourselves by saying "I think we're going to get the so and so show." So, yes, there was a sort of competitiveness between us in a way. Just as important was a close relationship with the director.

The system is so different now, with no real in-house training schemes as far as I know, What I do know is that my training on the job with people like Colin Clews and Laurie Dooley instilled a professional ethos with the way you behaved as a crew member as important as the way you operated.

Ambition as a cameraman
Being ambitious as a cameraman varies, depending on the individual. At one time we had a senior cameraman plus a number two, three and four with each job being defined with different rates of pay. The number four probably did seek promotion to number three and so on to the top. So there was a sense of ambition to some extent, simply by moving up another notch to eventually become a senior cameraman. Being number two was a funny situation. Somebody once said that number two was really a sort of intermediary. He was the one in touch with the rest of the crew, including the trackers, as well as being in touch with the senior cameraman almost as if the senior cameraman was an officer, separated from the crew. It was a very good grade number two; you had a sort of level, but without all the responsibility, which was rather nice. I liked being a number two but obviously also liked being a senior cameraman!

How to be a good cameraman
Be willing and show interest in the production. This is as relevant today as it always was. You are, after all, paid to do the work, and as you now realise, I'm very heavy on professionalism. This means, among things, you don't turn up late and keep people waiting; be contributive and show interest in what you are doing. I know there are a lot of boring programmes in which there's nothing to be interested in, or about, but that's no excuse for doing a bad job. By that I don't mean pretending that every show

you do is the most important one in the world; of course it's not, but it is important to demonstrate a sense of involvement to the director. He, or she, after all, is deeply involved in what to them is the most important thing in the world. So do contribute, particularly in the case of those who don't know much about the business. As a cameraman, you can contribute a lot, especially with light entertainment where it's not so scripted, simply by putting shots up and offering shots. This even applies to some extent with drama. Don't just sit there and wait to be told what to do.

Some memorable programmes

Of all the programmes or series on which I worked as a cameraman, the most exciting was a single drama, *Children Playing* in 1966. Peter Wood was directing and a lot of it was shot on location where we used a big Chapman crane, which was rather an exciting Hollywoodish thing to do.

Before starting, the producer and director went round the country researching, mainly in the Midlands, for real kids and auditioning them. They were all between the ages of nine and 14, that sort of age, and I think there were about 12 of each. They were staying down in Clapham with their teacher-cum-chaperones. It was an unusual, slightly dark, play by a well known Royal Court type playwright of the time. Cecil Clarke who ran Globe Productions was executive producer.

The kids got taken to Battersea Funfair and I'd go out with them as well, and as the senior cameraman, I got deeply involved with the production which was quite an exciting one to do. We did a shot, for instance, of a game of rounders – following somebody's feet running for 360 degrees on this great big crane. There were four guys on the arm, following the running feet. The stills we saw later showed three of them at an oblique angle lying backwards with their heels dragging in the ground to stop the thing. It was both visually and also socially exciting; the writing was damned good and there were some good actors in it too.

The one thing we used to dislike most was working on was the *Ralph Reader Gang Show*, a Boy Scout show. We all thought it a bit odd. I went to Baden Powell House once to see a rehearsal, and there were all these office types with pens in their pockets dancing and jumping about doing drag acts. It was all a bit bizarre. Latterly towards the end they used to have Girl Guides on it as well, also Rangers, real women. It was so terribly hearty and ho- ho- ho as well as being slightly dated. We'd say

"Oh, you've got the Gang Show, good luck mate!" Oh dear, oh dear. It was almost good it was so bad, unbelievable!

Working on a period drama
Such programmes today are generally shot – like films – on location, using lightweight cameras. I would love to work on a period drama, say *Bleak House*. The idea of being on location in old buildings, on old streets or wherever would be the most exciting part. When I was around, handheld stuff wasn't really quite there; you could just about handhold the camera and it was jolly heavy. Now, of course, they're much lighter and you can do so much more. That's what I would like to, simply because I was never able to have a camera small enough to be that free.

Once working on a play with Dennis Vance, about an old Hollywood actor who'd won an Oscar, we did some scenes handheld, which I thought were very exciting. But you didn't have a viewfinder, instead it was a sort of wire frame contraption. They were so heavy, I had to nick a cushion from a sofa to put against my stomach because it hurt so much. That was the nearest I ever got to handheld.

Is more better?
The proliferation of television has created a huge problem. You're getting the same size cake with more people cutting bits out of it. This is bound to lead to a loss of quality; with insufficient time there's a danger of quality having a taint of *Big Brother* about it. *Big Brother* has it's points I suppose, but generally the makeover shows proliferate because they are cheap to make. I think the attitude is changing, at least I hope so.

You still get great smashing programmes like *Bleak House*, also great comedy such as *The Green Wing* which is wonderfully surreal. Even though the sitcom has basically gone, there is an amazing one running as we talk which could almost have been done ten years ago. It creaks, but it's good.

Documentaries are fine. Fly-on-the-wall documentaries have had an effect and even led to laws being changed in some cases. But then so did the social drama *Cathy Come Home* all those years ago.

Those memorable moments
The first time I caused a retake was not long before I became a director.

I was working with actor Patrick Wymark on *The Power Game*. John Moxey was directing and for some reason something went wrong. I lost it a couple of times and caused two retakes, which I'd never done before. I felt terrible about this and following day when I saw Pat Wymark sitting in the bar I borrowed the broom used for sweeping up and as I went past him said: "They kept me on Mr. Wymark!"

I also knew the director Dennis Vance socially; he was sent to prison for stabbing his ex-P.A. on company premises. On his release he was given a contract by the director of programmes Bill Ward, bless his heart, and a lot of the guys on the crew who had never met Dennis expected some slavering killer with a knife in the control room. In fact, he was a charming guy and when he came in and did *Harpers West One* everyone was quite surprised. It was strange though as it was the first time he'd worked since he came out of prison.

There are others like pop singer Dusty Springfield, a nice woman who used lots and lots of make up. Once while her friend was with her in rehearsal another woman went by so she asked who it was. "She drives the mascara wagon," came the reply. It wasn't me, I promise!

32 LIGHTING A MUST

Any aspiring cameraman should learn about lighting. You may never be required to do much apart from the odd talking head interview, but it is essential that you have some knowledge of it at all levels as it increases your awareness of how important it is. When you are operating, it will mean you have a better understanding of what the LD/DoP is trying to achieve with any set-up. This in turn means you will be better value to the production as you will be able to make the most of what may have already been rigged and focused before is it looked at with a camera.

No LD expects his original lighting plot to work without modification as a production progresses; they all know from experience that a lot of compromises and adjustments will have to be done to get a good result. They will have been to several planning meetings to set the style and look that has been agreed with by the director and they will be loathe to move away from that because of a cameraman failing to comprehend the situation through standing on his ego in a misguided attempt to make himself seem more important.

Three-point lighting at Eco TV in Paraty, Brazil. Photo: Jeremy Hoare.

Taking the time to learn about lighting will enable you to work out the production objectives as soon as you start working at the studio or on location. An informed look at what type of lamps are rigged and what gels are on them will give you knowledge about the lighting feel of what you are about to shoot.

Lighting for television is a compromise; a lot of discussion is required even before a plan or plot for the shoot can be drawn up. After the logistics of getting lamps to the shoot, they are rigged and focused before a balance to create the look; only then is a camera pointed at it and the LD can work on the main requirement of his input, which is the abstract creation of pictures the cameraman frames to tell the story. It is no good for a cameraman to insist that the shot is as he frames it, they have to take into account the programme's look and objectives, as well as the timescale and budget. So it is better to compromise and move the camera, maybe to include a bit of a window to establish where the light is coming from, rather than sticking to a shot that does not. This compromise is about telling the story and it is a responsibility to play your part in this team effort. Standing on your ego does not work, and you could end up losing work in future if you are considered inflexible.

Three-point Lighting

Three-point lighting is fundamental to all forms of portraiture, always has been and always will be; pictures of people is what a lot of television consists of. Think how often you see talking heads, they are the basis of a lot of airtime and will always remain so as they are cost effective. There are so many variations it would be impossible to count them, but the basis of all is a key, fill and backlight set-up which is certainly one any cameraman must learn, whatever the aspirations for the future.

Fortunately there are numerous ways to learn about lighting. Books can be a good start but there is nothing quite like getting your hands dirty, so here are a few ways to learn I've done which do work:

- study old master painters, particularly Bellini for softlight and Caravaggio and Rembrandt for theatrical effect – they are the masters of light.
- study and analyse classic films, *Citizen Kane* shot by Gregg Toland with deep focus at f9 and anything shot by DoP Freddie Young.

- get to light amateur drama and music productions; poor performances maybe but you'll learn a lot.
- operate a followspot in a theatre if you can't get to design the lighting; it provides a great vantage point from which to observe and learn.
- shoot stills in all forms of lighting you can find then edit them together as a movie story on a computer.
- use a domestic camcorder and shoot in all forms of lighting you can find. I can't understand why anyone does not do this today.

If you can manage even some of the above you will learn a lot, and that can only help your career as it will become known that you are very helpful and interested in picture creation, not just as a cameraman. It is a team effort with one aim after all!

33 NIGEL ROBERTS – Cameraman

> *To be successful you've got to be confident in what you can do, without being pushy. This has always been so to some extent, but an awful lot of young camera operators are pushy, along the lines of "I can do this, I can do that, and I can do so-and-so." This is great up to a point but in the end you think, "Shut up – you are more confident than your actual ability."*

Nigel Roberts
Photo: Jeremy Hoare

I was an immature 19-year-old when I joined the Camera Department and virtually grew up in it, Nigel Roberts in his mid-twenties was far more mature and could have had his mind set but that wasn't the case. He was very keen to learn and I was always willing to teach people like him. Being older he had worked elsewhere before and came from a performer background of being a puppeteer and magician so during the quiet moments of a production we could be assured he would be polishing up on his camerawork as well as his magic tricks.

A lot of good camerawork comes through being confident, and Nigel, just like myself and most others I know of, inevitably lacked that to begin with. You are in a position of frighteningly real power on any production by operating even the least used camera. Confidence comes with time and experience and it was gratifying to see Nigel go through that phase.

He left ATV and went to what was Meridian at the Maidstone Studios where he stayed for 19 years as a senior cameraman and is now freelance. He is clearly still the cameraman of choice for productions at Maidstone and after many years Nigel is of course now supremely confident with a camera, almost too laid back, a surprise to me at first until I thought about it then realised that inside him are still all the hopes and fears that make all good cameramen tick. They never go away in anyone who is a real professional, and Nigel most certainly is that.

> *Typical of many, this cameraman knows that sometimes the only way to get a shot is to be confident, chance his arm and go for it.*
>
> *Nigel Roberts enjoys teamwork and close working relationships with the other production people, and also a famous puppet, Basil Brush!*

I left school in 1966 and, like a lot of others at 18, didn't really know what to do. With not enough A levels to get to university, I looked instead at my big interest at the time – amateur theatre. However, with not an awful lot of money to be made in theatre, I turned to television which was really big at the time.

My school managed to arrange an interview for me with the BBC who, on hearing I wanted to be a director, asked why I had applied to be become a technical operator/cameraman which I assumed I should learn about first. So I was told: "No, go away and work in the theatre and come back later." However, while working in a pub during the evenings I met a guy who was able to tell me when vacancies cropped up at ATV Elstree.

I kept applying and even got interviews, while at the same time earning a bit of money as a puppeteer. The trouble was that they always seemed to offer me a job at Elstree about a couple of weeks after I started another six months contract as a puppeteer! So it took me four years of going to interviews, and still being keen, before I joined ATV in 1970 as a trainee even though they told me I was bit old for the job. I have been a bit old for it ever since!

A Brush with Basil

Right now I'm working on the *Basil Brush Show*, the response to which could easily be an unimpressed: "Oh, so you do the *Basil Brush Show*?" But the present show is totally unlike the original which was really a light entertainment show. This is a sitcom with puppets – there are, for instance four different puppet characters.

It's still shot in the old fashioned way, multi-camera with two booms, and a director who knows exactly what he is talking about – he directs *Corrie* for example. I've also known him for 25 years, so we're old mates. It's also nice to have time to sort stuff out; you know he's already done a camera script and you can go straight into a camera position knowing everything is ready for you. This gives time to sort out the camera and

boom problems and, with a puppet show, hiding a puppeteer such as a shot with a puppet lying on a camp bed. This meant the puppeteer had to lie underneath it with us hiding his feet and head with sleeping bags. I really love doing the show which takes up about seven weeks a year.

The rest of the stuff I do, such as sports presentations, doesn't demand an awful lot of the camera operator. I've never managed to get on the live sports circuit. I was full-time at Maidstone Studios for 19 years which meant a lot of my colleagues who left about eight years or so before I did were already on the freelance circuit. I was quite a bit older too, and trying to break into a market dominated by them was that much harder.

I was lucky in as much as I was already camera supervisor and senior cameraman on a series of programmes which were being made in Maidstone at the time. So when I went freelance I simply came back as a freelance senior cameraman. But eventually these commissions disappeared and haven't been replaced as such. So it's not so easy to find the really interesting stuff. But I'm always hopeful!

I think the reason I enjoy being a cameraman stems back to my love of theatre. I like the interaction with artistes which is why I love doing things like the *Basil Brush Show*. The actors are now my mates and I've known a lot of them for five years. I also like what used to be the glamour of the TV studio. I never played a major role on things like the *Tom Jones Show* but I used to love it when we rushed out and bashed cables on it. That was really in many ways what I enjoyed most in telly.

Pushing the boundaries

I cut my teeth as a proper camera operator on *Sapphire & Steel* which starred David McCallum and Joanna Lumley, where programme director Shaun O'Riodan really pushed the boundaries. I remember literally sweating on some shots and thinking "Well the only way to get this shot is to go for it" – so I did. When it worked I thought, "Yes, that's it!"

Only a short time ago I had a horrendous shot involving a reflection of a girl in a mirror. As she spun round I had to whip into a BCU of her - and the only way to do this was simply to go for it. But, yes, after all these years of experience you still think: "Oh, am I going to manage to sort this shot out, and how do I get out of it if I don't?" What I really like is the ability to change what you, or the director, can visualise into a picture that other people can relate to.

The joy of multi-camera work

Despite the emphasis nowadays on single camera shooting, it's nice to say that some 75 per cent, possibly more, of what I'm still doing is actually multi-camera. This is certainly so at Maidstone which is nearly all, but not entirely, concentrated on children's production. I still work as crew leader a lot of the time, although at others times it's quite nice just to be a jobbing cameraman, without worrying about other people's problems.

But on things like the *Basil Brush Show*, I do love solving problems by getting together with the director and a very pleasant lighting director; the guys on the booms are great, too. You change things that suit everybody; that is what is so good about being a member of the crew. When things start to go wrong, you can correct them.

We have had done most of the ITV Saturday morning shows here since the first one in 1982, which going out live means you do need to rely on everybody else. I suppose I work regularly with eight or ten camera operators – mates who I know who will pretty well sort out the show with me.

Unusually, we still use booms in the show. Fortunately, there are probably about half-a-dozen experienced freelance boom operators covering the country. Occasionally you have to make allowances for them, as they are never going to be quite as experienced as the old boys. Sometimes it takes a bit longer for them to foresee problems, but fortunately we are not doing drama every day of the week when you learn to sort them out immediately. But they get solved in the end.

Changing face of sitcoms

Inevitably, I suppose, this has slowed down production. To be honest, we would be hard pushed to do a half-hour sitcom today like we used to in the old days, in a 14-hour stint. It could probably be done, but if you actually look back at those old sitcoms, a lot of what you shot was very simple – and you kept it simple. Nowadays because most of the drama is shot on single camera you have time to sort out complicated problems. Therefore you make the shots more complicated and if it doesn't work first time you can go back and do it again.

When we were doing almost live sitcom you would plot it, rehearse it, dress run it and shoot it all in a day. You had one or two complicated shots to add interest, but for the rest of the time it was matching singles

and two shots – and to be fair that is what we still do on live Saturday morning shows.

Getting the best from a shoot
You automatically get the best out a camera when you know what that camera can do. I don't even think it necessarily has to be the best camera, though this helps. I once did a series of website shoots based at Maidstone Studios many years ago for a Swedish Company who wanted a little item shot in London. Basically it was me and the presenter/producer who went off to do it and the first week they asked me "What are you going to shoot on?" and I said "We'll shoot it on DigiBeta." That was absolutely great. A couple of weeks later they asked: "Could we just shoot it on DV?"

I agreed, though. having done training courses for runners and the like on how to use DV, I know how much harder it is to shoot on DV cameras as the focusing on most is atrocious. To my mind, there is not enough definition in the viewfinder to see if something is in focus. So it was much harder for me to do these relatively, having worked with DigiBeta on and off I suppose for 15 years, I knew what the switches did, I knew what latitude was in the picture, and what I had got to see in the viewfinder.

Ambition and success
Ambition is not a word I particularly like; it's different for everybody. Once in the old TVS days a woman from a local college did a job profile of me stating: "Nigel is good at talking to people and that sort of stuff." When it came to ambition I said: "I would love to be doing the same sort of job in 15 to 20 years time, still doing good quality programmes." I've known other people become horribly unstuck because they want to do more than they are actually capable of. One cameraman who was supposedly ambitious did everything. But he is still only doing what I'm doing these days, possibly frustrated because he did not achieve most of his ambitions.

To be successful you've got to be confident in what you can do, without being pushy. This has always been so to some extent, but an awful lot of young camera operators are pushy, along the lines of "I can do this, I can do that, and I can do so-and-so." This is great up to a point but in the end you think, "Shut up - you are more confident than your actual ability." At the same time, some are too nervous – "Oh I don't really want to do this

shot" – or they hold a shot too wide because it's easier, whereas it would be much nicer if they chanced their arm a bit because that's really what makes a good cameraman. Again it depends on what show you are doing; if it is being recorded or single camera, push your chances until you've actually wasted a bit too much time trying to get a nice arty shot.

How long you can remain a top cameraman is difficult to say. The job changes all the time, but I think there are still guys of my age, and other others around 60, who are still working on the top stuff – whichever way you define the meaning of top. Some would say this means working as many days of the week as you want to work, as long as you are getting a reasonable rate. Others would say it's going off and doing the cream of the TV programmes around the world as a lot of English camera operators now do.

Being a team member

Your importance as a team member depends on what you do. If you are doing single camera operating you've got to fully understand the other six or eight close members of the team, even the production manager and people like that – though the problems they face are not yours as a cameraman. I have also known very good camera operators who, in many ways, are not good team members, including one particularly good one who is a still very busy today. He still wants to do most of the shots and won't delegate. I have known directors and producers moan about this person because he hogged the shots. But that's not what the show's about. And it means we have to wait while he wheels his camera across to do a less difficult shot, whereas I'd rather wait a couple of minutes, for a less experienced, perhaps even a less good, operator to sort out the problems over there.

Being a trainee

Being quite close to Ravensbourne College in Bromley, Maidstone has had quite a lot of their ex-students from the technical operators course come here. This means they know what they are talking about when it comes to operating and the technical side of it – unlike some in the past who've said: "I've done a course in media studies at so-and-so" yet are unable to unlock the camera or have to ask,: "What does this bit do?" – all the basic stuff.

My son, who works at the London Studios as a trainee, is amazed just how many trainees they take on become so bored they drop out before they come to the end of their training. I don't know how many they take on in a year; perhaps half-a-dozen, and probably two of these drop out because it is not as interesting as they thought it would be. You wonder how they got that far after being taken on in a fantastic training scheme with a fantastic future. I have also worked with some youngsters who have been absolutely fantastic, yet others say "Oh yes it's a great job" but then turn up for work late. That's frustrating.

Remember, the job is not as easy as it looks. If you want to be in telly, then get into telly. It's certainly not the same as when I joined, but the fact that people can go off and do reasonably interesting things earlier in their careers is quite an advantage. I think there will be a lot more people dropping out of television by the time they get to 40. The other problem is that there are those joining who don't realise how much work it entails.

The best and worst of times

One of my proudest achievements was probably changing from being a reasonably competent senior assistant/junior cameraman at ATV to going to TVS where, within six months, I became deputy head of the department and senior cameraman on a lot of interesting programmes. The biggest thing that I can remember, as a sort of single one off, was a Saturday morning live children's programme called *Number Seventy Three*. Although it was networked, not many people saw it, but it was extremely clever and in the end became quite a big Saturday morning children's show, mixing drama and factual stuff which was not easy. The fact that we actually went out live on a Saturday morning without too many mistakes was something to be proud of.

As for the worst, I don't know if there is a specific programme, but post-TVS, in what I call the dark days of Maidstone Studios, there were about 12 of us that kept it going, by doing a few children's programmes like *Art Attack*. I suppose it was the money from that kept it going. But we had an awful lot of people come in because we were offering a free pilot show, the idea being that afterwards you made your series at the studios. There were some horrendous things we were asked to do. One or two were really awful, but I can't remember the names because most of them never made the air.

Dealing with directors

Because directors to a certain extent have to be jack of all trades, you, as a cameraman, have got to sort out the specifics for that director. Some are particularly good and, even if left to their own devices, would still end up with a good product. Others have got no more idea than how to fly. I've worked with some who vaguely ask for "a nice shot". When you ask what they mean by that, you get the answer "Well can you make it dynamic?" You take it further. "You mean you want me to move faster, you want to make it bigger?" But they really don't know what they want, which is when you have to carry them.

34 MARTIN BAKER – Producer

However much the business has changed today and however much we whine and moan about it, there's always something that gives us the energy and the enthusiasm to get up and go to work. So for all that might be wrong today, television has still got to be doing something right to generate that sort of spirit. I don't think I am alone in that feeling.

Martin Baker.

The ATV post room was the starting place in television for quite a few beside myself who went from there into production. Martin Baker was another and he always wanted to be a cameraman and would no doubt have been a good one but was put off by camera operators who suggested he do otherwise.

So he set his sights on becoming a producer and was fortunate enough to be working as an assistant floor manager on *The Muppet Show* where he got on well with Jim Henson who had made a green frog called Kermit known and loved by a world audience. Martin's association with Jim brought many of the Muppet shows and films to fruition, among them *The Muppet Movie, The Dark Crystal, Fraggle Rock, Labyrinth* and *The Muppets at Walt Disney World.*

Then in 1990 Jim Henson, one of the geniuses of puppetry, unexpectedly died and it seemed the Muppets could not go on. However, his son Brian directed and Martin produced *The Muppet Christmas Carol* in 1992 to critical and audience success.

While is easy to become cynical with time, Martin still has an infectious sunny disposition and all the same enthusiasm for the business as when I first met him, and is about to produce the latest Muppet film, testament to the endurance of good entertainment in the right hands being a benefit for millions of people.

In May 2008 I was just back from the States where my Los Angeles based company had been making two specials for the Disney channel. Basically we'd come up with a sort of Muppet-style show in which we introduce all the current stars of the highly successful new Disney channel shows, such as *High School Musical* and *Hannah Montana*. This way we hoped to introduce the Muppets to a whole new generation of kids. Back in London we had also finished production of a kids' series again on the Disney channel – and were waiting for news on that for a second season.

My favourite programme must inevitably be *The Muppet Show*. They have been a huge part of my life, growing out of my years as floor manager on the show and then going on to produce Muppet movies with Jim Henson's son Brian. It was at that point, when Jim, who had created the characters of Kermit and Miss Piggy, etc. in the highly successful *Sesame Street* years before, sadly passed away. Everyone myself included, asked: "How can the Muppets survive without Jim Henson?" He was the Muppets, he was everything. And yet somehow two years after he died, with Brian directing and myself producing, we did the *Muppet Christmas Carol*, which people say was one of the best Muppet movies ever made. This was a real tribute to all of us, and Brian particularly as a director. We were justifiably able to say: "Yes, the Muppets can survive, and they can live on." It did however put us under tremendous pressure because it was our first big production after Jim died.

Acting was my initial love

It was as a youngster that I decided I wanted to be in TV production. I always had a fascination with television from when I was around seven, eight or nine years old. My early thoughts were to get into television as an actor, and I remember writing to the BBC saying I wanted to be a policeman on *Dixon of Dock Green*. Anyway the letter must have found its way to the producer who wrote me the sweetest letter back explaining that I was most probably a little too young to play a policeman. His advice

was to persevere as an actor, though I soon realised that I wasn't cut out for it and became more interested in television production and particularly cameras. I was always surrounded with cameras and I spent a lot of time visiting sets and locations.

My first job in television was working in the post room at ATV House in London. I can't say I had fond memories of those days but made I the best of it until quickly moving to the studios at Elstree where I worked in the design department as a dyeline printer. This meant working on the drawings and elevations for all the designers. I loved it and, while it wasn't necessarily a career move, the couple of years there gave me a real insight into that side of things which I have always appreciated; for instance, I can now see a show come together from a designer's viewpoint.

My next job was working on the studio floor. In those days I was called a callboy, something my mother always had a problem with. So, given that it wasn't socially a very nice name to be labelled with – her friends failed to realise it was actually an old theatre term – I remember going with union colleagues to get the title changed to stage assistant. So that's what I became. I was really the gofer, getting in the teas and coffees for a few years until round 1968 to 1970 I got the leg up to floor manager. I have to tell you, I loved every minute of it. What was wonderful about being on the floor from that early age was a real appreciation of how the floor ticked. I wasn't just coming at it as a cameraman or a soundman; even as a junior floor manager, you really got to understand how the floor ticked and what made it work. I will always appreciate such a good grounding. So from a callboy, I became first an assistant floor manager and then floor manager.

British cameramen are the best
Throughout those early years, I was sent on a lot of outside broadcasts where I drove the cameramen crazy with my love of cameras. All would almost inevitable ask: "Why would you want to go into cameras? You know it's got a limited life. It's much better to go into the production side." I guess I must have taken this on board because though even now I love everything about camerawork, it was the production path I eventually took. Ultimately it was the right decision.

I was with Jim Henson in the early eighties, when we went to Toronto to make *Fraggle Rock*. Having come out of ATV, and all that it represented,

I suddenly I found myself working with a different style of cameraman.

I was now working with crews from CBC Television, the BBC of Canada as it were, and whereas I'd left feeling the cameraman's life was that of a cameraman, I was meeting guys for which television was their second career. A lot had farms out in the sticks and would come into Toronto two or three days a week to operate the camera. It wasn't that they were lazy but they had a different approach to camerawork. It was, after all, a second job, rather than being their life's passion.

It was a real wake -up call to me and the realisation that cameramen in England were the best. And having travelled a great deal, particularly with Jim, over the years, working a lot in America and Canada, I still say we have the best. The grounding they have is second to none. There's something about the work ethic here I haven't found anywhere else.

Team work counts

What I love about the business is all about being a team member, especially as a cameraman. Those who aren't stand out like sore thumbs. Okay, so, some go on to be very successful, and some don't, but generally team playing is crucial to every department in television. We've all seen bad camerawork and we've all also heard bad sound. But good cameramen stand out very clearly, and bad and lazy cameramen don't work very often.

My memories of cameramen are of a cast of characters; you could have made a sitcom about any of the crews - each of them a typically dysfunctional family. There were those that got on and those that didn't and were always rowing. Others were egoistical along the lines of "I'm better than you." I think if you put all the cameramen together during my era at ATV you'd have an amazing sitcom.

Rating grabbing is what counts now

Television today, of course, is dramatically different to the era that I grew up in and loved so much at ATV. Reality television now dominates, some of it's good, some of it entertaining and some is pretty gross. The economy today is such that reality television plays into the hands of the TV financial people because all they want is rating grabbing television costing a fraction of what it would have done 20 years ago. That's today's business model.

I don't know what experience youngsters get today. Even though my son's now a floor manager he has only ever known freelance work. He simply works from job to job. Personally I regret that the kids coming into the business today don't have the opportunity we had, when we were growing up, where getting a pay cheque every week meant we all gave a 150 per cent. We believed in the company and grew with it. It doesn't happen like that today.

How fortunate I am

Cameramen, like floor managers, just work from job to job. They don't know any different, because they never knew the era we worked in. It can't be easy. How do you train the way that we trained? You pulled cables for a while before you got an opportunity to go on the camera. I don't know if it happens in the same way today.

All I can say is I have loved every minute. I feel very fortunate having now worked in television for about 40 years; I can still get up in the morning and look forward to going to work. Not many of my friends can say that. However much the business has changed today, and however much we whine and moan about it, there's always something that gives us the energy and the enthusiasm to get up and go to work. So for all that might be wrong today, television has still got to be doing something right to generate that sort of spirit. I don't think I am alone in that feeling.

35 DICK HIBBERD – Cameraman

The role of a cameraman is now difficult to define, the roles are so diverse and so multi–skilled. Even so, the cameraman's contribution should always be to create a picture which adds towards the story or helps the production in some way or other. When you are asked to frame up on something you don't just put a camera at head height, at eye level, and squirt it at whatever is in front of you.

Dick Hibberd
Photo: Jeremy Hoare

Dick Hibberd has had a varied career and while well past retirement is still operating a camera. I was lucky in my early years and tracked him on numerous occasions, he was kindly and I learnt a lot from his gentle but no-nonsense approach to camerawork.

I tracked him on the first play to be shot at ATV Elstree, *A Man Condemned*, which was directed by the awesome Quentin Lawrence, who would work out every shot and mark on the floor exactly where the camera should be, and which lens it should be using. Nobody else did this and his stock saying when a shot worked as he expected it to is burnt into my memory: "Every frame a Rembrandt!"

Dick was, together with Dai Higgon, the inspiration for starting the Guild of Television Cameramen, which had a slow acceptance at first as cameramen then were not 'joiners' by nature – being more individual as people outside the team spirit of the crews. I joined later on and became a GTC member with a fairly low number, but no one can top Dick as his is 0001 which entirely befits the man who started it.

While still at school, and pondering what to do, a friend told me he was going into documentary filming. "What a jolly good idea." I thought, I'll do that. I met him again 45 years later; he had become a civil engineer while I had gone, guess what, into documentary film-making! And I'm still working at the age of 78.

I was fortunate enough to start off in Germany as a sort of runner with Crown Film Unit who were making a film about my own father who, as part of the occupying forces, was the intermediary between the civic authorities and the occupying military authorities. The Unit were commissioned to make a film about this for the general public. I joined in and helped – though I didn't get paid of course.

On my return to the UK I tried to join a film unit in London, only to face a typical Catch 22 situation. This was along the lines of: "Are you a union member? 'No?' Then you can't join. We can't take you on unless you are a union member. 'So how do I get to be a union member?' Well you would have to have worked in the industry!"

So, placed in a seemingly impossible situation, I ended up in Edinburgh being looked after by my sister. However, someone from across the road had a small film company, Campbell Harper Films – and so I joined them instead as trainee assistant director at £3 10s a week in old money, £3.50 today, of which £2.10s was spent on my digs. This left me a pound to spare.

I enjoyed the work tremendously because it took me all over Scotland doing all sorts of things, though I was rather surprised at the attitude of the people I worked with. When I asked if I could load the camera for them the reply was: "Oh no, you mustn't touch that". It was very much a case of hands off and "No, you can't possibly do that". But in the course of time, I did do everything, and I found it very simple. Their secretive attitude, I admit, didn't go down well with me.

No knowledge – no job

It didn't, however, seem a particularly good way to earn enough money to take out a mortgage and raise a family. So I tried moving to television, thinking that at least I would get a permanent job. Sadly the BBC told me: "You haven't got a technical enough background," so I worked for Ferranti for a couple of years on the development of their gunsight during which I used a Mitchell camera while aeroplanes dive-bombed me. The film was then analysed at the end of the day.

Then came a job with Decca Radar who were commissioned by the Ministry of Defence to do the same sort of thing. Unfortunately they didn't get awarded the contract, which left Decca Radar thinking: "What the hell are we going to do with Dick Hibberd?" – so would I like to become a lab technician? Well, I thought, if I did I might at least get the right technical background.

So I attended night school in Wimbledon, did day release courses and took part in Telecoms One courses; my last job at Decca Radar was to design a video amplifier. I didn't really know what video meant at the time, but I did this sort of jury rig of potentiometers going into valves and hopefully amplifying a signal which I didn't understand. The upshot was I got another interview with the BBC who this time said: "You've got just the right background, come and join us!" So I became a technical assistant at Lime Grove, yet never used that background knowledge again until I joined Thames Television 35-40 years later as a studio supervisor. This meant I needed to know what everybody could do and whether they were doing it properly.

The only job I ever wanted

I left the BBC to become a cameraman with ITV along with others, though I'd managed to do my course at Evesham with them before joining ATV where I had a lovely time. I originally wanted to be a director, but fell so much in love with the job of cameraman I forgot all about that for about 25 years.

Though all the senior cameramen I worked with at ATV were certainly influential, I think it was probably John Glenister who influenced me the most. This was because, as a number three cameraman working my way up through the grades, it was he who sat me on the front of the Mole crane on the *Mantovani* show. I still remember to this day that I had a close up of Emile, the accordionist, in the middle of serried ranks of swinging strings.

My task was to track back and crane up so we reached the full orchestra by the time the musical phase had ended. This we did in due course, though why John Glenister let me do it as number three cameraman I don't know. But I'm eternally grateful to him because when I moved to TWW it was me on the front of the Mole crane every week.

The Mole remains my favourite

The Mole crane still remains my favourite piece of camera equipment. I really loved working on it, and if you had a good crew they always responded to your signals when you told them to stop, especially as you had to indicate a bit earlier due to the five second delay before the end of the track; this unfortunately was not the case with some crews.

I think the Mole crane was a lovely instrument even though the shots you get on a Jimmy Jib or a Polecam nowadays are absolutely superb. You can never beat the thrill we used to get on the front of the Mole crane or a Nike or the Transatlantic, that of being swung around the air. It really was a wonderful feeling.

I've never had difficulty making decisions when it came to camerawork. Even now I still enjoy making pictures; everything I see is a picture whether it is a landscape or portrait or whatever. There is always a frame round everything I see. I just love making pictures.

Some aspects never change

The role of a cameraman is now difficult to define; the roles are so diverse and so multi–skilled. Even so, the cameraman's contribution should always be to create a picture which adds towards the story or helps the production in some way or other. When you are asked to frame up on something you don't just put a camera at head height, at eye level, and squirt it at whatever is in front of you. You look around to see what you can take advantage of to make it more emphatic, more interesting, more dynamic.

Being a team member remains very important and I suspect it's even more difficult nowadays than it ever was. Quite often it seems directors have little appreciation of what cameramen are capable of doing, or not capable of doing, judging from the end product on the box. You are asked to do all sorts of weird things which all too often look absolute rubbish – but then if you're going to earn your living by doing as somebody bids you've got to follow instructions.

All of which confirms the vital relationship you should have with the director. Quite often you find – or at least I used to find – if you were in a crew the cameramen would sometimes be acting rather woodenly, not understanding what the director was asking of them. I think you have really got to get inside the director's head to try to understand him as an individual. Then you can probably give him the best pictures that he deserves. If you don't understand him or her and there's no empathy you're not on a very productive wicket.

The only real experience I have with camera training is at Ravensbourne College, Bromley, and that's minimal experience. It would seem to me that they gain a very sound grounding but, of course, whatever equipment you use nowadays at a training establishment is going to be superseded by the time you get into the market place. This means you have to get a very wide knowledge of equipment and of as many skills as you can.

To get the best out of a camera doesn't always mean doing as the manufacturers say. I think I've always been rather brutal with cameras, pushing them to the ultimate and being as hard on them as you can. Try them in every way you can, it won't always work, but sometimes you can be surprised what wonderful results you can get.

Single cameras are now a lifeline
How long is it possible to stay at the top today? I would think for ever! With a single camera operation, you have an opportunity not only to reset and relight but get your breath back in between. When we were on a marathon operation, trying to keep your reflexes 100% through something which lasts 12 hours, it was always going to be difficult to do that past the age of 55 to 60. But here I am at 78 and I believe I still do as good a job as I ever did.

What of ambition?
As for ambition, when I was head of a small department, I used to interview my cameramen every year, and suggest directions for their future. I would also give them an opportunity to be critical of me in the same way I could be critical of them, But, as somebody pointed out to me, we cannot all be chief's – there has to be a few Indians as well and some people are happy to be cameramen all their life. I was a cameraman too long to become a

director, I enjoyed it so much, and still do. I am pleased I never became a director in professional television. I wouldn't have been able to spend as much time with my family and that was very important to me.

If I had known that it was important to be in the bar chatting about how wonderful I was on the last recording, then I might have got on better. But my first priority was to bugger off home as quickly as possible and see my family. As a consequence, I only rose to the giddy ranks of camera three at ATV. However, I found that moving to Alpha Television enabled me to become a number two and by moving to TWW enabled me to become a senior cameraman. By then I think I'd understood how important it was to tell people how clever you are, but I really didn't have any appreciation of that fact when I started.

Essence of our work

This kind of self-publicity is really quite important today, even if it's not natural for a really good cameraman. The very essence of our work is that the viewer shouldn't be aware of how clever we are. We're simply doing a job and we want them to enjoy the end product of the drama or documentary, not to be thinking about how difficult it must have been for the cameraman to lie on that shelf and take a shot from 60 feet up or whatever. But if you don't tell people how clever you, in the nicest possible way, they'll just take you for granted and that's not right.

Giving credit where credit's due

The Guild of Television Cameramen, of which I was co-founder, started because nobody knew about other cameramen and nobody got credits in those days. Why that situation was allowed to perpetuate I really can't understand. It's vital that everybody should be credited. Why, for instance, would an inclusion of 30 seconds of film mean the film cameraman got a credit, but all the camerawork for the rest of the production received no credit at all? It was really quite bizarre but I'm glad to say it is mostly eradicated now and people do get credit where credit's due. Likewise they can get blame where blame is due – and if you see some crap work you know who's done it. Mind you, when it is all concertinaed down into the side corner of the screen where nobody can read it, it's a bit of a nonsense anyway.

Being a manager

I always found it difficult dealing with management decisions which I felt jeopardised the working capabilities of my camera department or camera crew. This meant I had to argue that it wasn't safe for them to do certain tasks, and they would have to find another way of doing what was required of me. I remember one occasion when I was on a Simon hoist and the director wanted me to crane round and take a shot from a different angle. I pointed out to him if I did that I would be over some high tension cables which I didn't think was a good idea. He ranted and raved saying: "Of course you can do it!" Fortunately I never did because not long after one of the hydraulic pipes burst and the crane came down of its own volition. I was very pleased I had dug my heels in. We all tend to take risks as cameramen, but you have to be careful. Today you're not really allowed to with all the Health and Safety rules, but it does happen.

36 CHRISTOPHER TIMOTHY – Actor

> *I've read books, seen documentaries and listened to interviews during which people talk about "having a love affair with the camera" or "the camera loves them." I don't know how much that is so – but I do know that what can be achieved between the gut operating and the actors performing is sometimes magical.*

Christopher Timothy
Photo: Jeremy Hoare

Christopher Timothy played the lead role of James Herriot in the BBC's *All Creatures Great and Small* which made him a star and celebrity overnight, but was playing a small part in an ATV production of Shakespeare's *Twelfth Night* when I first met him. I was driving the Mole crane and had time between rehearsals to chat so soon found out that we lived close to one another.

He had become well known as an actor and was supportive in helping a local amateur drama group realise their ambitions by directing them. He soon roped me in to light them and sometimes to design the sets as well. One production was *Night Must Fall* in the village hall which unfortunately had double booked us with a boxing club. So for that rehearsal the actors had to perform on the stage with the boxers thumping away at punch bags on the floor in front of them, totally bizarre.

On one television drama we were working on together, Christopher had a small part so I would give him a lift and found out he had aspirations to direct television, not just amateur theatre. So when there was a chance and neither of us was involved in a scene, I got him to operate the camera while my tracker and I stood in and showed him what happened when actors didn't hit their marks and the adjustment that was needed.

He learnt something that day which he may have remembered in recent years as he not only had a lead role in the BBC medical soap *Doctors*, he directed several episodes as well. This makes Christopher unique as being the only person in the book to have been both sides of the camera at this highly professional level.

As a regular cinemagoer, from as early as seven or eight, I quickly realised the affect of a close-up on the audience. By then I was already looking at film annuals and magazines, full of 'on set' photographs, almost always featuring a cameraman and director. I still believe in this two-way relationship – each, after all, are reliant upon the other. And ultimately it's the cameraman and/or director who make the choice as to what the audience sees.

However, in the theatre, I have always maintained that the bottom line is no one's more important than anyone else. From the lady in the box office to the followspot operator, the leading actor, the walk-ons – each has a role to play. The same applies in a TV studio or on a set – even at a factory, office or a building site come to that. If only we all appreciated and respected what those around us are doing.

This applies to the cameraman as much as anyone – caring about the product, and particularly what's wanted from the director, actors and the designer, is what counts here. As a performer, I've had huge help from cameramen who have either signalled the size of frame or quietly hinted I should shift weight from one foot to the other. Not that it's easy to accommodate a cameraman's wishes even if the actor's sure he's right in what he's asking for: changing a position, a look, an exit or an entrance – all should be easy enough, or still possible, but *not* easy. I've also been in situations where a compromise has been reached whereby a cameraman has altered a shot to accommodate something I'm doing.

Always strive for excellence
I recall rehearsing a scene – just for Terence Redmond and myself – during the filming of *Eskimo Nell* which we thought could be quite funny if we got it right. However our amusing repartee was interrupted by a girl coming in her undies and asking: "Anyone seen my tights?" Anyway we did rehearse without the girl – though the cameraman warned: "I shouldn't waste time

rehearsing if I were you, no-one's going to be looking at you!" In actual fact, on the take, without us knowing, the girl came in *naked* and said: "Anyone seen my knickers?"

Andy Paine was a BBC cameraman, now freelancing, who I got to know and respect both while acting in *Doctors* and directing, Andy strives for excellence, as do I, and what everyone else should do. This way we might actually make the audience laugh, cry, gasp, jump but, most important, delight them!

I've read books, seen documentaries and listened to interviews during which people talk about "having a love affair with the camera" or "the camera loves them". I don't know how much that is so – but I do know that what can be achieved between the gut operating and the actors performing is sometimes magical. And in my experience, I've been part of "striving for excellence" more often than not!

37 CAROLE LEGG – Vision Mixer

> *It's a team effort at the end of the day – which means with a scripted show that the best type of cameraman is the guy who's where he should be, and at the right time. It's a great joy to sit in the box watching really good camerawork; I've seen some brilliant stuff.*

Carole Legg
Photo: Jeremy Hoare

A vital part of the production team was, and in multi-camera shooting still is, the Vision Mixer and Carole Legg was always the best to have in the box when I was operating a camera.

All ATV's Vision Mixers were female and considered closer to the Camera Department than any other. So if one went sick or had missed an amended earlier start time, it fell to the Camera Department to provide someone to cover. I was always keen to have a go and memorably for me at least vision mixed a sketch on a *Morecombe & Wise* show at Elstree with Colin Clews directing and another time mixed a difficult rowdy union meeting scene of Arnold Bennett's *Clayhanger* series. The Vision Mixer didn't get an amendment but arrived in time just before the take so I suggested she should do it but she told me to go ahead and complimented me afterwards, praise indeed.

Carole was completely dependable and as a cameraman I was always grateful when she was also on the same show. She would very discreetly let a cameraman know over talkback anything she felt important enough, but only that, so always gave me a sense of confidence that I wouldn't be cut to if I hadn't made a move as fast as on rehearsal. She was just as reliable on drama or light entertainment; it was always good when she was mixing.

After leaving college, I joined one of the original ITV contractors, Kemsley Winnick Television, created by Lord Kemsley and Maurice Winnick the impresario, based at the bottom of Kingsway in London. I was due to work in the new Press Office, but it never happened as everyone fell out with each other. So my boss suggested working in television itself. We literally walked across the road where he got me a job initially in personnel when ATV was still ABC. That would have been around May 1955.

From there I worked in presentation, then in Master Control at Foley Street where I kept the logs of programme contents which went straight to Lew Grade – who wanted to know exactly what was on every second. It was while at Foley Street that I saw the studios and was fascinated just watching the vision mixers at work. That, I decided, was what I wanted to do.

While visiting the Birmingham studios I spoke to the boss, Bernard Greenhead, about my plans. Six months later, he rang to ask if I was still interested and if so to move up there. It literally happened as quickly as that. I spent two years in Birmingham, often working with Colin Clews and Bill Ward when they came up from London. So when they needed someone I went before the board, got the job and so returned to ATV in London.

Seeing cameramen perform

My favourite programmes, quite frankly, are those that are any good, especially with such a lot of dross around. I like light entertainment where you can be very creative; good drama, too, can be very satisfying. Naturally you get a unique insight into camerawork. I've probably sat and watched every cameraman who ever went through Elstree. It's not for me to judge their work, of course. But it is my job to make sure they're where they should be at the right time. As far as a vision mixer is concerned, you need a shot to be at the point you want it. You don't want it late, so it's important that they are doing what they should do. So reaction is important as is reliability.

The cameraman's role, of course, is absolutely vital, but that applies to a lot of other people. If you watch vision without sound what have you got? Nothing really. It's a team effort at the end of the day – which means with a scripted show that the best type of cameraman is the guy who's where he should be, and at the right time. It's a great joy to sit in the box watching really good camerawork; I've seen some brilliant stuff. You do what you do as a cameraman and this applies equally to a vision mixer as well, it can be complicated what with DVEs and all the rest of it. You're moving at such a rate that if you actually analysed what you are up to you'd probably never do it! It's one of those jobs you have to have a feel for both the camerawork and the mixing to be any good. And naturally you've got to be confident you've got to think, "I know what I am doing", and get on with it.

Your eyes are scanning all the time
Jeremy (Hoare) talked about a big scene on the Arnold Bennett *Clayhanger* series when, because the vision mixer was late, he volunteered to mix a complicated ten-minute scene cutting to dialogue but while still watching reactions and everything else. But he did it despite it being nerve wracking. This simply proves how important cameras are – because without them Shot 31 would have gone pear-shaped. It's essential that the guys are there and correctly positioned. I remember being late once or twice myself and maybe with the vision engineer already sitting there at the vision mixing panel. The reaction as I walked into the control room was "Thank God you're here!" simply because there's such a lot to take on.

Your eyes are scanning all the time, you're looking at your mixing and you're reading a script. It's rather like driving a car: you wonder how the hell you will ever do these things all at once and get it right too. Though I never operated a camera, I had a bit of a tweak but not that much. But I sometimes think everyone should go in every department; if a cameraman had any idea how much a vision mixer's got to look for, how much you've got to do … it's a hell of a lot actually, it really is. But, as I say, it comes with experience.

38 TYPES OF CAMERAMAN

Anyone can be a cameraman, or woman, as gender is somewhat irrelevant, it is not a job that needs brute force today as it may have done in the past when cameras and mounts were much heavier.

I once met a freelance cameraman and asked how he started his career. He offered himself for a job and got accepted on the strength of blagging, no experience whatsoever, just read a few books showing where the controls were and what they did, but had never actually touched a camera until being paid to do so. I have also heard of so-called cameramen who got onto a shoot and couldn't work out how to raise the height of the camera on a tripod. I would never recommend these as ways into television but there are various aspects to the television industry and particularly of different cameramen for different jobs.

With the television world now mostly freelance, the top of the tree has to be the broadcast cameraman, someone who works for a major network on mainstream programming. This individual can tackle anything put in

News cameraman at a protest in London. Photo: Jeremy Hoare.

front of them; they have seen it all before, know most of the answers and are completely at ease whether in charge on a single camera location shoot or as a cameraman in a multi-camera studio environment. Invariably they tend to be the older ones by weight of experience, but they went through a thorough training so do not just write them off because of their age; spend time to learn from them before they are no longer around.

Somewhat different are the news and documentary cameramen. Their skills are of a more individual nature as they are more often or not working solo, not as a member of a crew, so are inevitably self reliant as there is nobody to ask if things go wrong, and they do. They also really have to think like an editor, because if they do not shoot the right shots it will be hard to cut together. More specialist still are the aerial, underwater, Steadicam, high speed, rostrum and special effects cameramen.

It would be difficult to put every type of cameraman into a different category but there are many people who work for organisations such as military, police and fire services who are fully entitled to call themselves cameramen. They also tell stories with a camera and often under very trying and emotionally challenging circumstances that I would not like to have done. No director would employ a cameraman for a prime time music programme whose last job was coverage of scraping remains off a motorway. Horses for courses – that's very true in the freelance camera world of today.

I have seen so many programmes where a foolish cameraman has obviously thought that he is obviously the key figure by the way they have been shot. Total rubbish, the subject is the focus and don't ever forget it; never let the camera become the focus of attention. Some egotistical cameramen sadly do, a delusion which becomes tiresome for the viewers who then probably switch to another channel. Camerawork is the servant of the programming, not the master. Ignore that at your peril.

39 TONY FREEMAN – Cameraman

> *Ambition In the early part is everything, particularly if you're a freelance. First, it makes you want to be a cameraman and then if you retain that ambition, to become one. And that means being a trainee - you're going to be an assistant – making sure the tea is hot, wiping the peds and doing all the horrible work that every apprentice has to.*

Tony Freeman
Photo: Jeremy Hoare

Tony Freeman arrived in Central Television in Nottingham from BBC Manchester as a cameraman not long after I had moved on to being a lighting director at the brand new Lenton Lane Studios, now closed.

What I found strange in my new role was that some people I'd worked alongside for years suddenly seemed to have a different and more difficult character. Tony is an affable cameraman with an easy-going personality, who I hadn't met before, but was immediately aware of the position I was in and extremely helpful to me.

Another very enthusiastic cameraman who relishes the challenges that are thrown up every working day, Tony worked on the last major production of great note as I was writing this book, the *Nelson Mandela 90th Birthday Concert* in London's Hyde Park which was broadcast live to millions of viewers around the world. To be at the sharp end of such a world event is many cameramen's dream job and Tony is one who has been there many times, a testament to what he brings to a production.

Regrets, he has a few – but doing it his way in the competitive world of high-tech cameras has brought fresh challenges.

Tony Freeman confesses to a life-long love of cameras – whether for the streamline magic of the Mandela concert or the creative disciplines of the sixties or seventies.

Being freelance today brings in a real mixture of jobs. During the summer of 2008, for instance, we completed the opera *Don Carlos* at the Royal Opera House, Covent Garden, for DVD release. This was part of the trend towards cinema theatrical release, and the last recordings we made were shown in Trafalgar Square, Canada Wharf and Liverpool, the year's City of Culture. It was a long production but fabulous to do. Then, of course, there was the *Nelson Mandela 90th Birthday Concert*. I don't know what the rig time would have been for the Queen's Coronation back in 1953 – the time span being covered in the book – but I bet it took weeks to get the cameras in place. There was one apparently located in the organ loft of Westminster Abbey, operated by a guy I used to work with at BBC Manchester, Don McKay. The only reason he got to do this was because he was five foot nothing – and, as the smallest cameraman at the BBC, he could fit in the loft!

Compare that to the Mandela concert of which the most impressive aspect was that it was put together in two days. Not just the OBs, the cameras and stuff like that, but the fact that, only a week before, the entire infrastructure took, I don't know, possibly a week to build. The equipment now is fantastic and so ultra reliable. In the days of multicore and all that malarkey, you would take out more cables than you put in, simply because they were never working properly. Now you turn up, plug in cameras which work, and get fabulous pictures. They're also smaller, lighter and cooler. Everything about the Mandela concert shows how far we've come since 1953. The technology is fabulous, and with it the level of camerawork. Okay, so it's changed too. Just think of the fabulous shots they can achieve now with the cranes. Yet when I first started you just swung them around in a wide shot. You were shit scared to go in because it would go soft or would wobble a bit. Now you've got a 40–1 lens. There was a crane behind the stage looking out at the audience at the Mandela concert. It was called The Vortex – and was Matt Gladstone's camera: he

showed me a shot of the top of Battersea Towers where he came from a hundred foot to zero in about five seconds – and the crane remained as steady as a rock all the way. That is such a tremendous leap forward, and the thing is, like most of modern technology and progress, its growing fast. While working at Shepperton I went over a camera company who produce the smaller miniature cameras for Olympics. We used to call them gun cameras years ago. Their new HD camera is about the size of two cotton reels put together with a little mini shot head on it. The picture they got out of it was just amazing.

This is why I say the Mandela concert could not have been done without the technology we now have. From the television production side, it helped create a good atmosphere. For the punters, too, it was all about Nelson Mandela and watching good bands. Despite the usual array of cameras and cranes near the front of the stage, people are now far less aware of them and even forget about the technology. Even if they haven't had their own 15 minutes of fame, they know someone who has. We have left behind the sixties, seventies and eighties when live OBs were big events, and you spent half the time looking at the camera crew rather than watching what was going on. We're now able to cover events where you get greater audience participation, all because they are enjoying the event and not looking at you. I think it's great.

Scope is replacing job security
I still enjoy being around cameras, I always have done. In November 2008, I will have spent 34 years in the business, 32 years of which will have been operating cameras. As for today's budding cameramen, I would love to give them a whole arm and a leg of advice – probably to go away and do anything else! It's a real struggle to get in – more a case of luck now than it ever was before. But given the enthusiasm and drive, the opportunities that confront them are enormous. So are the pitfalls. Job security, for example, not just in broadcasting but right across the board, disappeared in the eighties with the election of Mrs Thatcher's Conservative government. That was the downside. But the upside was that opportunity quadrupled. No longer did you have to go through the rigours of various apprenticeships. By the same token, once you got the job there was no security, a situation that continued through the nineties and does today.

Careers are fewer and far between. People have to be prepared to move

from one job to the next. But then that applies to the most secure of industries, like banking and financial services. So be keen, be enthusiastic, do as you're told, listen and all those sorts of things and do whatever you can by yourself. If not, you can bet your bottom dollar that there will be plenty of others who don't know the right people, doing the same thing. They will go out and buy a camera and take snaps, buy a movie camera and make films, buy a computer and edit their own stuff. That's the opportunity, that's the upside.

We can no longer simply talk about camerawork, at least not in my own generation terms, which is basically major broadcasting camerawork. The gamut of camerawork goes far beyond that. I can remember Keith Bradshaw, who was with me at BBC Manchester, buying the very first Sony Camcorder. It was a ghastly thing but, being a good Liverpudlian keen for a bit of extra business, he used it to shoot wedding videos. He once asked me to cover one for him, showing me how to operate it. My framings were wonderful, but everything was a bit blurry and the colour was blue one minute and green the next. Quite frankly I hadn't a clue about the technical side of it.

But it was from those humble beginnings, outside of mainstream broadcast, that we have today's range of offshoots – DVDs for example, and corporates involving people who while actually operating cameras and being cameramen, probably wouldn't know how to spell 'broadcast' let alone actually being involved in broadcasting. But they're just as intuitive and they're just as creative and artistic as we are. So though job security has gone and the main edifices like the BBC and the ITV companies have been broken down, the opportunities have risen correspondingly. You can come at it from all sides. Buy ten thousand pounds' worth of equipment off the shelf, and you've got enough to make a feature film, shoot it on DV if you like, then edit it yourself.

Interest wins over photo portfolio
What's interesting is the assumption that people who buy and operate cameras are automatically cameramen. I was never asked for a portfolio of photographs when I had my first interview. In fact when they asked me what my camera was, I replied: "I've got a Kodak Instamatic!" And the only reason I had that was because I nicked it off my Mum to use on a two-month trip to Sweden before the interview! My confession came to

light after answering various technical questions on exposures, whether I had brought any photos along – and what camera were they taken on. There was a slight pause when I said an Instamatic, explaining I wasn't really interested in photography, more the results. While I wanted to become a natural history cameraman, I was more interested in the natural history part. I just wanted to go off to all those fancy places and take shots of all those wonderful animals. I was 17 and still at school when I first applied to several places, including the BBC who, though no doubt annoyed as I kept writing to them, gave me the interview for a post at BBC Manchester. And, because they were recruiting specifically for camera assistants for the first time, and needed a couple at Manchester, I got the job.

Worst moments

What I should also admit is that one of my worst moments in TV occurred during this time – or rather when I was doing my entry course with the BBC. In those days you had to complete Part A, Part B and Part C, and you only went to the last, which was the actual operating bit, if you averaged 60 percent in the various academic tests in A and B. If you didn't you were "terminated" – the 75 ohm resistor basically. I went from bad to worse, I'd just spent five years doing nothing but GCSEs, A levels, and was thinking of going to University – I just blew up. I couldn't do tests any more. I recall the Course Director coming up to me and saying: "You've got one feedback test tomorrow and you've got to get 80 per cent, otherwise you are going to lose your chance of a career at the BBC." I was absolutely terrified and I just wanted it to be the day after tomorrow, so I would know one way or the other.

Anyway, I did the test but they withheld the results until they announced who was going on to do the third part. I spent a day basically packing my bags and mentally getting on the train home; when my name was on it, I thought I must have done really, really well. It wasn't until I successfully finished, that the guy who ran the course said: "Well done Tony, you've done very well and I hope you enjoy your career at the BBC; you're going up to Manchester, everything will be fine." But when I asked what mark I got he said: "You got about forty per cent. The reason you didn't get chucked out was that you showed us enough in the other first practical, so we thought you were going to be OK." So that's how I got away with it.

Discover the joy of camerawork

So with all that happened with me, don't simply say: "I want to become a cameraman" as it doesn't necessarily mean to say you initially want to operate a camera. What you really mean is you want to emulate what you see on the screen. In my case I was into art and design and stuff like that. It wasn't until I actually became a cameraman through a set of fortuitous episodes that I suddenly realised exactly what being a cameraman was all about. By the same token, some guy will insist he wants to be a cameraman. "Okay", you reply, "There's your laptop, there's your camera, go out and do it." Off he will go and have a lovely time. But that still doesn't mean that he's going to be, or want to stay, a cameraman. It's not until you start moving into more regulated camerawork that you discover all the other aspects. It's not just a question of knowing how to frame a shot, it's not just a question of knowing how to push a ped round, or where the tape goes in on a Betacam. It's a combination of all of these things, linked to the fact that you want to do it more than anything else.

Keenness equals ambition

Which is where ambition and keenness come in. Ambition in the early part is everything, particularly if you're a freelance. First, it makes you want to be a cameraman and then if you retain that ambition, to become one. And that means being a trainee – you're going to be an assistant – making sure the tea is hot, wiping the peds and doing all the horrible work that every apprentice has to. I clearly remember the words of dear old Peter Jones, who wrote the 'Technique of a Television Cameraman' for the BBC which I read a couple of times for guidance during the three-and-half-hours it then took by train for my interview in Manchester. In the final chapter he said the qualities of being a cameraman involved 30 or 40 per cent sweat or talent - and 60 per cent keenness. And that keenness is even displayed when you're doing the roller caption at the end of a live show and you can't be arsed to get it straight. A real cameraman wants to achieve everything, even that roller caption; he wants everything to be absolutely plumb on going through his screen.

Enjoy the freedom of freelancing

The one person that impacted most on my career – not so much to do with camerawork but more to do with attitude, and, as leader organising a

crew – was my supervisory cameraman at Manchester, Don Groom, who previously worked at Pebble Mill. He was not only a fantastic cameraman, but had two other guys on his crew who were too. I loved his attitude, especially the way he dealt with me when I cocked up. We used to use mobile cranes called Herons. I would be the first to admit I wasn't a brilliant Heron tracker sitting on the back. They were bastards to operate as it had two pedals, one for the hydraulics while the other twisted the seat round which was ghastly but it was the only crane you could go into crab and still steer it. Yet Don would always turn to me and say: "Tony are you ready?" to which I would reply: "Yes I'm ready". He would then laugh and say: "Right you track and I'll compensate!" But we got on like a house on fire and I had a tremendous amount of respect for him as a person in dealing with both cameramen and production.

Just do your best
Do I have a favourite piece of camera equipment? Not particularly, there is nothing that leaps out at me as being brilliant. As for the role of a cameraman I don't think there's one simple answer. You could say it's to do exactly what the director wants – and we are talking now about multi-camera techniques perhaps more than single camerawork. But that does not mean having no input. The director might well say: "I want that two-shot" but if you can't get it from where you are, you may well have to move the camera, move the desk or even half the props. It could also mean asking the lighting guy: "Can I do it from this side?" In other words, do what you can and after that assert your influence and suggest "I will take the picture from this angle, or take it on another camera or we can do this, we can do that."

One thing that's really nice about the changes in television over the last 20 years and the influx of freelancers, is that you're dealing much more with personalities, and not tied down to the dogma and rigidity of the old studio system. With very strict crews, like those at the BBC, you would never dare say anything over talkback. If you had an idea you'd tell the supervisor and then he'd tell the director – and then the director would tell him to shut up! But now with that rigidity gone, you can actually talk directly to the director and input fantastic ideas. That's one of the things I've enjoyed the most about my job over the past 15 years since I've been freelance. The same applies with the approach to lighting directors,

engineers, the props guy or the girl doing the art direction. I feel more involved in every aspect of the job since I've been freelance, and not just with sit-coms, dramas, and LE.

Always share your skills with others
The importance of being a team member depends on the ever-changing nature of camerawork: there's multi-camera, studio camera and then there's single camera. The genre these days comes in so many different flavours. With multi-camera teamwork, I tell assistants wanting to become cameramen: "First, you've got to become a really good assistant. That means making sure the teas arrive hot and on time and then make sure everyone's got a sharp pencil and they've got tape for the floor." The trouble is most assistants want to be a cameraman. First this means pointing out that by becoming a good assistant first you will inevitably become a good cameraman. It shows discipline, and within a multi-camera crew that's your starting point. Once you get your experience and once everyone knows you, and what you do, then you can start making decisions on your own to help the crew.

A classic example is when you've got a shot that you know you can't get to, but know the camera standing next to you can. We used to be very protective. We all wanted the most shots on our card, this way we would be the busiest camera. But by offloading shots on to others because they are literally in the better position – rather than just pushing them out of your way – you're being a team member. Sometimes what you don't do is more important than what you do, at least in terms of the amount of shots.

Training today takes many shapes
While there's a lot of training going on, through colleges, media courses and the like, it only works when you've got a structure to train in, an edifice, like the BBC or the London Studios. You can't train under a freelance structure unless the production you're working on are happy to help you become a better operator, trainee, or whatever. It's a real problem, it relies so more much on training on the job than it ever used to. One of only two places left that I know of now that train, and train well, remains the BBC – when they can be bothered. The other is LWT at the London Television Centre, who put a lot of effort into training. Over the last ten years, or so,

they have turned out some very good competent cameramen, who have come up from being assistants.

Getting the best from a camera likewise holds many answers. It could be where you put it, or again where you don't put it. The director may want you to put it in a specific place to which you can only reply: "Well if I put it there I'm not going to get anything so I'm going to look for somewhere else." The thing I've learned about using cameras are through making several mistakes, such as: 'I'm going to crane down here, move across there and that's going to look fantastic." Then you look at it on a ped and admit it was crap. Whereas if you limit what you're doing, you can still get a similar impact without over-egging it.

I'm consistent in my way. I do like to think less is more. I love to have a camera in a position to provide a frame and let the person move around it wherever possible.

Use the camera wisely

Sometimes you're required to move and compose a shot, but I do like the idea of using the camera as a point of view and not thrashing about all over the place. If I do have to move it, I do so in such a way that the viewer doesn't notice the camera's moving too much. I was once doing an opera in which the camera I was operating was low and to one side of the stage. Inevitably when people moved towards, or away, from the camera it meant panning up or down a lot. You can't pre-set a frame for that, so this was an instance where you had to move the camera to keep the subject in the frame. But because 70 of the cast can sometimes all move downstage, the camera movement can be really jarring, So you've got to find a comfortable frame for them to move in while still allowing you to move the camera smoothly. I find that a real challenge.

Knocking knees produced a winner

The highlight of my career – the one, I suppose, that always stands out to me – isn't really necessarily that important and some would say a strange show to choose. But in the very first year of BBC Music Live we did *The Marriage of Figaro* at a house in Oxfordshire. It was directed by Trevor Hampton and we were there for eight days. It was going out live at the time of the day when each act of the opera was written – and it piddled down with rain for seven of them! On the final day the sun eventually

came out for the three acts alone. Now, I've never suffered with nerves, apart from the first time I operated a camera as a trainee doing the news at BBC Manchester. Ever since then it's a problem I've never faced. Yet on this occasion I was so nervous until the final shot that the assistant who was helping me on the Jimmy Jib I was operating, said: "Your knees were knocking" and when I looked down they were doing literally that. I was so nervous that if I'd had have anything to drink that morning I would probably have peed myself! And that was not just because of what I did, it proved a tough call for everybody. We had a Steadicam shot with Dominic Jackson, a multi-camera sequence upstairs with Paul and Martin Hawkins, and Dave Gopsil was doing stuff downstairs with me ... every single shot was perfect.

All of us individually had struggled with various bits and pieces: the artistes were virtually in the most perfect positions. Chris Clayton, who lit it, had to light for rain and sunshine because we hadn't got a clue what the weather condition was going to be. As for the sound boys, they should have had a bloody Oscar as far as I'm concerned. It was pure perfection and for about 14 minutes, which was as long as the act lasted, every frame, every sound, everything was perfection. So much so a member of production rang the truck to query whether the programme was going out live under the circumstances. Told it was he said: "I can't believe it!"

Yet I think my hardest decision has yet to come. It's probably when I say: "That's it; I'm not doing it any more!"

40 HOW TO MAKE IT

It is a question I have been asked so many times that I would be rich if had a pound for every time someone asked me: "How do I become a television cameraman?" I have always said what I consider to be the truth. No one thing will ensure this; it is a mixture of contacts, luck and talent, plus it certainly helps if you have an easygoing personality, but mostly it's not what you know but who you know. Not ideal, but nothing's perfect in television just like in every other walk of life.

For myself it was nepotism, the contact was my theatre manager father getting me into ATV as a post boy at 15. But once through the door it slammed firmly behind, I was on my own and nearly sacked once because I failed to get a vital commercials contract delivered until a day later. The luck was being able to work in studios at weekends for no money where I learnt the disciplines of production on live programmes and the talent … well I'd be dishonest to say that didn't have any. I must have or I would not have survived – television production is a tough life with no room for passengers.

Students at Ravensbourne College. Photo: Chizuko Kimura.

Today there is no incentive for TV companies to teach the craft of camerawork, the bean counters killed them off as being unproductive to the bottom line. But there are many colleges and media courses which try to fill the gap and will provide the very basics of what I went through, at a cost. Some are excellent with talented tutors who can inspire even though they may not actually have been very good, some are rip-offs with poor tutors who cannot get over more than the basic principles of camera operation. To find a good one is a bit like sticking a pin into Yellow Pages, so try to talk to someone in the business and get their opinions. If you don't know anyone then now's the time to start blagging your way to meeting a few; this is one of the skills you will need anyway so start early.

If you find there is little choice it might be better to save some pennies by not going down the pub so much and getting a basic domestic video camera to learn with. There is absolutely no way that this can teach you the discipline required with a crew on a professional shoot but you can learn a lot about composition and the timing of shots. Then you can edit on a computer using the often bundled software, add some music and upload it to YouTube or similar. If it's brilliant, you may even get work, but probably not the sort that puts money in the bank. It's good experience though, and it will give you confidence operating a camera.

If I was to sit on a panel interviewing potential cameramen today I would expect something like a DVD of what they'd done from every applicant as it shows a willingness to take risks, be creative and inventive. I would not even consider anyone who hasn't done something like this when it is so easy now and clearly demonstrates the ability of someone to think creatively for themselves.

This is a path I would have followed had it been possible when I started; all I could do was buy a 9.5mm cine camera and shoot silent footage then cut and splice it together. But even from this now dinosaur system I learnt a lot about shooting with a single camera long before it was used generally in television production except for news.

Having your own video camera would also give you the luxury of making mistakes and being able to experiment without restrictions on time before going into the wide world of the television industry for real where the motto is, "You're only as good as your last job". Never ever forget that.

41 ALAN BEAL – Cameraman

> *My personal success, I feel, has been based on the sort of person I am. Though a lot of people disagree, I think you let your work do the talking. There are too many people simply schmoozing, taking directors out for lunch or buying flowers for female producers. If your work can't say what you want it to say you'll soon get found out.*

Alan arrived at a good time in both television and at ATV Elstree where he was immediately liked and admired for his wit and humour as well as his obvious enthusiasm for cameras. He fitted in well into the Camera Department which had a huge range of characters.

Alan Beal with one of his two Emmys
Photo: Jeremy Hoare

A gentle soul, he is the only cameraman in the book who has won an American Emmy, and not just one, but two. This is one of television's highest accolades that can be bestowed on an individual and Alan deserves both of his, an amazing achievement for a British cameraman.

He had the courage to go out into the freelance world when it was precarious to do so. But as he explains, the choice was almost forced on him by circumstances. The business of television is constantly evolving, and Alan took a leap of faith and gambled that his talent would be needed; he was right and has made the most of it.

Alan is now content to just do the work that appeals to him, an enviable position to be in, but he only got there because of his underlying determination and success which is a great example of how to be a cameraman.

With most of my work concentrated solely on concerts or other big events – including, until fairly recently, quite a bit of ballet and opera which I love – my musical education has been considerable for someone starting out with no real knowledge. This is despite having cupboards full of CDs by performers who I would previously never even have heard of. I also travelled a lot to the Kirov ballet in St. Petersburg, or Leningrad at a time when the Bolshoi Ballet and various opera houses were respected worldwide.

The most enjoyable part of being a cameraman however, remains the variety of work. I started off doing everything. One day it would be racing from Doncaster and the next *La Boheme*, though too much variety is not always a good thing. You can't be good at everything.

More than just a job

Being a cameraman is more a way of life than just a job. All the people I know are either cameramen or work in television; the majority in my circle of friends are in television too, of which 90% are cameramen. I must admit it doesn't leave you much time to do anything else, but it is a very fulfilling job, for almost 50 years it has been enough.

There were only about eight or ten of us freelance cameramen when I started freelancing nearly 25 years ago. Now there are probably more freelancers than there are those in employment. The big difference is you can now specialise, with enough work around thanks to the increase in the number of channels. This means I didn't have to do things I didn't like as I moved towards the second half of my career – such as football. I never liked sport and I never thought I was any good at it. But you still had to work.

Now there's always enough work of the kind I like. The one thing I miss is drama. We did a lot at Elstree, but going freelance more or less put paid

to that. There was hardly any in the sort of circles I moved in; sitcom was about as near as you got to doing anything approaching a drama.

Good money is not enough
I don't know if there are any official training schemes these days with people coming from the likes of Ravensbourne College in Bromley, Kent. All I know is that youngsters coming in as camera assistants get what I consider, for somebody who's only 18, pretty good money. And since they're in demand the good ones can work a lot. But I wonder if some are simply in it for the money? It can be very lucrative if you can earn £200 a day for what amounts to kicking cables.

Don't get me wrong, I am not saying they all do that, but I think there is a large element of applications along the lines of "My friend's doing that and he tells me he is earning a thousand pounds a week." By the same token, I think a lot of camera assistants are absolutely brilliant, and they quickly pick things up. You can also tell the ones who really want to learn, though they often pretend to know more than they do. I think that's a mistake; it's far better to pretend you know less than you know. If somebody tells you something three times it doesn't matter. But if they assume you know and they don't tell you at all, then it's not a good way to proceed.

It's difficult to say how long it's possible to stay at the top. Let's say I've been lucky enough to win two Emmys – and I think we were nominated for another one. But these were all team efforts, all on multi-camera shoots. One was Janet Jackson at Madison Square Garden, and one was Cher at either the MGM Grand in Las Vegas or Miami.

Though they were thousands of miles apart, they were both for David Mallet whose ideas are brilliant. To put cameras where they need to be on a live show, give the crew a brief as to what they should be doing, and then put the whole thing together afterwards proves he's the best man for the job. I'm lucky to have been working with him for at least 15 years, travelling all over the world. My career would have been a much sorrier affair if I hadn't run into him.

The clue to his success is his knowing who he wants for certain jobs. He uses three different vision mixers depending on whether it's classical music or whatever. He tends to take a small core of people everywhere – and I was fortunate enough to be one of them.

Let your work talk for you

Ambition is now more important in the freelance world. You've got to be ambitious just to stay where you are. I was never ambitious, just so pleased initially to be a cameraman. I never dreamt about doing anything else, I just wanted to be good at it.

My personal success, I feel, has been based on the sort of person I am. Though a lot of people disagree, I think you let your work do the talking. There are too many people simply schmoozing, taking directors out for lunch or buying flowers for female producers. If your work can't say what you want it to say you'll soon get found out.

For me the biggest change in the type of big concert work I do is the use of 24 cameras when once it was four. It's such a huge change. As for the length of the lenses, we are probably working much further away from the action because that's where theatres and concert halls want you to be - at the back. This makes life more difficult so in a way it hasn't got easier, that's for sure; working further and further away certainly doesn't get easier as you get older.

Major change in lenses

We've got now huge lenses, 1000-1 or 500-1 or whatever. The 10 to 1 that Dai Higgon introduced years ago – and only he operated – was a major change at the time. At least with people like David Mallet, who I mentioned earlier, he has optimum distance that he wants cameras to be at. He also has the power to demand.

When I did an Elton John concert at Madison Square Gardens I had to be way up in the gods to get a decent shot, including one of his hands on the key boards – all from half a mile away. Asked if I was happy with this position, I replied: "Ideally I would like to be higher," and that really, from that distance, I needed to be quite a bit higher to make any difference whatsoever. And that meant losing an awful lot more seating. Mallet was absolutely brilliant, saying: "I will speak to Elton." After lunch he informed the powers concerned: "Elton says if that camera doesn't go there we haven't got a show!" He could do anything. He could even get walls knocked down if necessary. He's renowned for that sort of thing.

Okay, that means having a tough personality. With a cameraman, it relies instead on the way he deals with the powers that be. If you are sure what you want is the right thing, then you should be able to say so to the

director. I don't say a lot, I'm not even renowned for talking a lot, but if I had something I really think is important then I will take it all the way, otherwise it's not going to be any good.

Help directors achieve the best

The initial role of a cameraman is obviously to keep the director happy. However I don't think you can achieve this without improving, or bringing in, something he hadn't thought about, along the lines of: "Well, what about if we did this, would that be better than doing that ...?" and so on.

Being a team member is, of course, vital, though it doesn't happen very often in the freelance world. Even with a crew of freelancers, some of which you may know, you're still not a unit in the same way as when working with people from ATV who, between them, helped make the end product as good as possible. In the freelance world there are always those more interested in making a name for themselves, rather than the overall production. They just want to come out looking better that anyone else.

As for the relationship with a director, if I like somebody, or respect them, be it he or she, then I always feel it's a good one. If I don't it's really a personality issue. Either way, I always do the best I can, but might go that extra mile for somebody for whom I have huge respect, like immensely or think they might need a bit of help. Occasionally you get inexperienced directors who really do need help – even if their whole demeanour shows otherwise, or are at least never going to admit it. I'd far rather have somebody say: "Look I don't know quite what's going on here, do you think you can help?"

We did a six-part sitcom years ago using one single camera, which I operated, but I didn't light it. The entire script was written by a woman who wanted to direct the whole thing, and no way was she going to let them produce it unless she did so. When she came in to shoot the first scene, she had shot cards, each saying 'as directed'. Yet she readily admitted: "Look I've never directed anything in my life, what shall we do?" I think any right-minded cameraman would immediately say: "Alright then" and get on with it. If people are happy to admit a lack of skills you can still respect them by helping out.

My all time favourite camera

My favourite piece of camera equipment must be the Technocrane. It's the most amazing piece of equipment, an incredible crane with a remote head

which has a telescopic arm. This can move in and out at will which gives a huge advantage over anything which has a fixed arm length. It means, too, it can be pulled back to work in small spaces and then extended in a way to make it look as if it's tracking in situations impossible to shoot with a pedestal camera.

Paul Freeman is just one who's done amazing stuff with this piece of equipment: the opening shot of *Drop the Dead Donkey* which just goes through the whole newsroom is a superb example. You see it trailing through all kinds of places, ending up with a mid shot of the newsreader saying 'Good evening' and then it's into the programme. It's just fantastic.

Photography was my intro

Oddly enough it was photography that introduced me to television. When I left school at 15, I had no qualifications; I simply wanted to be a photographer because that was the only thing I was interested in, especially as the school had a darkroom. It also had a woman teacher whose subject was basically history but was keen on photography. So I latched on to her, taking pictures and using the darkroom for developing and printing films.

When I reached 15, I applied for a job with Odhams Press in the mailing room. You've got to start at the bottom, I thought, and this was one way of graduating as a photographer. This was what I always wanted to do, hopefully with a newspaper or magazine as Odhams published *The People* and the *Daily Sketch* as well as various women's magazines.

I started by running errands all over London until, after some six months, Odhams decided to open a new department to make commercials for the newly arrived ITV. Until then they only advertised their publications in other newspapers and magazines. The guy who got the job of running it took a liking to me, and I started working with him and two others making commercials for *Ideal Home* magazine and *Woman* magazine.

My first bit of studio work

I was, of course, only there in a very lowly capacity, but at least I was part of it – and since the guy had never made a commercial before we were all learning together. Once a week we would go to a Wardour Street studio to shoot what was usually somebody standing in front of a camera holding up a copy of a magazine saying: "Buy *Ideal Home* this week: we are giving

away a free whatever it was". The commercials used to be printed off nine times and go in cans to nine regional companies for showing.

I worked there for two years, after which a woman, who I got on well with, joined the department from the personnel office of ATV at Great Cumberland Place. I told her I was a bit fed up because the job was not taking me anywhere. "Write to ATV House and ask if they have anything suitable," was her suggestion, which I did, stressing an interest in photography. The response to which was that, while they didn't currently have anything camera-wise, they did have a vacancy in the film traffic department at ATV House. I went for an interview and got the job which was basically keeping an eye on the comings and goings of the various films. I was 18 by then and, though I always wanted to be a photographer, I think by then I'd set my sights on being a cameraman.

First taste of studio work
So I applied for another job, this time for a transmission controller. This, I thought would at least get me into the studio and the right type of environment. Sadly, I was too young. At the same time, I was both taking night classes at the City Lit for photography and studying for O levels which I thought were now important.

By the end of my period there I was doing stints as the weekend duty officer at Elstree, answering the phone complaints from angry viewers which were then written in the duty log and shown to Lew Grade every Monday morning. This way I got a taste for being around studios, something I desperately wanted.

When a job for a trainee camera job eventually came up, I had no O levels but I pretended I did, and since nobody asked to see them I got the job. This meant I had to leave my parent's home in order to get to ATV Elstree in my new role as a trainee. This, I thought, was the be all and end all!

Of all those I worked with, Bill Brown had the greatest influence on me. Some I liked and some I didn't – but I was in awe of him. He was so good at what he did and so self-effacing. Nor did he ever throw his weight about or anything like that, which is what I liked about him. Others, much less talented than him, did just the opposite.

Going freelance was once dodgy
My hardest, yet easiest, decision was to go freelance, even though I never thought of myself as that sort of person. It was a shock for me, for my

parents and everyone else who knew me. It stemmed more from a fear of having to go to Nottingham as ATV Elstree was closing, also the thought that if I did so before anyone else I would at least have a foot in the door. At that time I had no idea now many were likely to take that option, or even how many were preparing to go.

People would come up to me and say: "I've heard you are going freelance!"; they couldn't believe it either. One person had already left but he had a regular and quite well paid job. I think I was the first not looking to be a director but a cameraman. So my one bit of hope at the time was that Derek Chason, who had gone before me, was working for a company which had just embarked on a series of Gilbert and Sullivan operas. He had already offered me work which was quite a compliment. But I still had to audition for the female producer, a very high-powered American lady who worked for one of the big networks. I went on a day when there was no one in the studio. A camera was switched on and while she sat upstairs I had to prove my worth by shooting a piece from Gilbert and Sullivan, on which they were working at the time. It was literally an audition for a cameraman. After that everything went smoothly.

One of the best things
One of the best things I have worked on camera-wise was *After Dark* which was an open-ended live discussion programme on Channel 4 on Saturday night. The set was two sofas and a couple of arm-chairs in the round. It could go on until all hours if it was interesting and was the only programme I had ever worked on where we were given a free range to pan around. You could start on somebody's eyeball and then go down to a smoking cigarette; you were given a totally free range as to what you did.

There were only three cameras and quite often the camerawork was mentioned in reviews of the programme, remarking perhaps on the 'the exquisite camerawork'; I have never read anything like that elsewhere.

42 DOWNSIDE

The job of a cameraman is the practical application of creative skills, but sometimes it can be more a technical exercise in 'shot achievement' which is depressing to say the least – the non-artistic nature of it which when linked to getting that 'next job' can be damaging to your personal beliefs as well. So while the life I have had as a cameraman has been a great deal of fun, with many moments of pure exhilaration, like all things there is a downside as well, and there are far worse things than a boring working day.

Being emotionally driven human beings, we all tend to have personal relationships of one sort or another and the pressure on them from being a cameraman can be highly detrimental to having an easy ride through life; this is a great business but there is a price to pay by working in it. You should always do your very best as a cameraman no matter what circumstances you find yourself in, or that are dominating your thinking through personal and relationship problems that happen to us all the way

The Law Courts London. Photo: Jeremy Hoare.

through life. The old showbiz adage that 'the show must go on' is certainly very true for cameramen as well as actors.

Many a time I have had to totally blank-out my mind to near total disasters at home in my personal life when working in a studio; I actually revelled in the fact I was being asked to do something difficult with a camera as it became an escapist opportunity. In many ways the studio, or location, became an island for me, a sanctuary I couldn't wait to get back to where I could be at emotional peace and just deliver whatever I could which would add to a production. But after the wrap, and as soon as I drove out the gates, I was back in the world of reality; there was no real escape, just temporary refuge behind a camera.

Throughout my entire life in television production, and having known and met hundreds of people through that time, I can only think of a few relationships that have actually been able to stand the added pressure that the business adds to maintaining a happy and durable partnership. Two of mine certainly didn't and I know that the job was a large contributory factor, so like many others they eventually came to an end. It is a sad fact that in either divorce or relationship breakdown, it has been emotional carnage on a grand scale and I'm writing from painful and personal experience. Of course this has happened to many more outside the television industry as well with our ever increasingly faster lifestyles, but I suspect the percentage is higher for television personnel and for my friends in the business, many of their relationships have been torn apart by the nature of the job.

The anti-social hours, meeting new people almost every day, the opportunities that exist when on location to 'play away' and easy availability to alcohol and worse are the main culprits. In the past most television was made in studios when the majority of people would go back home at the end of the day, but in today's freelance world where so much more is shot on location, the opportunities to go off the rails are even more possible. These factors exist in all business environments but as with anything even fringing onto the entertainment world, television usually has the seeming overlay of glamour attached to it. We probably all start from that viewpoint, but it doesn't last more than a day for any realist.

After working for 12 or more hours on a production, particularly in a studio when you would normally go home, the most natural thing is to unwind with your colleagues and share the day's highs and lows over a

few drinks. So then the time you finish is not the time you go home and maybe your wife or partner sits alone watching TV long after the kids have been put to bed. This is very hard for them as you are depriving them of your company, having chosen to spend that time with people you've been with all day. It can build up and cause resentment which leads to the inevitable relationship breakdown or divorce. But I have known some cameramen, including myself sometimes, think that their relationship was more valuable than the after show drinks and go straight home. Though that brings the risk of being considered anti-social by your colleagues.

If you are footloose and single the after-show life can be very good as long as it lasts, but most people in my experience eventually want a loving stable relationship, whatever it means for them individually. When you have one you have to be very careful to nurture it and that means sometimes passing up on the after show party and going home.

But there is an Upside too!
Being a cameraman on a daily basis is often full of stress but I believe a dose of that is good anyway and overall it is like having a workout for the mind and body. The upside for me personally is that after having been over half a century in the television production business, I am totally convinced it has kept me younger in mind and spirit than I might be now. I know I have been fortunate health-wise but also I really believe that I am fitter and healthier than I would have been in a more sedentary occupation where I wouldn't have been required to use my creative interpretive skills and physical ability to such an extent. This is not just myself, it has been apparent that this has been true of all that I have interviewed for this book; without exception, they all have a young attitude of mind whatever their age in years. And that is a real plus for life!

43 MIKE DUGDALE – Cameraman

I love the camera crew humour, the different daily challenges, and never having to wear a suit except when in the company of royalty. Best of all pictorially I love interpreting the feeling, atmosphere and actuality that lies in front of your lens – and to portray that intent to millions on a small screen.

Mike Dugdale

Mike Dugdale must have had cameras in his genes and has had a very full career that spans a greater variety than most of us, certainly myself.

Like I do, he sees all of forms of photography as ways of telling a story with whatever camera you are using. His camerawork has covered a huge range of programming from the Falklands War to one that many will remember, the Queen's Jubilee – with Brian May playing guitar on the top of Buckingham Palace – it was Mike who did that shot.

Today he is just as enthusiastic as when he tracked me years ago. I knew I would not have an easy day when I had him track me, as unusually he was pushing me to be better. He would always push me and when I was operating Camera 1 on a Nike crane on *Bonkers*, a show made for an American network, I talked the director Peter Harris into letting me do a whole three minute number as one shot. I was gambling that I could pull it off but with Mike and Steve Harrow on the arm and Claude Walters driving it went far better than I could have hoped for in reality!

Now his son Paul is following on as a cameraman so the story continues into the next generation. If he is as talented as Mike he will be around a long time and provide viewers with great story telling pictures, just as his father has done for so long.

How a six-year-old turned his filming skills into a freelance life of shooting the rich and famous – along with covering riots and worldwide disasters.

Mike Dugdale, now a freelance cameraman, looks back on some 40 happy years of interpreting "The feeling, atmosphere and actuality that lies in front of the lens".

These last two weeks give as good a picture as any of not only how one year but how the last two, five, 20 even 40 years have provided me with so much variation. Take the last two days covering a memorial service at Windsor Castle at which both the Queen and Princess Anne were present. This was totally different from what I had previously been doing only a week before, working with rough and ready rock bands. One job involved elegant camera moves during a hymn, tilting down from 11th century rafters to a choir, the other throwing the same identical make and type of camera around. Both helped portray a mood.

While the first helped to enhance a respect for tradition royalty and Englishness, the other aimed to capture the essence of a rock band. One minute I was in Windsor Great Chapel, a fantastically private place where I had to wear a suit and be shiny shoe-ed, the next being as scruffy as I am now. In the middle of all that I spent a day amid the laughter at the Comedy Store in London. You can add to that *Watchdog,* shot in an office at the BBC, and *Harry Hill's TV Burp*, one of the most popular programmes on television.

I was also off shooting Cirque de Soleil at the O2 in Greenwich. I'd actually worked with Cirque before both in Sydney and in Canada. Oddly enough budget restraints meant that what took one day at the Dome would once have taken three: the first night used as a bit of a rehearsal, the second to shoot it and the third to include tight daring cutaways.

This dramatically illustrates the cutbacks that are affecting television. David Mallet might be one of Britain's most respected directors, yet even he had to cover Cirque de Soleil in just one day. All of which creates pressure simply because you don't have the time or money available.

Then there was the TV BAFTAs ceremony at the London Palladium, so that was my gamut in just two weeks. I think my entire career has probably been of a similar nature. That's the great thing about being a London

freelance cameraman, both in the studio and on PSC. It means I have been involved with everything from the controversial *Jerry Springer the Opera* to covering major world events, in locations around the world, along with plenty of concerts both in the UK and abroad, along with comedy, chat shows, documentaries and so on.

Nothing beats the joy of freelancing

Initially I was a studio-based staff cameraman, working on fantastic costume dramas with unbelievable attention to detail. The budgets then were massive as were those for light entertainment shows. Today's period dramas, sadly, have a much lower budgets ear-marked for them.

I would loved to have worked on *Brideshead Revisited*, such was the wonderful camerawork. I can still recall a long shot of two people coming out of the door of a country residence. There is a long lens track where they walk along a veranda. As they walk, the camera tracks past out of focus trees that virtually block out the frame. Then – and this shot lasts probably two minutes – they walk down a path towards the camera, do a turn that actually allows the camera to widen and track back with them, tracing through the same number of trees again now on a wider lens and with the trees in the foreground sharp. I have actually counted the trees, 12 dirty and out of focus trees going from left to right, then 12 dirty trees going from right to left. It's a genius shot; if I'd been the cameraman I'd want it to be shown at my funeral.

Royalty knows how to perform for the camera

I've even had the late Queen Mother wink at me! That was when, with a brick wall directly behind me, I found myself completely trapped in the wrong place. But the Queen Mother passing within two feet of me, and realising I was trapped, continued to look at the 20-foot brick wall behind me while pretending to wave at a crowd of onlookers. By waving at the bricks, the Queen Mother provided me with just the shot I needed.

Being a freelancer means I have worked on everything thing from football and music to royal events, as well as on major news events. I was, for instance, the second camera unit at the IRA Brighton bomb outrage; I was at the Zeebrugge ferry tragedy and was one of the first units on the Falkland Islands following the Falklands War. I have walked with Ian Botham from Spain to Italy, providing nightly live reports and

a documentary on his charity work. I have been run over by an out-of-control Phantom jet, hung over cliffs in a basket, beaten by striking miners, fallen out of helicopters and filmed in Amazon huts and English palaces. It's been fun!

A roaring success

Despite all that, a quite simple shot that I'm particularly proud of occurred while working on *Drop the Dead Donkey*, on which I did all the location shooting, mostly with the disaster prone young reporter played by Stephen Tompkinson. I 'played' Jerry his cameraman. In one particular scene he was conducting an interview at a zoo when suddenly someone spots an approaching lion which attacks the cameraman from behind. So here I am with possibly two of the most famous comedy writers in Europe, wondering: 'How are we are going to portray this?'

I asked for a tarpaulin and got everyone on the crew, other than the cast, to hold it on the ground. When we reached the spot when the reporter suddenly shouts: "Oh my God, I have just seen a lion behind the cameraman!" I ran backwards and, using the terrifying sound effect of a lion at my legs, dropped onto the tarpaulin and got 12 people to run with it as fast as they could with me laying on the ground, whilst the reporter with outstretched hand ran after me. This way it appeared the lion had got my foot and was dragging me backwards at 30 miles an hour. Later, standing in the studio as this footage was replayed, I watched the audience so doubled up with laughter they had to stop the recording; it was probably one of my best moments! All for a 20-second shot.

My 'dream' programmes

If I could work on my dream programme – and this sadly reflects the way I think television is going - it would be on a documentary called *Civilisation* made many years ago and fronted by Sir Kenneth Clark. The programme looked at art and architecture around the world. A remake would be my total dream job. As an amateur archaeologist, I'm passionate about the subject, especially about the unseen treasures of England.

For example there's a huge 13th century pavement in Westminster Abbey which has been hidden under a carpet. It's called the Cosmati Pavement and was made of rare marble glass and stone in 1268. It's worth a documentary on its own but the budget restraints of doing such a thing would for me be

enormous. I just want to make pictures, not have the tedium of budgets, crews, parking permissions, meal breaks and all the rest of it.

Family starred in my TV 'debut'

My first 'documentary' ever was about my own family, exploring our home environment – with my father sitting in his chair, my mother at the sink, and my brother doing his homework or whatever. This was an imaginary colour documentary I made way back in 1955 at the tender age of six. I used my favourite cardboard box which had a square hole at one end and another – bigger – square hole at the other. That was my television camera and I would roam around the house making various pretend documentaries.

Ironically, my favourite piece of equipment remains – and this should come as no surprise to anyone – the EMI 2001 camera which is not that dissimilar to my same childhood cardboard box! The only difference was that someone was clever enough to design a camera with a box which had a hole you look through at one end, and a box you look through at the other end. The EMI 2001 ergonomics as a studio camera have not been bettered to this day.

Unhappy schooldays no hindrance to getting a job

I couldn't stand school. I thought I was unintelligent because my teacher told me so – simply because I could see little point in learning the Pythagoras theorem or the importance of terminal moraine. I didn't believe it would be of any use to me and now, at nearly 60, I still don't! So, in my in my sixth year, when we were due to see the careers advisor, I announced I wanted to be a television cameraman.

My reasoning was simple. My father was a keen photographer and, from the age of five, I spent hours in his darkroom enthralled by the capturing and reproduction of an image. The thrill of capturing a moment – a glance, a shadow – still sends a chill down my spine. I was so proud of him when he won a Wallace Heaton certificate for a photograph of sunrise taken from his bedroom window at six o'clock one summer's morning. Wallace Heaton, after all, was then a well-known photographic store in London and I thought father was just the bee's knees.

Not only, I reckoned, could you capture images, but make money out of it as well. My other love was theatre – where that came from I don't

know – and the two things seemed to combine beautifully on television – which is why I so wanted to be a television cameraman.

The response from my headmaster was: "Dugdale I think it's time you faced the real world!" True I stood absolutely no chance at all – other than being the qualifying six feet tall to enable you to peer into a viewfinder when the camera was at the top of a pedestal. But, more disturbingly, you had to have an A level in both physics and maths. So I decided, at 16, to ignore his 'kind' words – and took myself first to the BBC where a man who looked rather like Churchill gave me the most arrogant and terrifyingly engineering-based interview.

"Sir", I pointed out, "I have come here for a camera interview". To which he replied: "We're talking about physics and if you don't understand how these things work, you are no use to us as a cameraman". "What about my portfolio of pictures?" I demanded to know. "Frankly, I am not interested," he said. And that was that. Now, rather ironically, I work as a freelance cameraman at the BBC on a regular basis.

A few days later I had an interview at Associated Television in Elstree, Borehamwood, in Hertfordshire, commonly known as the Elstree Studios. It could not have been more different. This time it was conducted by four very relaxed, humorous and lovely senior cameramen who this time seemed genuinely interested in seeing my photographs.

It was a hot day, and I had turned up in a suit. "For God's sake take your tie off," they told me. "Take off your jacket, too, and make yourself at home." It was a real breath of fresh air. They suggested I went to Art College for three years, which I did, studying fashion and commercial photography until I reached the intake age. At 19, true to their word, I was offered a place in the camera department at ATV where I stayed for 13 years. It was possibly the happiest, working period that I've had in my entire life – and I owe it to those four men who were broad minded enough to realise I simply had a passion for theatre and to make pictures.

Lead the viewers to the laughs

Two people have had a powerful impact on my career. One was a director called Liddy Oldroyd, essentially a sitcom director, and one of the most theatrical ladies I ever met. She was so theatrical and a genius as a television director. She taught me so much about operating a camera at a time when I had stopped wanting to learn, and taught me so many things

about comedy and television. I did a lot of single camerawork for her on location, and was always itching to make the arrival of the funny point as obvious as possible along the lines of – "Look here everybody, here it is!" – but she would caution: "Make it small, let the viewer discover it. They will find that funnier because it's them that has discovered it, not you as a cameraman going, "Look at this"."

Tragically Liddy, a mother of young children, died of a rare liver cancer some years ago in her early forties; she was a massive loss to television. In her obituary for *The Observer* magazine I said: "If she taught me anything, it was not to dot the 'I'". Even though I don't do much comedy shooting now, I still remember watching my own footage and how just as Liddy had taught me, the audience wouldn't just guffaw, but were in total uproar.

A scene-hand made good

Also exciting to work with, while at ATV, was a new young director James Gatwood, formerly a scene-hand at ATV but by then an up and coming new director. He was the first person I knew that around 1970 would shoot through a glass of beer while shooting say a pub scene in a sitcom at a time when things were shot fairly straight

But then we were still experiencing the fantastic new creativity of the sixties and his style was terribly exciting. Now, of course, it's done all the time. He would shoot a close up – and a dirty close up at that – in which maybe a person would bob in and out between two beer glasses. Frame making with this man was exciting. He went on to be chairman of Television South, TVS in the south of England.

The next generation

If I can be sycophantic, my life has gone from my father's darkroom to my own career and now I watch my son, Paul who has also became a cameraman. He now makes music videos, and from conception, shoots, edits and grades them before he presents a DVD to a production company which is then aired across the world. It illustrates how far television has gone from when I first started. I cannot believe, that in my day, to achieve what he does now, with a very small crew would have taken probably 15 to 20 people. The concept from beginning to end is his. He shoots it, edits and grades it. You have now got the whole editing kit on a Mac. Until relatively recently, it would have taken a room full of humming

equipment. Nowadays sophisticated editing and grading can be achieved on a laptop.

Working with a crew on multi-camera shooting, however, remains largely unchanged. You are still dependent on each other, with each cameraman able to anticipate what another will do in an intuitive way; the best freelance crews tend to be formed from those who are the best at what they do, be it sport, entertainment etc, and already work a lot together.

Television camerawork can often mean compromising over where the most perfect camera position, angle or size of shot is. It is, therefore, essential to work as a team that creates a series of complementary shots. Hopefully, but not always, the director, be it he or she, should be part of the team. That means teamwork is vital.

Television, unlike film, is a compromise. Instead of having five different takes by a single camera, you'll have five different cameras on a single take which basically means that cameras can't get in each other's way, so an agreement is always struck. The sad thing about television is that there is a compromise of position for the camera. This means if you are the close-up camera, you cannot push in to get your best background, or even maybe pull back to get the differential focus that you need to reduce the depth of field – all these compromises out of consideration for the other cameras.

Training schemes are utter rubbish

Camera training schemes are now virtually non-existent. In my mind the best way to get training is on the job, and many young people now work as an assistant for free for some weeks just to get in with a crew, and to play with a camera during the coffee and lunch breaks until the camera does what they want it to do. The only way you can get the best out of a camera is by putting the best operator behind it; I have seen some stunning music footage shot on an old 8mm cine camera bought at a boot fair.

However, I think it's possible to stay at the top for about 40 years! I have many students and young people who e-mail or phone me saying: "I want to get into television" So I ask: "What do you want to do?" "Well I haven't made up my mind". I am afraid that's it, for me you have to have a passion to make pictures if you want to be a cameraman. It's damn hard work, unsocial hours, relationship busting and leg wrecking. Does it still sound glamorous?"

Ambition, I agree, is very important. But if ambition is mixed with ego, it can be terribly destructive. I know many cameramen who are so ambitious that their ego actually destroys their camerawork and more importantly their respect and teamwork.

Being a freelancer can be quite tricky: you have to be a bit of a performer yourself, when the original idea was to be the person behind the camera. But oddly enough you can't avoid it.

What I do love about being a freelance cameraman now is that everyone is everyone's friend. There's no back-stabbing – everyone helps everyone else. When I started in television the crews were maybe ten strong – now my crew is possibly 60 to 70 and all are some of the best mates I have. I will take to my deathbed memories of good friends and famous workmates who've influenced my humour and even my thinking.

Go for it!
My advice to cameraman is just go for it. Be daring, even vicious, with your ambition to portray pictorially something that can show other people where you are and what you are seeing. And do be nice to the young runners; they will be the producers of tomorrow, that's for sure! Less flippant, be yourself, and forget 'Mr Safe' cameraman. No artist succeeded without being daring, breaking the rules, showing something different as to how we normally perceive life through our own eyes.

Crystal ball time
Thankfully, we have gone from a 4:3 picture format to a 16:9 format which allows for far more elegant framing. High Definition, on the other hand, means much more attention to focus. I've been making high definition shows for at least the last 15 years usually of a cultural nature, operas, ballets and so forth.

We need to find an efficient way of obtaining better differential focus with a TV camera. A continuous widescreen all over sharp picture is artistically dull and is what sometimes separates a film frame from a video one.

Throughout my life I've steered my career the way I've predicted the course television will take. Now, for the first time I really have no idea. What is possible is television on demand whereby there won't be an actual published programme schedule. You'll simply download whatever series or individual programmes suits your fancy, and at

whatever time you want. I don't see the current way existing more than another few years.

It's all about capturing emotion

Would I do it all over again? Most certainly 'yes'. In 1979, we had a huge strike that lasted three months. None of us in Independent Television felt we were being paid enough. There were only three or four channels then, not the hundreds you can receive now. I had been in television for 10 years by then; now, of course, you'd be a right old slow coach if you were still in the same job 10 years on. But I was completely comfortable in my fur-lined rut; I loved it, I knew how it worked and I was gaining respect.

In my spare time I ran a very successful antiques business and the biggest decision of my life was whether at the end of the strike I should concentrate on this, which was making far more money than I was as a cameraman. Other cameramen during that time did decorating, or whatever; this was an era where you didn't give in and draw the dole but instead managed to get by. So I had to think seriously whether I would go back or not.

My Father's advice was: "Listen. There's a pension at the end of it, so I really advise you to return." Which I did. If I'd gone into antiques I could well have been a multi-millionaire by now. Instead I'm a multi-millionaire in a different sort of way – just think of the places I've travelled to, the people I've met and the life I've been privileged to enjoy.

What I like most about being a cameraman is the way you get into secret places and meet secret people. For example, there's the thrill of operating a camera next to the Big Ben bell; or doing the same thing two weeks after the Falklands war ended. Walking across a battlefield with a camera on your shoulder and shell cases crunching under your feet is really something. I have also been in a helicopter where I have personally given the cue for two battleships to alter course so as to get the best shot. Nothing much compares with that.

I love the camera crew humour, the different daily challenges, and never having to wear a suit except when in the company of royalty. Best of all, pictorially, I love interpreting the feeling, atmosphere and actuality that lies in front of your lens – and to portray that intent to millions on a small screen. The main job of any camera is the means to capture the most suitable, and relevant, image quality. Whether it's a mobile phone camera used in the London Underground during a terrorist bomb attack

or a high definition camera for a wild life documentary, each tells a story, enhances the atmosphere and situation in which it was shot. Each is suited and enhances its own genre.

The camera is the tool of my trade. To me the job of a camera is to capture reality in such a way as to create emotion within the viewer. In doing so, you draw on a wonderful, wonderful, potpourri of unbelievable experiences.

44 AND FINALLY

Writing this book has been a real adventure for me – something I never thought I'd do, and a wonderful journey back through the past, into the present and with a look into the future. Just interviewing the many people whom I've been privileged to have worked with over the years has made me realise what a lucky person I have been to have survived my years in the industry. These people are some of the very best in the business who for half a century have defined the television production landscape.

Like me, they are all grateful for the life that television has given them so have been generous in giving their own experience for

Jeremy Hoare shooting Sleeping Beauty *in Kyoto Japan.*
Photo: Chizuko Kimura.

you to learn from. They all realise how important it is to pass on their hard-won wisdom, which one day you may be called upon to do.

Having read this book, I hope you are now much more prepared for the very real world of television production than you otherwise might have been. Whether you are on a media course or something similar, shooting your own epic on a domestic camera, studying old master painters of the past, viewing well known classic films or any of the many ways to learn how to be a good cameraman, the path forward for your career should, I hope, be clearer to you now.

Being a cameraman means that every working day is different and it is a wonderful way of using your imagination. It is tough out there in the

real world, and competitive, and it won't matter in the end what diploma or academic qualifications you have – camerawork is all about being a good contributing team member, pushing yourself beyond your creative limit, and telling a story.

I wish you all the luck in the world!

45 TECHNO TERMS

Television production is full of acronyms, terms and jargon and here are some that are used in the United Kingdom.

2k – two kilowatt Fresnel spotlight
2.5k/1.25k – two-and-a-half, one-and-a-quarter kilowatt lamp
2/S – two shot, two people in the frame
4:3 – traditional picture aspect ratio
5k – five kilowatt Fresnel spotlight
10k – ten kilowatt Fresnel spotlight
14:9 – intermediate picture aspect ratio
16:9 – widescreen picture aspect ratio

Accountants – bean counters with little or no creative skill who only know a 'bottom line'
ACTT – Association of Cinematograph and Television Technicians, a trade union that wielded immense power in the 1960s and 1970s with it's 'No ticket, no job; no job, no ticket' closed shop policy

Outside broadcast control room. Photo: Jeremy Hoare.

AD – Assistant Director

Aspect ratio – the ratio between the height and width of a picture

Bacon sarnies – life giving energy for sparks and the crew

Barndoors – movable shutters to shape and control a Fresnel lamp's beam

BCU – Big Close Up shot

Bean counters – accountants

BECTU – a modern trade union for production personnel

Best Boy – first assistant to the Gaffer

Betacam – camera made by Sony

Beta SP – videotape format made by Sony

Blackwrap –thin black metal in sheets for shaping beams on lights

Blacks – black drapes on flats or as a cyc for a backing

Blonde – 2k open face light

BP screen – Back Projection screen

Boom – long extendable arm with a microphone attached dangled above actors on a set

C4 lead – IP rated electrical connector, i.e.splash-proof (theatrical; used in EU as standard)

Callboy – theatre term for what today is a Runner, the bottom rung of the ladder

CCU – unit for control of exposure and set up of the camera from a remote position

Chromakey – usually a blue screen behind a presenter into which another scene is inlayed

Clapper-board – board held in front of camera logging takes to synchronise sound and vision

Colour temperature – colour of light; daylight is 5600 degrees Kelvin, studio lights 3200

Contrast ratio – the ratio of key to fill light output to adjust shadow depth

Control Board – board for controlling the light output and cues

Crab – sideways camera movement

CSO – Colour Separation Overlay, a BBC term for Chromakey

CU – Close Up shot

Cue cards – large cards with held under a camera for a performer to read from

Cyc – abbreviation of Cyclorama

Cyclorama – cloth suspended behind the rear of the set as a backing

Cyc Lighting – specific type of lighting which covers cyc evenly from above and below

Debrie pedestal – an old make of basic studio mount on three wheels for studio cameras

De-rig Unit – portable multi-camera control room in flight cases for temporary situations

DigiBeta – Digital Betacam camera and videotape format made by Sony

Director of Photography – person who lights the scene but does not normally operate the camera, a film term originally but increasingly used in television

Dolly – a device for moving the camera on shot, either manually or motor driven

DoP – acronym for Director of Photography,

DP – another acronym for Director of Photography

Drapes – cloth backings

Dry hire – hire of equipment without an operator

Dual source lamp – switchable dual wattage reversible hard and soft source light

DVE – Digital Video Effects are devices for picture manipulation

EMI 2001 – classic 1966 colour camera with the lens inside the body, the 'cameraman's camera' if there ever was one

ENG Kit – Electronic News Gathering set of simple lighting equipment

Fig Rig – wheel-like camera mount developed by Mike Figgis to steady handheld shooting

Flattage – line of scenery

Flat Clamp – clamp to fix a lamp onto a set or other flat position

Floorplan – scaled drawing of a studio with sets and camera positions marked

Flood – light comprised of open wide reflector, used for covering wide area

FOH – Front Of House, a theatre term often used for lighting

Four-waller – studio with nothing provided, an empty 'black box' shell

Fresnel – spotlight with a flattened concentric ring glass convex lens, the basic studio light

Frost – diffuser gels from a nearly clear ice to white opaque for softening the light source

Gaffer – chief electrician

Gel – plastic resin type of filter placed on a lamp, usually coloured

Gennie – generator on a truck to provide power where there is none conveniently available

Gobo – metal cutout which fits into the gate of a profile lamp to project a pattern

Grip – camera technician who moves a camera on shot, what used to be called a Tracker

Groundplan – scaled drawing of a studio with sets and camera positions marked

Groundrow – specific lamp for lighting a cyc from the below

GVs – General Views, shots taken to smoothly edit a piece of the surroundings, etc

HD – High Definition, commonly 1920 x 1080

HMI – discharge lamp with daylight colour temperature, always with a ballast unit

Iceblock – the prism which splits light to the RGB sensors

Idiot boards – large cards with the script held under a camera for a performer to read from

Key – main light source for the picture

LD – Lighting Director in television who plans and lights a production

LDK 5 – Phillips colour camera with three tubes

LED – Light Emitting Diodes which are revolutionising lighting

Lighting Balance – the adjustment of light output from lamps relative to each other

Lighting Cameraman – person who both lights the scene then shoots it

Lighting Cues – noted position of a change in the lighting condition

Lighting Plot or Plan – the drawing done by the LD which is used as a starting point of the lighting design

Look – the overall visual style of the way a programme is lit and shot

LS – Long Shot

Luminance – monochrome part of the colour signal

Magic Arm – lockable arm which will support a small lightweight lamp in almost any position

Mizar – 300/500 watt Fresnel spotlight

Mole Richardson Camera Crane (Mole) – converted from a Hollywood film crane

Monopole – individual lamp suspension system

Motorised Hoists – suspension bars which are electrically lowered and raised

MS – Mid Shot

Multi-camera – shooting and cutting through a vision mixer with several cameras

Negative gain – reduction in a camera's sensitivity below the set normal zero position

Nike – Chapman Nike camera crane designed for feature films originally

Noddies – cutaway shots of interviewers to enable an interview to be edited

OB – Outside Broadcast

OB scanner – UK mobile Outside Broadcast control room which is usually a large vehicle

OB truck – USA mobile Outside Broadcast control room which is usually a large vehicle

Open White – light left without a gel or diffuser

O/S – Over Shoulder shot

Pantograph – extending scissor type device for adjusting the height of individual lamps, sometimes spring loaded to balance the weight of the lamp.

Parcan – self-contained 'car headlamp' commonly used for colour washes and by rock bands

PC60 – 1960s Phillips colour camera with three Plumbicon tubes

Ped – abbreviation for Pedestal

Pedestal – versatile Vinten three-wheeled camera mount used in studios the world over

Poly – sheet of white polystyrene used as a reflector, usually 8 feet by 4 feet

Profile light – lantern similar to a coarse projector which can project gobos set into the gate

PSC – Portable Single Camera

PTC – Piece To Camera, a presenter/reporter talking direct to the viewer though the camera

Pup – one kilowatt Fresnel lamp

Pye – classic B&W 1950s camera with motorised lens turret

Racks – term for Vision Engineers controlling the CCUs

Redhead – 800 Watt open face light

Reflector – white panel or poly to bounce light off, mainly used for filling in shadows

RGB – Red, Green and Blue, the primary colours of light

Runner – bottom rung of the ladder, getting teas, etc. but learning production discipline

Saturation Rig – lighting installation where there is a large number of lamps to cut down on manpower and rigging time

Scaffold Rig – either a fixed simple means of lamp suspension or a temporally installed one.

Scrim – wire mesh to reduce light in a frame

SD – Standard Definition, the PAL 625 line system being phased out

Shot cards – shot description cards for a cameraman written by the director

Shoot – making a programme

Shooting – the act of making programmes

Soft light – lamp designed to create shadowless lighting, usually large in size

Spark – electrician, a gentle flower that blooms after tea and bacon sarnies

Spun – material in different strengths made of fibreglass used to soften a light

Standing Set – set which stays up for the run of a series to save cost of setting and resetting

Steadicam – Oscar-winning device which enables a person to seemingly float the camera smoothly along in places it would be impossible to lay tracks

Switcher – American term for Vision Mixer in both definitions

Technocrane – versatile camera crane with a telescopic arm for maximum versatility

Track – pre-recorded sound played back

Track – physical camera movement in or out

Tracker – term used for a Grip in previous times

Tracks – rails laid for a camera dolly to move along smoothly

Trussing – system of welded alloy tubes in joinable sections for lamp suspension

Tungsten – light source of 3200 degrees Kelvin; a studio light at full power

Twister – switchable dual wattage reversible hard and soft source light

Two-hander – usually an interview situation of cross shooting on two cameras

Two shot – two people in a shot

Vision Mixer – hands-on device for cutting pictures together

Vision Mixer – person who cuts pictures together for a director in a multi-camera studio

White Balance – means of setting the camera to read white as correct

Wrap – end of the shoot day

WS – Wide Shot

ENTERTAINMENT TECHNOLOGY PRESS

FREE SUBSCRIPTION SERVICE

Keeping Up To Date with

Through the Viewfinder

Entertainment Technology titles are continually up-dated, and all major changes and additions are listed in date order in the relevant dedicated area of the publisher's website. Simply go to the front page of www.etnow.com and click on the BOOKS button. From there you can locate the title and be connected through to the latest information and services related to the publication.

The author of the title welcomes comments and suggestions about the book and can be contacted by email at: jeremyhoare@hotmail.com

This book has a dedicated website at www.throughtheviewfinder.tv for news and views.

Titles Published by Entertainment Technology Press

ABC of Theatre Jargon *Francis Reid* **£9.95** ISBN 1904031099
This glossary of theatrical terminology explains the common words and phrases that are used in normal conversation between actors, directors, designers, technicians and managers.

Aluminium Structures in the Entertainment Industry *Peter Hind* **£24.95**
ISBN 1904031064
Aluminium Structures in the Entertainment Industry aims to educate the reader in all aspects of the design and safe usage of temporary and permanent aluminium structures specific to the entertainment industry – such as roof structures, PA towers, temporary staging, etc.

AutoCAD – A Handbook for Theatre Users *David Ripley* **£24.95** ISBN 1904031315
From 'Setting Up' to 'Drawing in Three Dimensions' via 'Drawings Within Drawings', this compact and fully illustrated guide to AutoCAD covers everything from the basics to full colour rendering and remote plotting.

Basics – A Beginner's Guide to Lighting Design *Peter Coleman* **£9.95** ISBN 1904031412
The fourth in the author's 'Basics' series, this title covers the subject area in four main sections: The Concept, Practical Matters, Related Issues and The Design Into Practice. In an area that is difficult to be definitive, there are several things that cross all the boundaries of all lighting design and it's these areas that the author seeks to help with.

Basics – A Beginner's Guide to Special Effects *Peter Coleman* **£9.95** ISBN 1904031331
This title introduces newcomers to the world of special effects. It describes all types of special effects including pyrotechnic, smoke and lighting effects, projections, noise machines, etc. It places emphasis on the safe storage, handling and use of pyrotechnics.

Basics – A Beginner's Guide to Stage Lighting *Peter Coleman* **£9.95** ISBN 190403120X
This title does what it says: it introduces newcomers to the world of stage lighting. It will not teach the reader the art of lighting design, but will teach beginners much about the 'nuts and bolts' of stage lighting.

Basics: A Beginner's Guide to Stage Management *Peter Coleman* **£7.95**
ISBN 9781904031475
The fifth in Peter Coleman's popular 'Basics' series, this title provides a practical insight into, and the definition of, the role of stage management. Further chapters describe Cueing or 'Calling' the Show (the Prompt Book), and the Hardware and Training for Stage Management. This is a book about people and systems, without which most of the technical equipment used by others in the performance workplace couldn't function.

Basics – A Beginner's Guide to Stage Sound *Peter Coleman* **£9.95** ISBN 1904031277
This title does what it says: it introduces newcomers to the world of stage sound. It will not teach the reader the art of sound design, but will teach beginners much about the background to sound reproduction in a theatrical environment.

Building Better Theaters *Michael Mell* **£16.95** 1904031404
A title within our Consultancy Series, this book describes the process of designing a theater, from the initial decision to build through to opening night. Michael Mell's book provides

a step-by-step guide to the design and construction of performing arts facilities. Chapters discuss: assembling your team, selecting an architect, different construction methods, the architectural design process, construction of the theater, theatrical systems and equipment, the stage, backstage, the auditorium, ADA requirements and the lobby. Each chapter clearly describes what to expect and how to avoid surprises. It is a must-read for architects, planners, performing arts groups, educators and anyone who may be considering building or renovating a theater.

Case Studies in Crowd Management
Chris Kemp, Iain Hill, Mick Upton, Mark Hamilton **£16.95** ISBN 9781904031482
This important work has been compiled from a series of research projects carried out by the staff of the Centre for Crowd Management and Security Studies at Buckinghamshire Chilterns University College, and seminar work carried out in Berlin and Groningen with partner Yourope. It includes case studies, reports and a crowd management safety plan for a major outdoor rock concert, safe management of rock concerts utilising a triple barrier safety system and pan-European Health & Safety Issues.

Close Protection – The Softer Skills *Geoffrey Padgham* **£11.95** ISBN 1904031390
This is the first educational book in a new 'Security Series' for Entertainment Technology Press, and it coincides with the launch of the new 'Protective Security Management' Foundation Degree at Buckinghamshire Chilterns University College (BCUC). The author is a former full-career Metropolitan Police Inspector from New Scotland Yard with 27 years' experience of close protection (CP). For 22 of those years he specialised in operations and senior management duties with the Royalty Protection Department at Buckingham Palace, followed by five years in the private security industry specialising in CP training design and delivery. His wealth of protection experience comes across throughout the text, which incorporates sound advice and exceptional practical guidance, subtly separating fact from fiction. This publication is an excellent form of reference material for experienced operatives, students and trainees.

A Comparative Study of Crowd Behaviour at Two Major Music Events
Chris Kemp, Iain Hill, Mick Upton **£7.95** ISBN 1904031250
A compilation of the findings of reports made at two major live music concerts, and in particular crowd behaviour, which is followed from ingress to egress.

Control Freak *Wayne Howell* **£28.95** ISBN 9781904031550
Control Freak is the second book by Wayne Howell. It provides an in depth study of DMX512 and the new RDM (Remote Device Management) standards. The book is aimed at both users and developers and provides a wealth of real world information based on the author's twenty year experience of lighting control.

Copenhagen Opera House *Richard Brett and John Offord* **£32.00** ISBN 1904031420
Completed in a little over three years, the Copenhagen Opera House opened with a royal gala performance on 15th January 2005. Built on a spacious brown-field site, the building is a landmark venue and this book provides the complete technical background story to an opera house set to become a benchmark for future design and planning. Sixteen chapters by relevant experts involved with the project cover everything from the planning of the auditorium and studio stage, the stage engineering, stage lighting and control and architectural lighting through to acoustic design and sound technology plus technical summaries.

Electrical Safety for Live Events *Marco van Beek* **£16.95** ISBN 1904031285
This title covers electrical safety regulations and good pracitise pertinent to the entertainment industries and includes some basic electrical theory as well as clarifying the "do's and don't's" of working with electricity.

Entertainment in Production Volume 1: 1994-1999 *Rob Halliday* **£24.95**
ISBN 9781904031512

Entertainment in Production Volume 2: 2000-2006 *Rob Halliday* **£24.95**
ISBN 9781904031529
Rob Halliday has a dual career as a lighting designer/programmer and author and in these two volumes he provides the intriguing but comprehensive technical background stories behind the major musical productions and other notable projects spanning the period 1994 to 2005. Having been closely involved with the majority of the events described, the author is able to present a first-hand and all-encompassing portrayal of how many of the major shows across the past decade came into being. From *Oliver!* and *Miss Saigon* to *Mamma Mia!* and *Mary Poppins*, here the complete technical story unfolds. The books, which are profusely illustrated, are in large part an adapted selection of articles that first appeared in the magazine *Lighting&Sound International*.

Entertainment Technology Yearbook 2008 *John Offord* **£14.95 ISBN 9781904031543**
The new Entertainment Technology Yearbook 2008 covers the year 2007 and includes picture coverage of major industry exhibitions in Europe compiled from the pages of Entertainment Technology magazine and the etnow.com website, plus articles and pictures of production, equipment and project highlights of the year. Also included is a major European Trade Directory that will be regularly updated on line. A new edition will be published each year at the ABTT Theatre Show in London in June.

The Exeter Theatre Fire *David Anderson* **£24.95** ISBN 1904031137
This title is a fascinating insight into the events that led up to the disaster at the Theatre Royal, Exeter, on the night of September 5th 1887. The book details what went wrong, and the lessons that were learned from the event.

Fading Light – A Year in Retirement *Francis Reid* **£14.95** ISBN 1904031358
Francis Reid, the lighting industry's favourite author, describes a full year in retirement. "Old age is much more fun than I expected," he says. Fading Light describes visits and experiences to the author's favourite theatres and opera houses, places of relaxation and re-visits to scholarly institutions.

Focus on Lighting Technology *Richard Cadena* **£17.95** ISBN 1904031145
This concise work unravels the mechanics behind modern performance lighting and appeals to designers and technicians alike. Packed with clear, easy-to-read diagrams, the book provides excellent explanations behind the technology of performance lighting.

The Followspot Guide *Nick Mobsby* **£28.95 ISBN 9781904031499**
The first in ETP's Equipment Series, Nick Mobsby's Followspot Guide tells you everything you need to know about followspots, from their history through to maintenance and usage. It's pages include a technical specification of 193 followspots from historical to the latest 2007 versions from major manufacturers.

From Ancient Rome to Rock 'n' Roll – a Review of the UK Leisure Security Industry
Mick Upton **£14.95** ISBN 9781904031505
From stewarding, close protection and crowd management through to his engagement as
a senior consultant Mick Upton has been ever present in the events industry. A founder of
ShowSec International in 1982 he was its chairman until 2000. The author has led the way on
training within the sector. He set up the ShowSec Training Centre and has acted as a consultant
at the Bramshill Police College. He has been prominent in the development of courses at
Buckinghamshire New University where he was awarded a Doctorate in 2005. Mick has
received numerous industry awards. His book is a personal account of the development and
professionalism of the sector across the past 50 years.

Health and Safety Aspects in the Live Music Industry *Chris Kemp, Iain Hill* **£30.00** ISBN
1904031226
This title includes chapters on various safety aspects of live event production and is written
by specialists in their particular areas of expertise.

Health and Safety Management in the Live Music and Events Industry *Chris Hannam*
£25.95 ISBN 1904031307
This title covers the health and safety regulations and their application regarding all aspects
of staging live entertainment events, and is an invaluable manual for production managers
and event organisers.

Hearing the Light – 50 Years Backstage *Francis Reid* **£24.95** ISBN 1904031188
This highly enjoyable memoir delves deeply into the theatricality of the industry. The
author's almost fanatical interest in opera, his formative period as lighting designer at
Glyndebourne and his experiences as a theatre administrator, writer and teacher make for a
broad and unique background.

An Introduction to Rigging in the Entertainment Industry *Chris Higgs* **£24.95**
ISBN 1904031129
This book is a practical guide to rigging techniques and practices and also thoroughly covers
safety issues and discusses the implications of working within recommended guidelines and
regulations. Second edition revised September 2008.

Let There be Light – Entertainment Lighting Software Pioneers in Conversation
Robert Bell **£32.00** ISBN 1904031242
Robert Bell interviews a distinguished group of software engineers working on
entertainment lighting ideas and products.

Lighting for Roméo and Juliette *John Offord* **£26.95** ISBN 1904031161
John Offord describes the making of the Vienna State Opera production from the lighting
designer's viewpoint – from the point where director Jürgen Flimm made his decision not to
use scenery or sets and simply employ the expertise of LD Patrick Woodroffe.

Lighting Systems for TV Studios *Nick Mobsby* **£45.00** ISBN 1904031005
Lighting Systems for TV Studios, now in its second edition, is the first book specifically
written on the subject and has become the 'standard' resource work for studio planning
and design covering the key elements of system design, luminaires, dimming, control,
data networks and suspension systems as well as detailing the infrastructure items such as

cyclorama, electrical and ventilation. Sensibly TV lighting principles are explained and some history on TV broadcasting, camera technology and the equipment is provided to help set the scene! The second edition includes applications for sine wave and distributed dimming, moving lights, Ethernet and new cool lamp technology.

Lighting Techniques for Theatre-in-the-Round *Jackie Staines* **£24.95**
ISBN 1904031013
Lighting Techniques for Theatre-in-the-Round is a unique reference source for those working on lighting design for theatre-in-the-round for the first time. It is the first title to be published specifically on the subject, it also provides some anecdotes and ideas for more challenging shows, and attempts to blow away some of the myths surrounding lighting in this format.

Lighting the Stage *Francis Reid* **£14.95** ISBN 1904031080
Lighting the Stage discusses the human relationships involved in lighting design – both between people, and between these people and technology. The book is written from a highly personal viewpoint and its 'thinking aloud' approach is one that Francis Reid has used in his writings over the past 30 years.

Model National Standard Conditions *ABTT/DSA/LGLA* **£20.00** ISBN 1904031110
These *Model National Standard Conditions* covers operational matters and complement *The Technical Standards for Places of Entertainment*, which describes the physical requirements for building and maintaining entertainment premises.

Mr Phipps' Theatre *Mark Jones, John Pick* **£17.95** ISBN: 1904031382
Mark Jones and John Pick describe "The Sensational Story of Eastbourne's Royal Hippodrome" – formerly Eastbourne Theatre Royal. An intriguing narrative, the book sets the story against a unique social history of the town. Peter Longman, former director of The Theatres Trust, provides the Foreword.

Pages From Stages *Anthony Field* **£17.95** ISBN 1904031269
Anthony Field explores the changing style of theatres including interior design, exterior design, ticket and seat prices, and levels of service, while questioning whether the theatre still exists as a place of entertainment for regular theatre-goers.

Performing Arts Technical Training Handbook 2007/2008 *ed: John Offord* **£19.95** ISBN 9781904031451
Published in association with the ABTT (Association of British Theatre Technicians), this important Handbook includes fully detailed and indexed entries describing courses on backstage crafts offered by over 100 universities and colleges across the UK. A completely new research project, with accompanying website, the title also includes articles with advice for those considering a career 'behind the scenes', together with contact information and descriptions of the major organisations involved with industry training – plus details of companies offering training within their own premises. The Handbook will be kept in print, with a major revision annually.

Practical Dimming *Nick Mobsby* **£22.95** ISBN 19040313447
This important and easy to read title covers the history of electrical and electronic dimming, how dimmers work, current dimmer types from around the world, planning of a dimming system, looking at new sine wave dimming technology and distributed dimming. Integration

of dimming into different performance venues as well as the necessary supporting electrical systems are fully detailed. Significant levels of information are provided on the many different forms and costs of potential solutions as well as how to plan specific solutions. Architectural dimming for the likes of hotels, museums and shopping centres is included. Practical Dimming is a companion book to Practical DMX and is designed for all involved in the use, operation and design of dimming systems.

Practical DMX *Nick Mobsby* **£16.95** ISBN 1904031368
In this highly topical and important title the author details the principles of DMX, how to plan a network, how to choose equipment and cables, with data on products from around the world, and how to install DMX networks for shows and on a permanently installed basis. The easy style of the book and the helpful fault finding tips, together with a review of different DMX testing devices provide an ideal companion for all lighting technicians and system designers. An introduction to Ethernet and Canbus networks are provided as well tips on analogue networks and protocol conversion. This title has been recently updated to include a new chapter on Remote Device Management that became an international standard in Summer 2006.

Practical Guide to Health and Safety in the Entertainment Industry
Marco van Beek **£14.95** ISBN 1904031048
This book is designed to provide a practical approach to Health and Safety within the Live Entertainment and Event industry. It gives industry-pertinent examples, and seeks to break down the myths surrounding Health and Safety.

Production Management *Joe Aveline* **£17.95** ISBN 1904031102
Joe Aveline's book is an in-depth guide to the role of the Production Manager, and includes real-life practical examples and 'Aveline's Fables' – anecdotes of his experiences with real messages behind them.

Rigging for Entertainment: Regulations and Practice *Chris Higgs* **£19.95**
ISBN 1904031218
Continuing where he left off with his highly successful *An Introduction to Rigging in the Entertainment Industry*, Chris Higgs' second title covers the regulations and use of equipment in greater detail.

Rock Solid Ethernet *Wayne Howell* **£24.95** ISBN 1904031293
Although aimed specifically at specifiers, installers and users of entertainment industry systems, this book will give the reader a thorough grounding in all aspects of computer networks, whatever industry they may work in. The inclusion of historical and technical 'sidebars' make for an enjoyable as well as informative read.

Sixty Years of Light Work *Fred Bentham* **£26.95** ISBN 1904031072
This title is an autobiography of one of the great names behind the development of modern stage lighting equipment and techniques.

Sound for the Stage *Patrick Finelli* **£24.95** ISBN 1904031153
Patrick Finelli's thorough manual covering all aspects of live and recorded sound for performance is a complete training course for anyone interested in working in the field of stage sound, and is a must for any student of sound.

Stage Automation *Anton Woodward* **£12.95** ISBN 9781904031567
The purpose of this book is to explain the stage automation techniques used in modern theatre to achieve some of the spectacular visual effects seen in recent years. The book is targeted at automation operators, production managers, theatre technicians, stage engineering machinery manufacturers and theatre engineering students. Topics are covered in sufficient detail to provide an insight into the thought processes that the stage automation engineer has to consider when designing a control system to control stage machinery in a modern theatre. The author has worked on many stage automation projects and developed the award-winning Impressario stage automation system.

Stage Lighting Design in Britain: The Emergence of the Lighting Designer, 1881-1950 *Nigel Morgan* **£17.95** ISBN 190403134X
This book sets out to ascertain the main course of events and the controlling factors that determined the emergence of the theatre lighting designer in Britain, starting with the introduction of incandescent electric light to the stage, and ending at the time of the first public lighting design credits around 1950. The book explores the practitioners, equipment, installations and techniques of lighting design.

Stage Lighting for Theatre Designers *Nigel Morgan* **£17.95** ISBN 1904031196
This is an updated second edition of Nigel Morgan's popular book for students of theatre design – outlining all the techniques of stage lighting design.

Technical Marketing Techniques *David Brooks, Andy Collier, Steve Norman* **£24.95** ISBN 190403103X
Technical Marketing is a novel concept, recently defined and elaborated by the authors of this book, with business-to-business companies competing in fast developing technical product sectors.

Technical Standards for Places of Entertainment *ABTT/DSA* **£45.00** ISBN 9781904031536
Technical Standards for Places of Entertainment details the necessary physical standards required for entertainment venues. New A4 revised edition June 2008.

Theatre Engineering and Stage Machinery *Toshiro Ogawa* **£30.00** ISBN 9781904031024
Theatre Engineering and Stage Machinery is a unique reference work covering every aspect of theatrical machinery and stage technology in global terms, and across the complete historical spectrum. Revised February 2007.

Theatre Lighting in the Age of Gas *Terence Rees* **£24.95** ISBN 190403117X
Entertainment Technology Press has republished this valuable historic work previously produced by the Society for Theatre Research in 1978. *Theatre Lighting in the Age of Gas* investigates the technological and artistic achievements of theatre lighting engineers from the 1700s to the late Victorian period.

Theatre Space: A Rediscovery Reported *Francis Reid* **£19.95** ISBN 1904031439
In the post-war world of the 1950s and 60s, the format of theatre space became a matter for a debate that aroused passions of an intensity unknown before or since. The proscenium arch was clearly identified as the enemy, accused of forming a barrier to disrupt the relations between the actor and audience. An uneasy fellow-traveller at the time, Francis Reid later

recorded his impressions whilst enjoying performances or working in theatres old and new and this book is an important collection of his writings in various theatrical journals from 1969-2001 including his contribution to the Cambridge Guide to the Theatre in 1988. It reports some of the flavour of the period when theatre architecture was rediscovering its past in a search to establish its future.

Theatres of Achievement *John Higgins* **£29.95** ISBN: 1904031374
John Higgins affectionately describes the history of 40 distinguished UK theatres in a personal tribute, each uniquely illustrated by the author. Completing each profile is colour photography by Adrian Eggleston.

Theatric Tourist *Francis Reid* **£19.95** ISBN 9781904031468
Theatric Tourist is the delightful story of Francis Reid's visits across more than 50 years to theatres, theatre museums, performances and even movie theme parks. In his inimitable style, the author involves the reader within a personal experience of venues from the Legacy of Rome to theatres of the Renaissance and Eighteenth Century Baroque and the Gustavian Theatres of Stockholm. His performance experiences include Wagner in Beyreuth, the Pleasures of Tivoli and Wayang in Singapore. This is a 'must have' title for those who are as "incurably stagestruck" as the author.

Through the Viewfinder *Jeremy Hoare* **£21.95** ISBN: 9781904031574
Do you want to be a top television cameraman? Well this is going to help!
Through the Viewfinder is aimed at media students wanting to be top professional television cameramen – but it will also be of interest to anyone who wants to know what goes on behind the cameras that bring so much into our homes.
The author takes his own opinionated look at how to operate a television camera based on 23 years' experience looking through many viewfinders for a major ITV network company. Based on interviews with people he has worked with, all leaders in the profession, the book is based on their views and opinions and is a highly revealing portrait of what happens behind the scenes in television production from a cameraman's point of view.

Walt Disney Concert Hall – The Backstage Story *Patricia MacKay & Richard Pilbrow* **£28.95** ISBN 1904031234
Spanning the 16-year history of the design and construction of the Walt Disney Concert Hall, this book provides a fresh and detailed behind the scenes story of the design and technology from a variety of viewpoints. This is the first book to reveal the "process" of the design of a concert hall.

Yesterday's Lights – A Revolution Reported *Francis Reid* **£26.95** ISBN 1904031323
Set to help new generations to be aware of where the art and science of theatre lighting is coming from – and stimulate a nostalgia trip for those who lived through the period, Francis Reid's latest book has over 350 pages dedicated to the task, covering the 'revolution' from the fifties through to the present day. Although this is a highly personal account of the development of lighting design and technology and he admits that there are 'gaps', you'd be hard put to find anything of significance missing.

Go to www.etbooks.co.uk for full details of above titles and secure online ordering facilities.